S0-AWB-919

500 POSES *for*
Photographing
Group Portraits

A VISUAL
SOURCEBOOK FOR
DIGITAL PORTRAIT
PHOTOGRAPHERS

Michelle Perkins

AMHERST MEDIA, INC. ■ BUFFALO, NY

RECEIVED

JUL 1 1 2013

My deepest thanks to the photographers whose work appears in this book. Their powerful images are truly inspiring—as is their commitment to educating other professionals. If you have a chance to learn from them, whether at a workshop or through their writing, take it; you won't be disappointed.

And, as always, love and gratitude to my talented husband—a constant source of love and inspiration.

Copyright © 2013 by Michelle Perkins.
All rights reserved.

Front cover photographs by Christie Mumm (large photo) and Brett Florens (inset photos).
Back cover photograph by Brett Florens.

Published by:
Amherst Media, Inc.
P.O. Box 586
Buffalo, N.Y. 14226
Fax: 716-874-4508
www.AmherstMedia.com

Publisher: Craig Alesse
Senior Editor/Production Manager: Michelle Perkins
Assistant Editor: Barbara A. Lynch-Johnt
Editorial Assistance from: Sally Jarzab, Carey Anne Miller
Business Manager: Adam Richards
Marketing, Sales, and Promotion Manager: Kate Neaverth
Warehouse and Fulfillment Manager: Roger Singo

ISBN-13: 978-1-60895-552-7
Library of Congress Control Number: 2012936517
Printed in Korea.
10 9 8 7 6 5 4 3 2 1

No part of this publication may be reproduced, stored, or transmitted in any form or by any means, electronic, mechanical, photocopied, recorded or otherwise, without prior written consent from the publisher.

Notice of Disclaimer: The information contained in this book is based on the author's experience and opinions. The author and publisher will not be held liable for the use or misuse of the information in this book.

Check out Amherst Media's blogs at: http://portrait-photographer.blogspot.com/
http://weddingphotographer-amherstmedia.blogspot.com/

About This Book

Designing outstanding portraits of a single subject can be a challenge, but the complications are compounded with each subject that is added to the frame. Not only must each subject look good individually, but the group must also look good collectively. Additionally, the relationships between the subjects often need to be established through the posing and composition of the image.

This collection is designed as a springboard for facing the many challenges of posing groups. Filled with images by accomplished professionals, it provides a resource for photographers seeking inspiration for their own work. Stuck on what to do with a particular group or unsure how to use a given location? Flip through the sample portraits, pick something you like, then adapt it as needed to suit your tastes. Looking to freshen up your work with some new poses? Find a sample that appeals to you and look for ways to implement it (or some element of it) with your subjects.

For ease of use, the portraits are grouped according to the number of subjects shown in the frame. Thus, the book begins with groups of two, then moves on to larger and larger groups—all the way up to images with more than twenty-five subjects. (*Note:* Groups of two, probably the most common portrait grouping, are more extensively covered in another volume in this series: *500 Poses for Photographing Couples*).

It can be difficult to remain creative day after day, year after year, but sometimes all you need to break through a slump is a little spark. In this book, you'll find a plethora of images designed to provide just that.

Contents

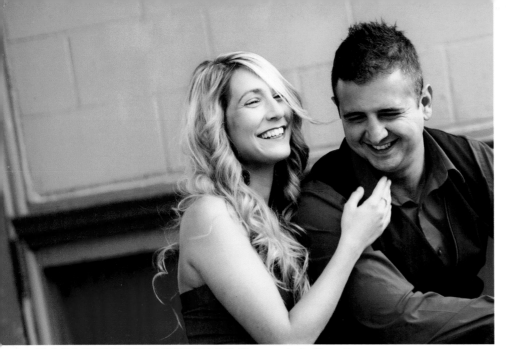

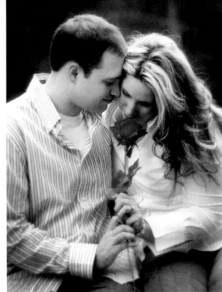

PLATE 3. Photograph by Tracy Dorr.

PLATE 1 (ABOVE) AND PLATE 2 (BELOW). Photographs by Tracy Dorr.

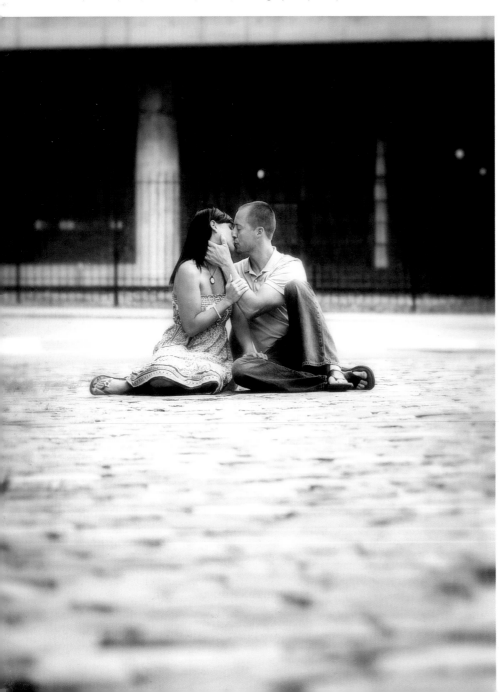

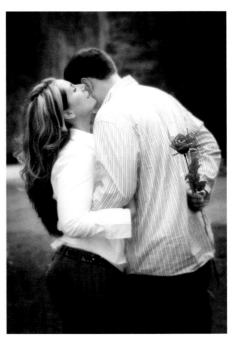

PLATE 4. Photograph by Tracy Dorr.

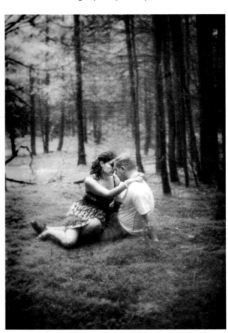

PLATE 5. Photograph by Tracy Dorr.

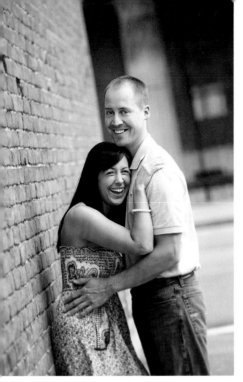

PLATE 6. Photograph by Tracy Dorr.

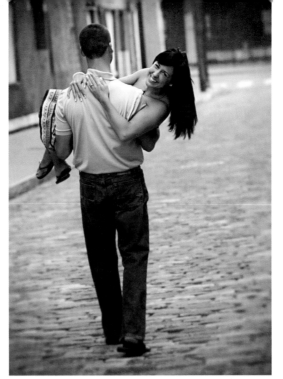

PLATE 7. Photograph by Tracy Dorr.

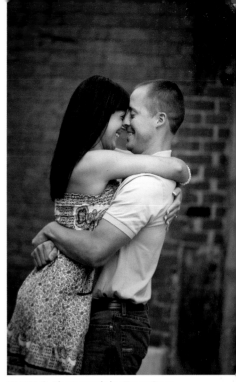

PLATE 8. Photograph by Tracy Dorr.

PLATE 9. Photograph by Tracy Dorr.

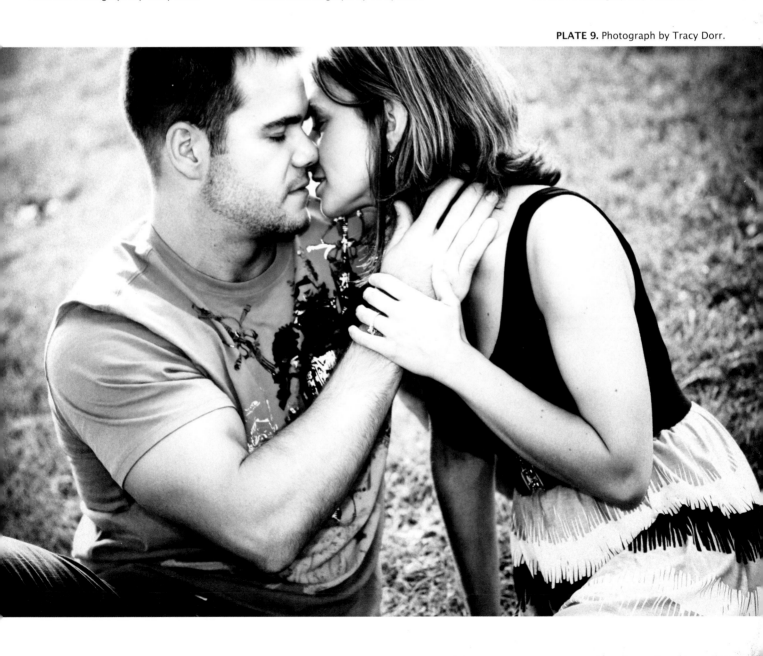

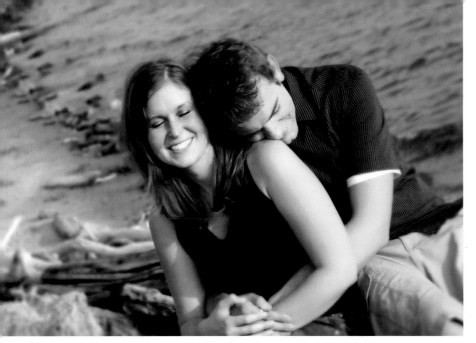

PLATE 10 (TOP LEFT).
Photograph by Tracy Dorr.

PLATE 11 (CENTER LEFT).
Photograph by Tracy Dorr.

PLATE 12 (BOTTOM LEFT).
Photograph by Tracy Dorr.

PLATE 13. Photograph by Tracy Dorr.

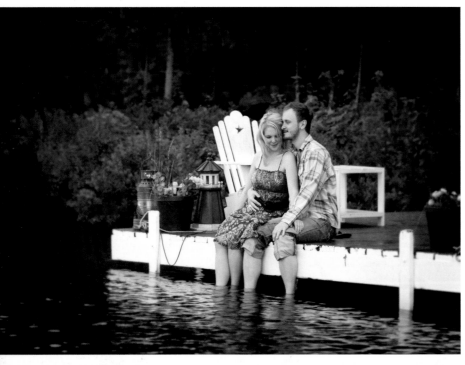

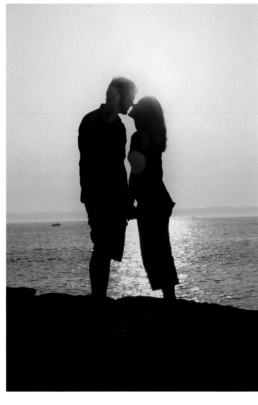

PLATE 14. Photograph by Marc Weisberg.

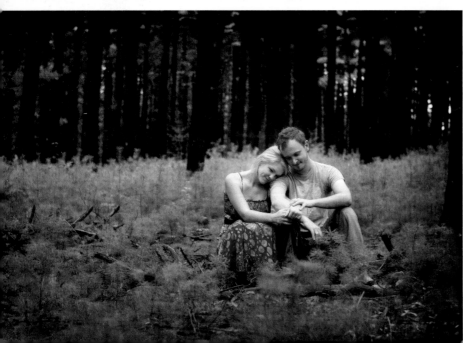

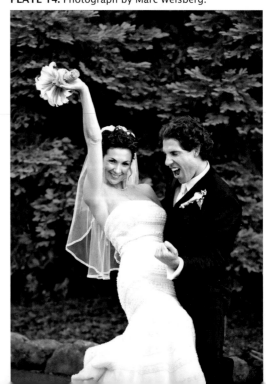

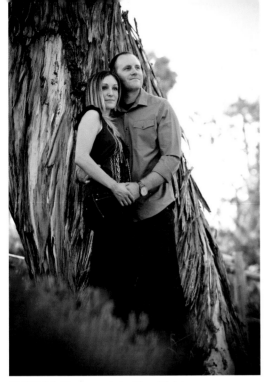

PLATE 15. Photograph by Marc Weisberg.

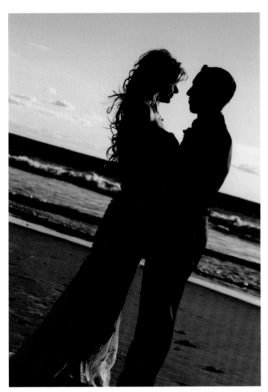

PLATE 16. Photograph by Marc Weisberg.

PLATE 17 (TOP RIGHT).
Photograph by Marc Weisberg.

PLATE 18 (BOTTOM RIGHT).
Photograph by Marc Weisberg.

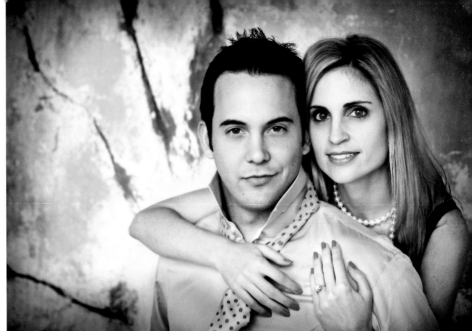

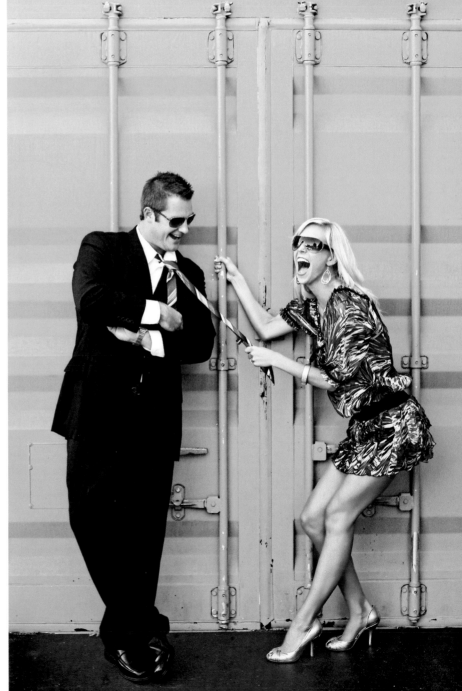

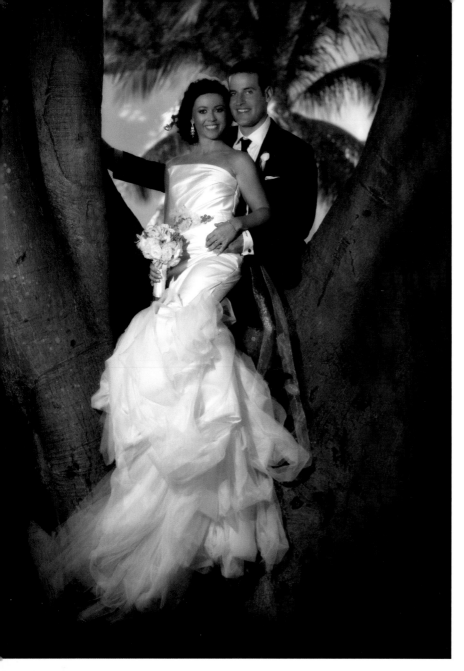

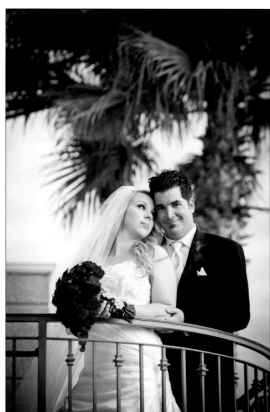

PLATE 19. Photograph by Marc Weisberg.

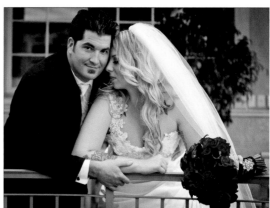

PLATE 20. Photograph by Marc Weisberg.

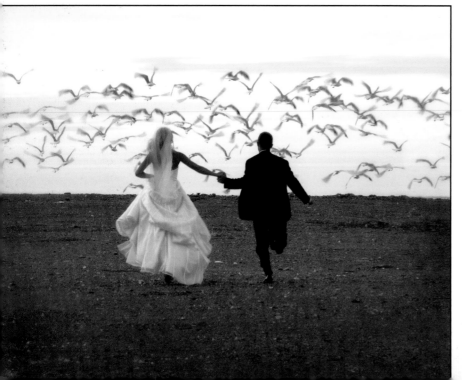

PLATE 21 (TOP LEFT). Photograph by Ellie Vayo.

PLATE 22 (BOTTOM LEFT). Photograph by Ellie Vayo.

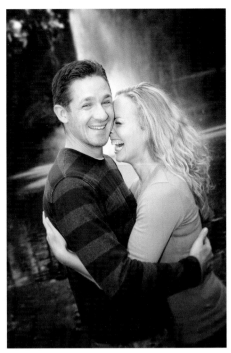

PLATE 23. Photograph by Tracy Dorr.

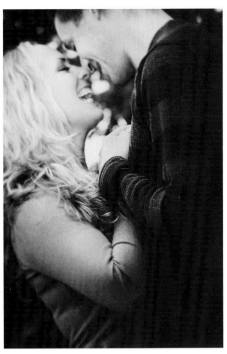

PLATE 24. Photograph by Tracy Dorr.

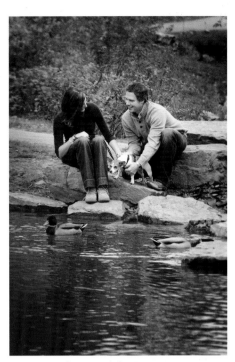

PLATE 25. Photograph by Tracy Dorr.

PLATE 26. Photograph by Mimika Cooney.

PLATE 27. Photograph by Mimika Cooney.

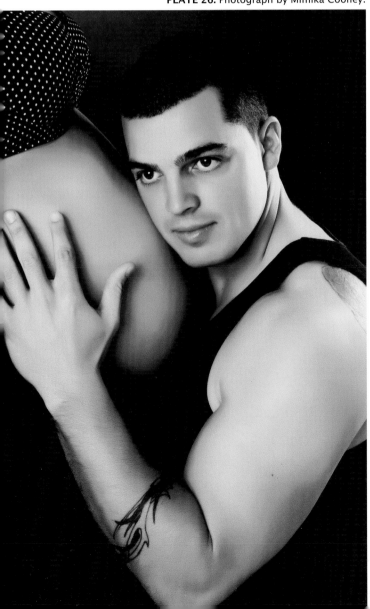

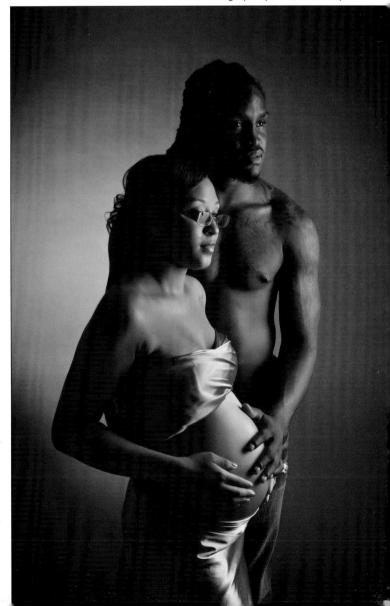

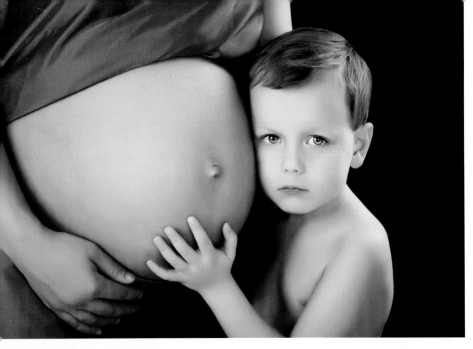

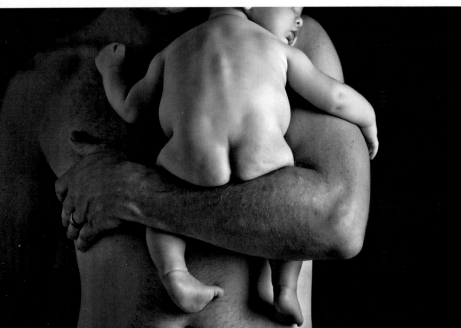

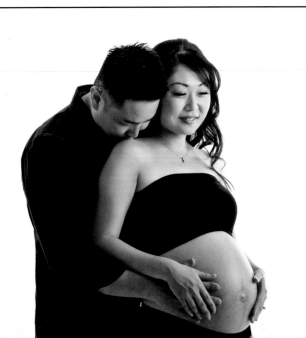

PLATE 28 (TOP LEFT).
Photograph by Mimika Cooney.

PLATE 29 (CENTER LEFT).
Photograph by Marc Weisberg.

PLATE 30 (BOTTOM LEFT).
Photograph by Marc Weisberg.

PLATE 31. Photograph by Marc Weisberg.

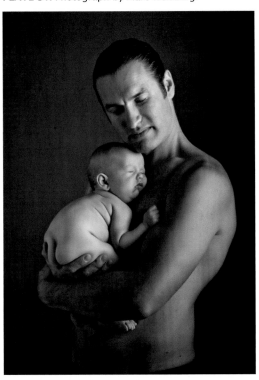

PLATE 32. Photograph by Marc Weisberg.

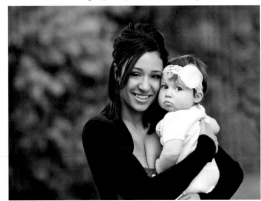

PLATE 33. Photograph by Ellie Vayo.

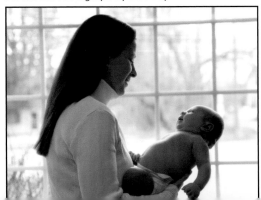

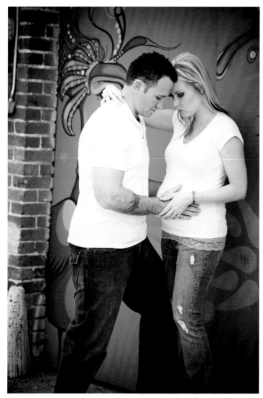

PLATE 34. Photograph by Christie Mumm.

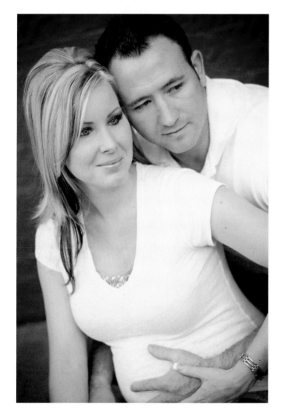

PLATE 35. Photograph by Christie Mumm.

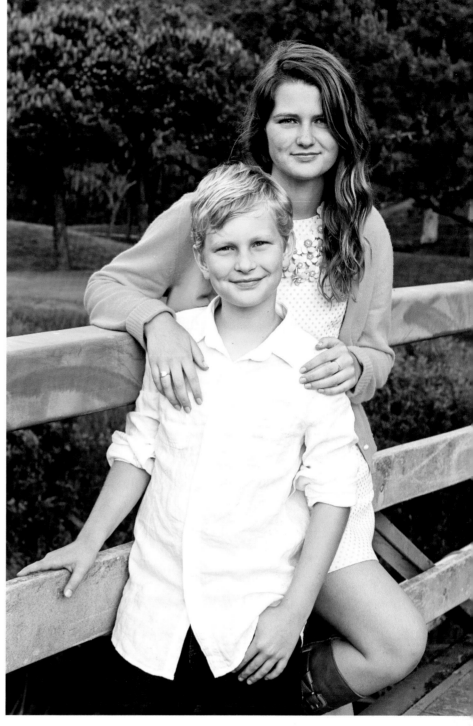

PLATE 36 (TOP RIGHT).
Photograph by Marc Weisberg.

PLATE 37 (BOTTOM RIGHT).
Photograph by Marc Weisberg.

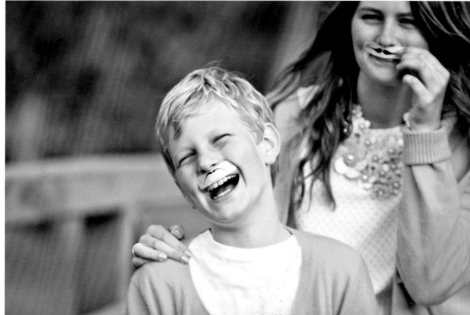

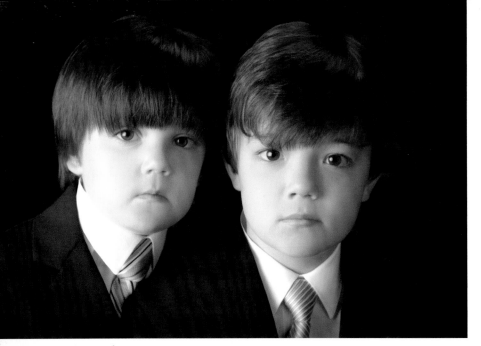

PLATE 38 (TOP LEFT).
Photograph by Ellie Vayo.

PLATE 39 (CENTER LEFT).
Photograph by Ellie Vayo.

PLATE 40 (BOTTOM LEFT).
Photograph by Marc Weisberg.

PLATE 41. Photograph by Tracy Dorr.

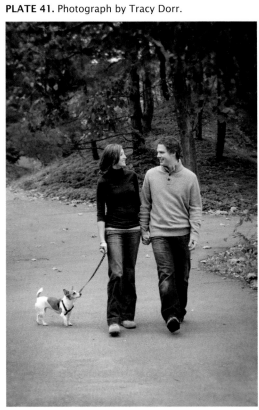

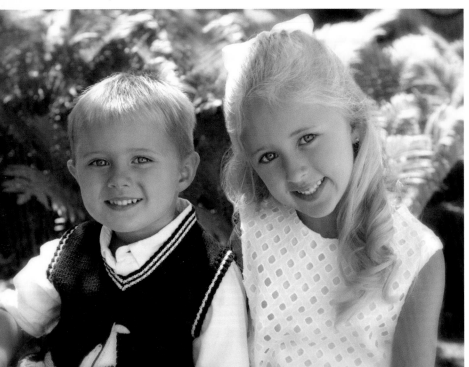

PLATE 42. Photograph by Marc Weisberg.

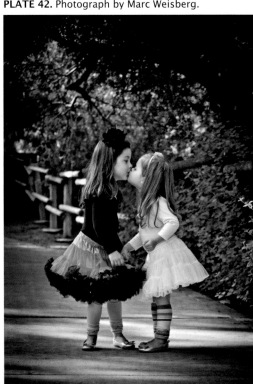

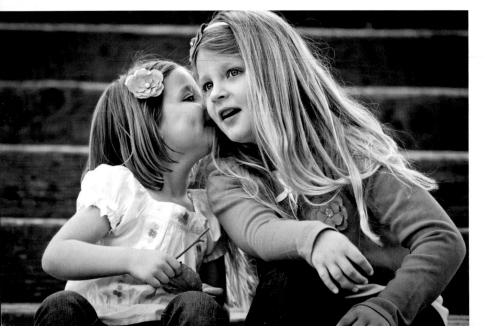

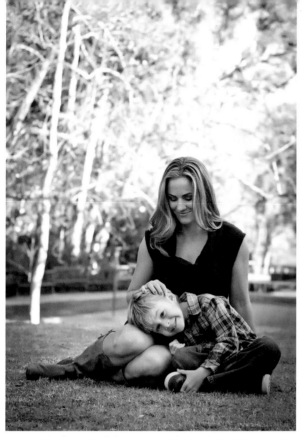

PLATE 43. Photograph by Marc Weisberg.

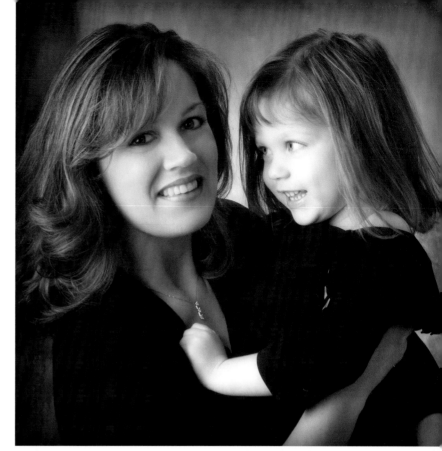

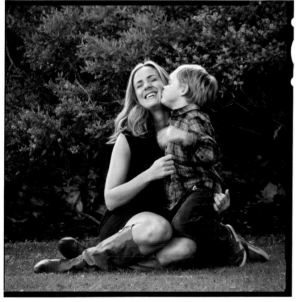

PLATE 44. Photograph by Marc Weisberg.

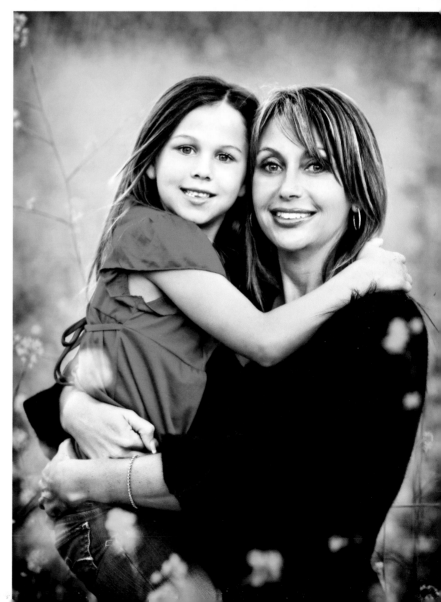

PLATE 45 (TOP RIGHT). Photograph by Ellie Vayo.

PLATE 46 (BOTTOM RIGHT). Photograph by Marc Weisberg.

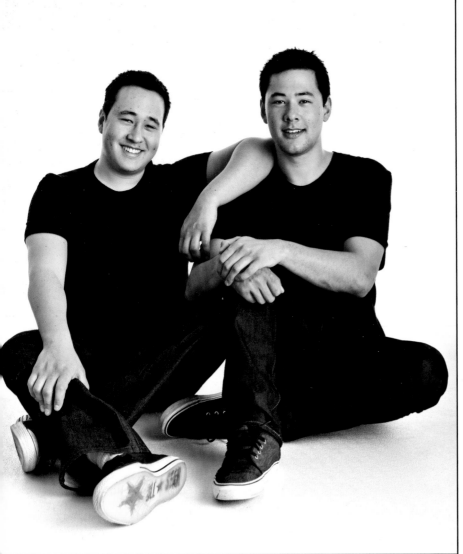

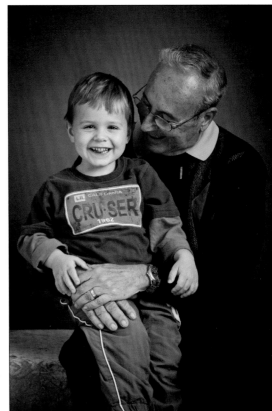

PLATE 47. Photograph by Marc Weisberg.

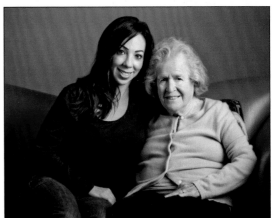

PLATE 48. Photograph by Marc Weisberg.

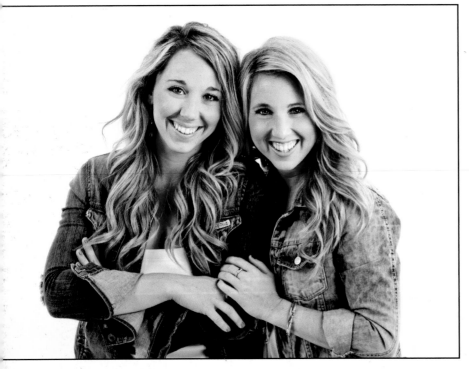

PLATE 49 (TOP LEFT).
Photograph by Marc Weisberg.

PLATE 50 (BOTTOM LEFT).
Photograph by Marc Weisberg.

PLATE 51 (TOP RIGHT).
Photograph by Marc Weisberg.

PLATE 52 (CENTER RIGHT).
Photograph by Marc Weisberg.

PLATE 53 (BOTTOM RIGHT).
Photograph by Marc Weisberg.

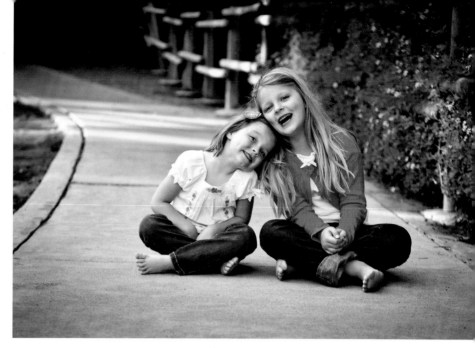

PLATE 54. Photograph by Marc Weisberg.

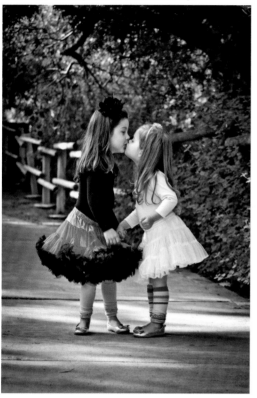

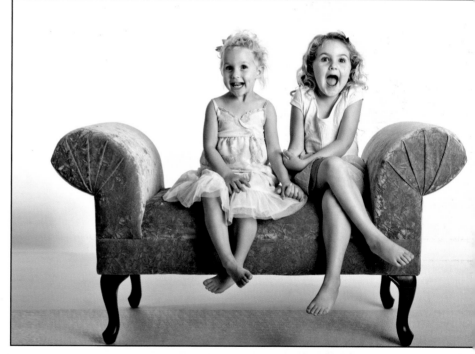

PLATE 55. Photograph by Tracy Dorr.

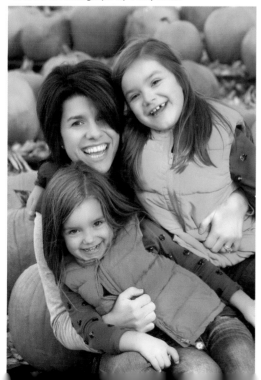

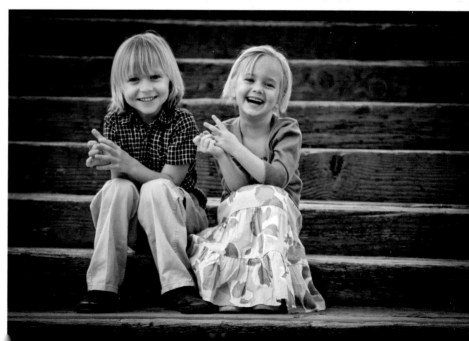

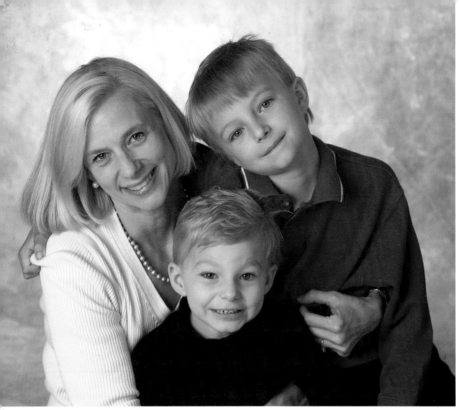

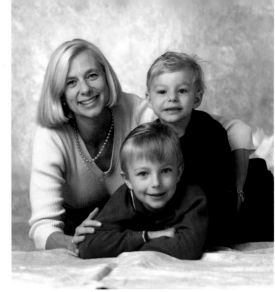

PLATE 56. Photograph by Doug Box.

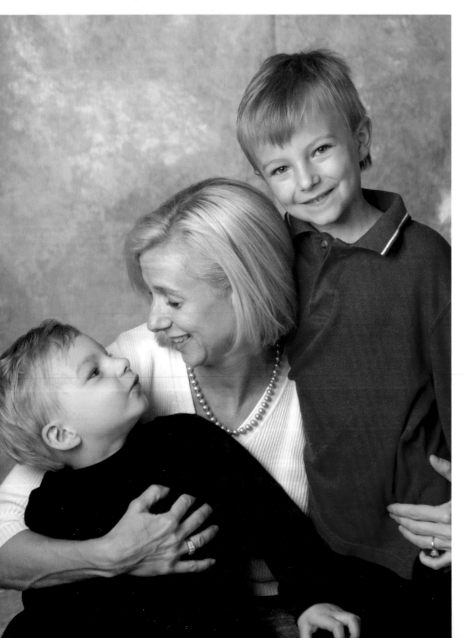

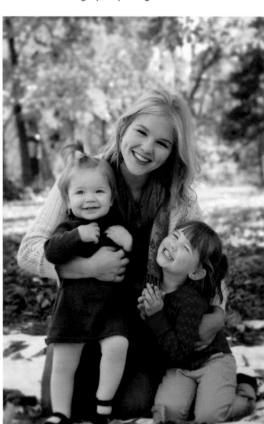

PLATE 57. Photograph by Tracy Dorr.

PLATE 58 (TOP LEFT).
Photograph by Doug Box.

PLATE 59 (BOTTOM LEFT).
Photograph by Doug Box.

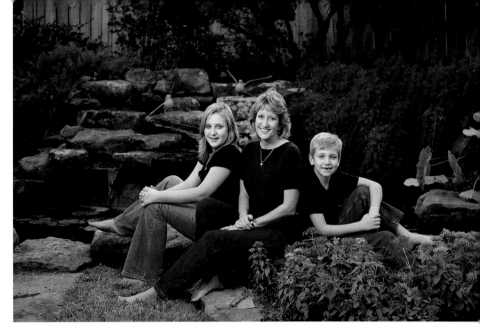

PLATE 60 (TOP RIGHT).
Photograph by Doug Box.

PLATE 61 (CENTER RIGHT).
Photograph by Doug Box.

PLATE 62 (BOTTOM RIGHT).
Photograph by Doug Box.

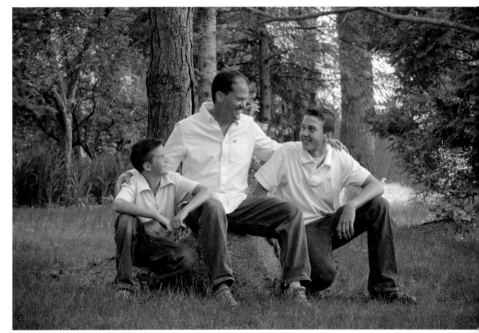

PLATE 63. Photograph by Tracy Dorr.

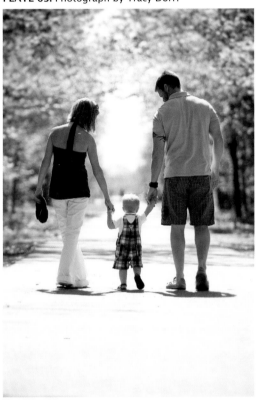

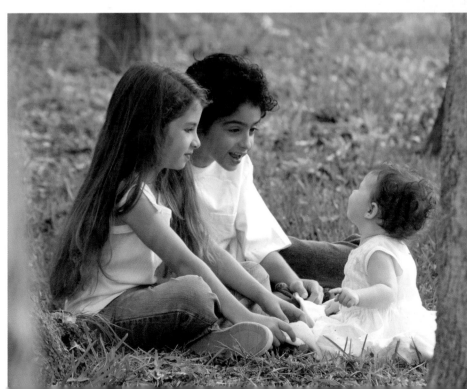

PLATE 64. Photograph by Tracy Dorr.

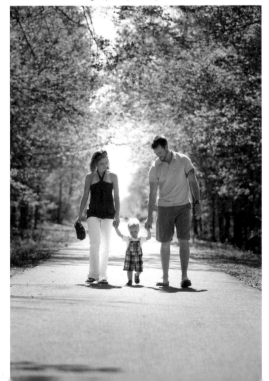

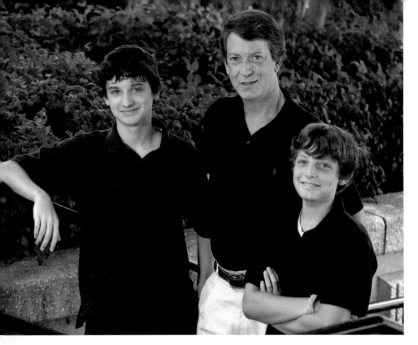

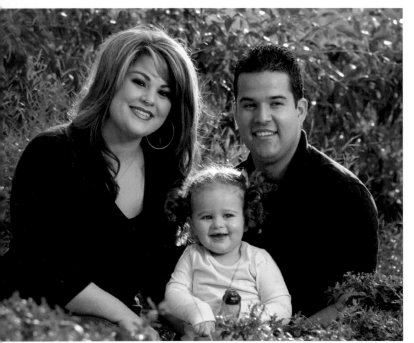

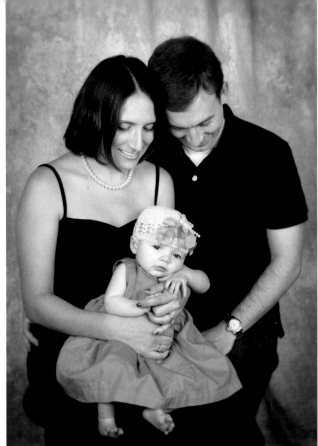

PLATE 65. Photograph by Tracy Dorr.

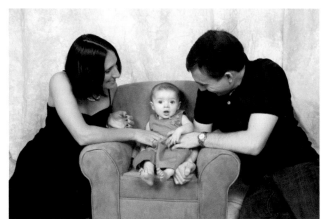

PLATE 66. Photograph by Tracy Dorr.

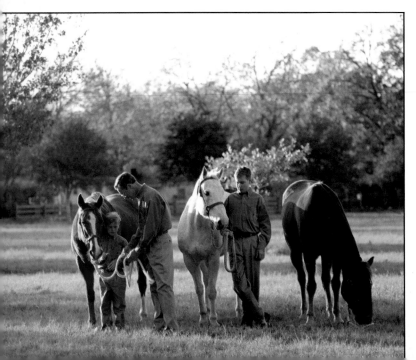

PLATE 67 (TOP LEFT).
Photograph by Doug Box.

PLATE 68 (CENTER LEFT).
Photograph by Doug Box.

PLATE 69 (BOTTOM LEFT).
Photograph by Doug Box.

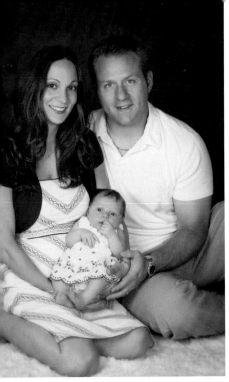

PLATE 70. Photograph by Tracy Dorr.

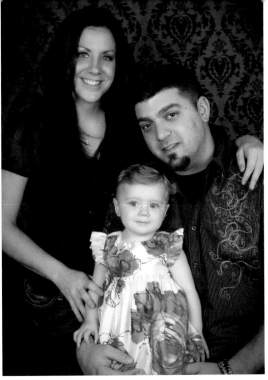

PLATE 71. Photograph by Tracy Dorr.

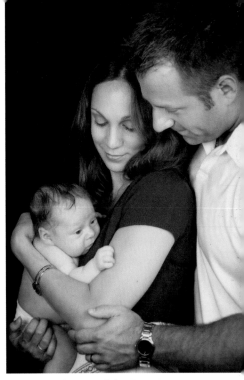

PLATE 72. Photograph by Tracy Dorr.

PLATE 73. Photograph by Tracy Dorr.

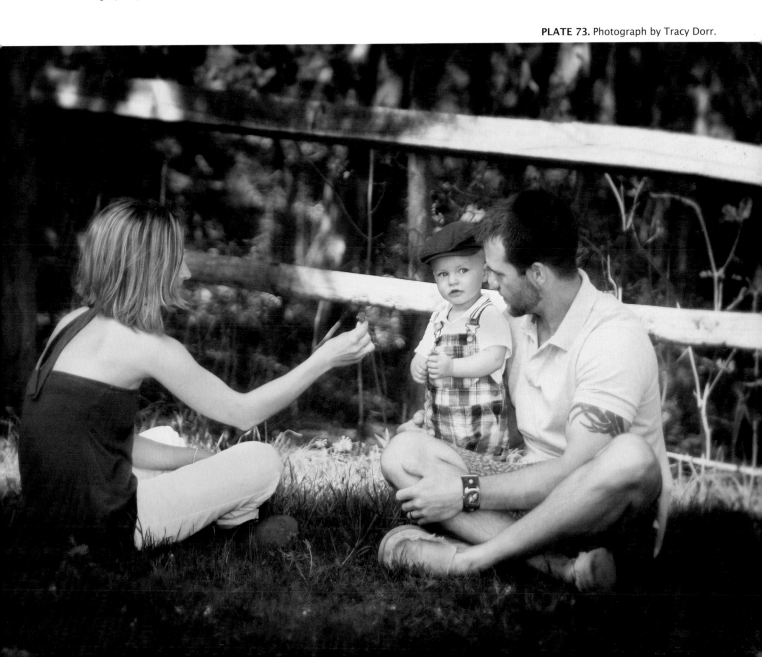

PLATE 74. Photograph by Tracy Dorr.

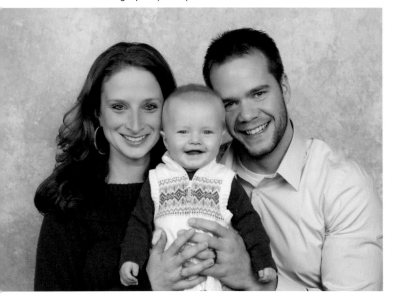

PLATE 75. Photograph by Tracy Dorr.

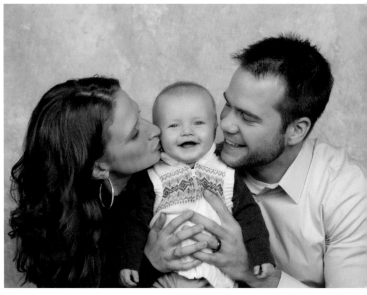

PLATE 76. Photograph by Tracy Dorr.

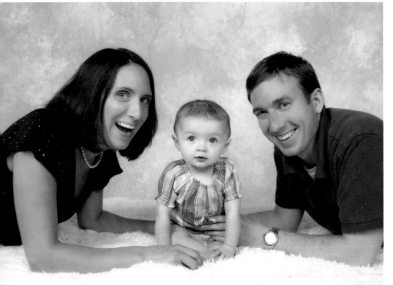

PLATE 77. Photograph by Tracy Dorr.

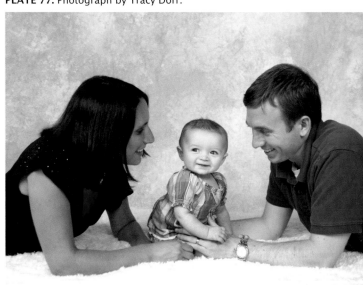

PLATE 78. Photograph by Tracy Dorr.

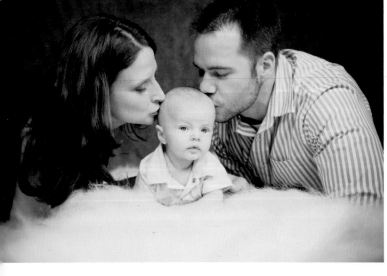

PLATE 79. Photograph by Tracy Dorr.

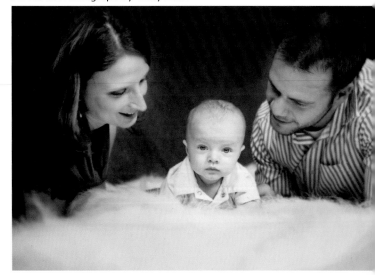

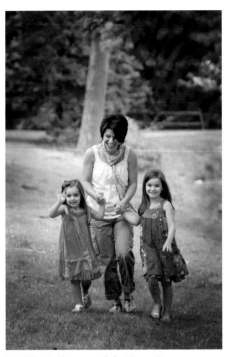

PLATE 80. Photograph by Tracy Dorr.

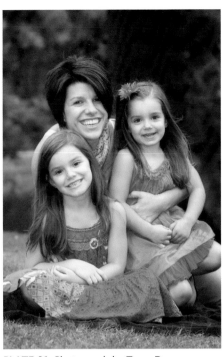

PLATE 81. Photograph by Tracy Dorr.

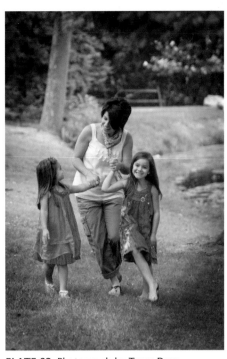

PLATE 82. Photograph by Tracy Dorr.

PLATE 83. Photograph by Ryan Klos.

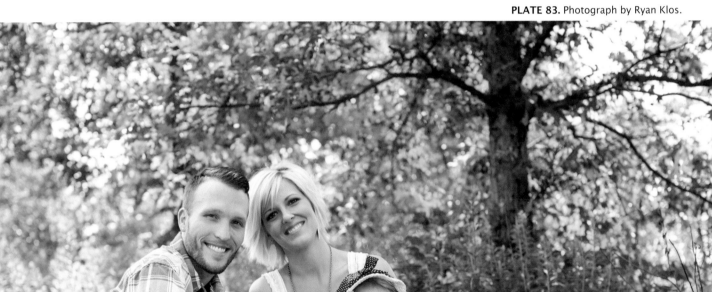

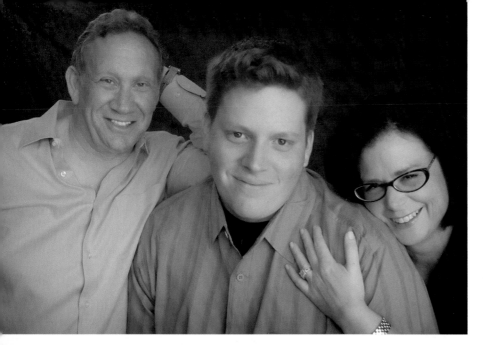

PLATE 84 (TOP LEFT).
Photograph by Jennifer George.

PLATE 85 (CENTER LEFT).
Photograph by Jennifer George.

PLATE 86 (BOTTOM LEFT).
Photograph by Jennifer George.

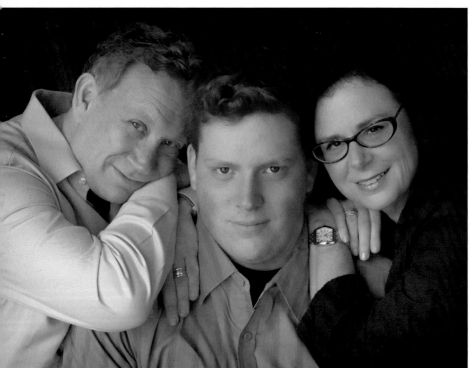

PLATE 87. Photograph by Jennifer George.

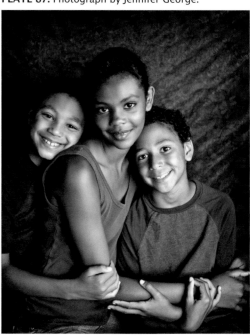

PLATE 88. Photograph by Jennifer George.

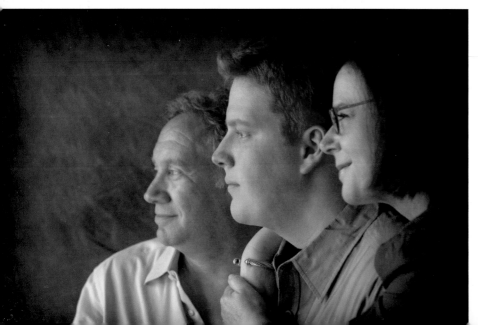

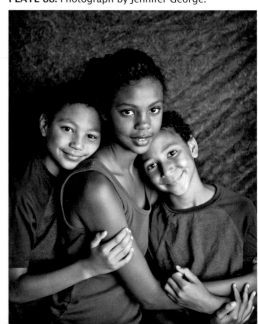

PLATE 89. Photograph by Jennifer George.

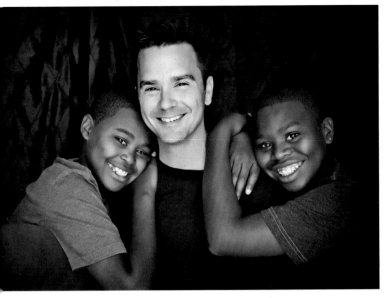

PLATE 90. Photograph by Jennifer George.

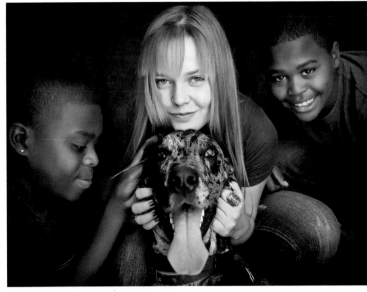

PLATE 91. Photograph by Jennifer George.

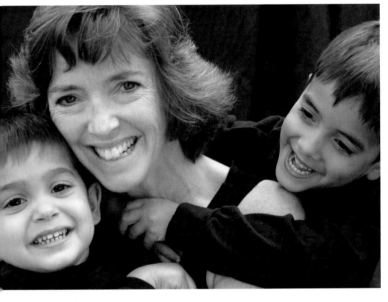

PLATE 92. Photograph by Jennifer George.

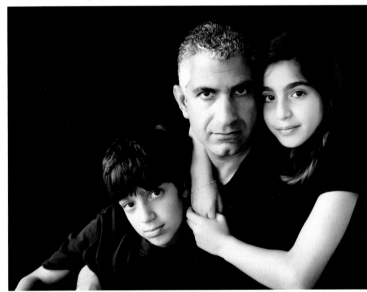

PLATE 93. Photograph by Jennifer George.

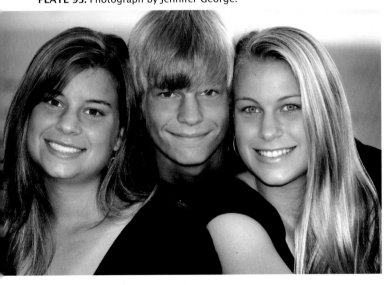

PLATE 94. Photograph by Jennifer George.

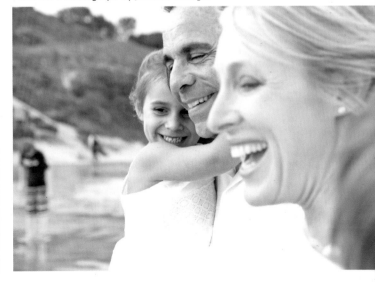

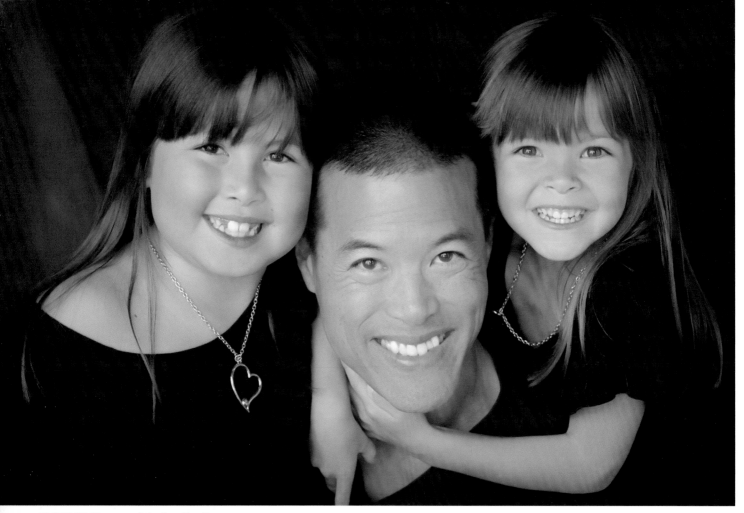

PLATE 95. Photograph by Jennifer George.

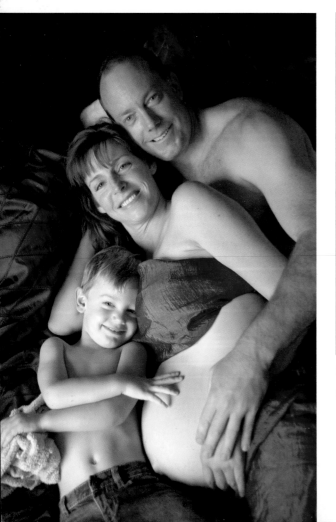

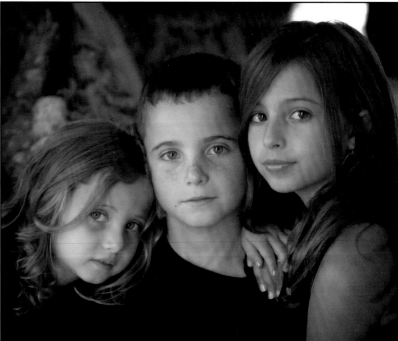

PLATE 96 (LEFT). Photograph by Jennifer George.

PLATE 97 (ABOVE). Photograph by Jennifer George.

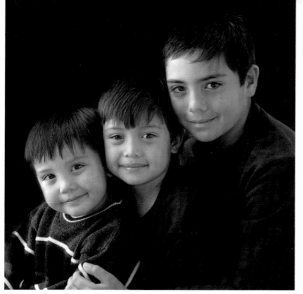

PLATE 98. Photograph by Jennifer George.

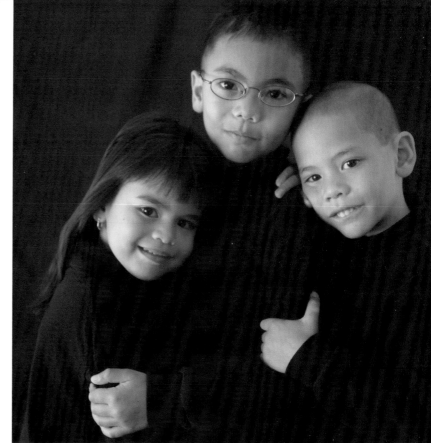

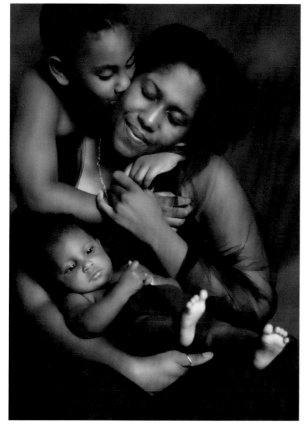

PLATE 99. Photograph by Jennifer George.

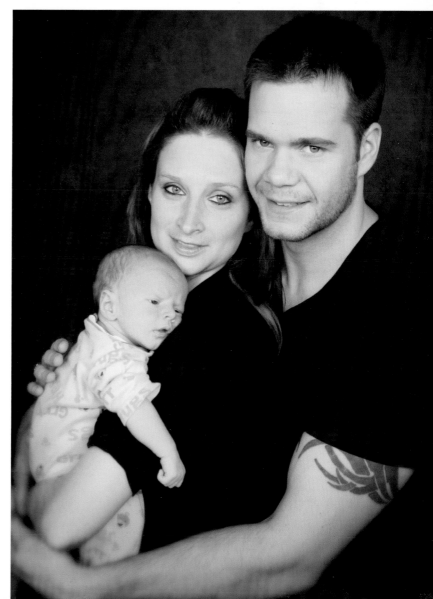

PLATE 100 (TOP RIGHT). Photograph by Jennifer George.

PLATE 101 (BOTTOM RIGHT). Photograph by Tracy Dorr.

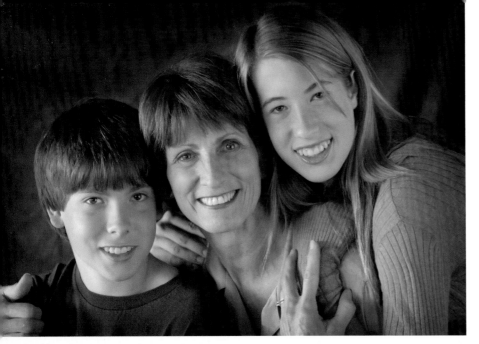

PLATE 102 (TOP LEFT).
Photograph by Jennifer George.

PLATE 103 (CENTER LEFT).
Photograph by Jennifer George.

PLATE 104 (BOTTOM LEFT).
Photograph by Jennifer George.

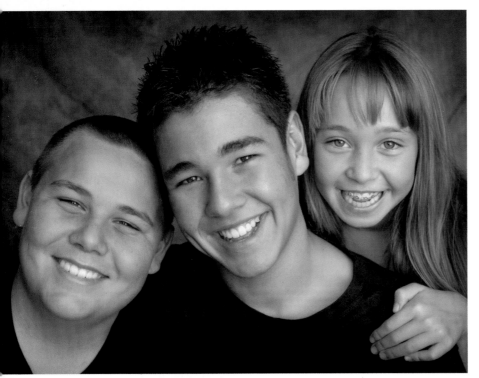

PLATE 105. Photograph by Jennifer George.

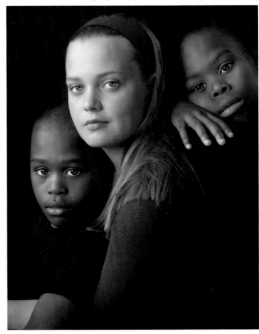

PLATE 106. Photograph by Jennifer George.

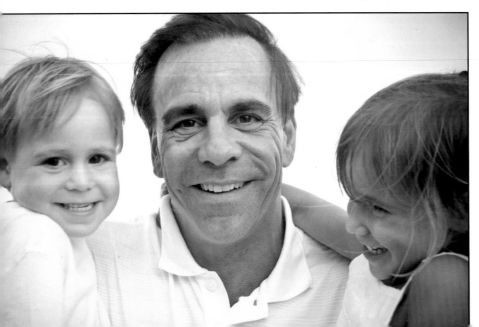

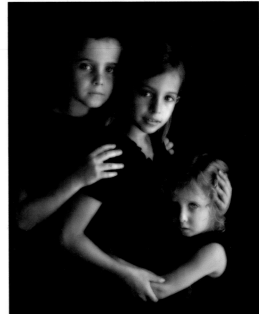

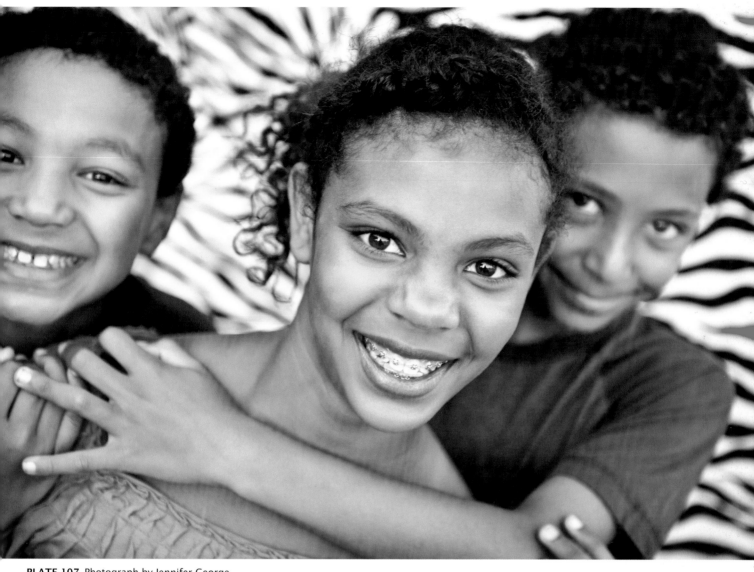

PLATE 107. Photograph by Jennifer George.

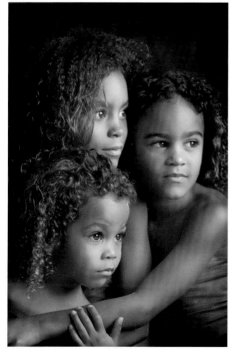

PLATE 108. Photograph by Jennifer George.

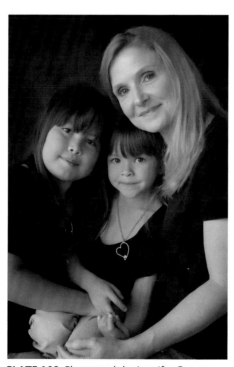

PLATE 109. Photograph by Jennifer George.

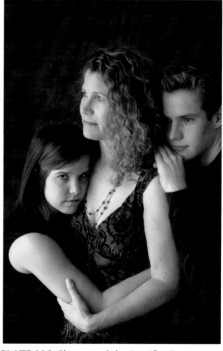

PLATE 110. Photograph by Jennifer George.

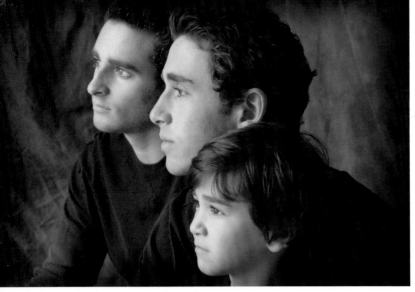

PLATE 111 (TOP LEFT).
Photograph by Jennifer George.

PLATE 112 (CENTER LEFT).
Photograph by Jennifer George.

PLATE 113 (BOTTOM LEFT).
Photograph by Jennifer George.

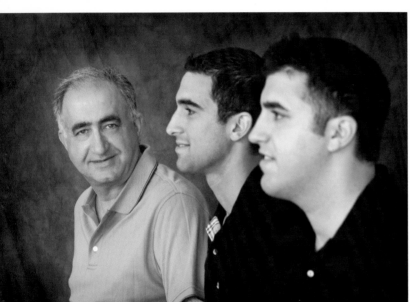

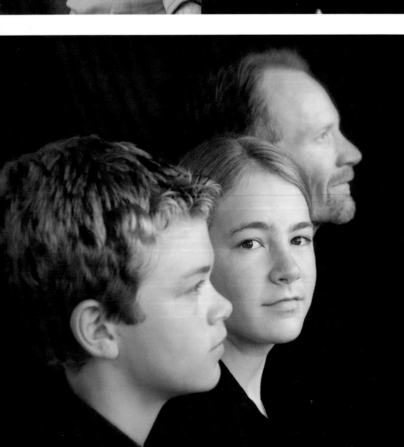

PLATE 114. Photograph by Regeti's Photography.

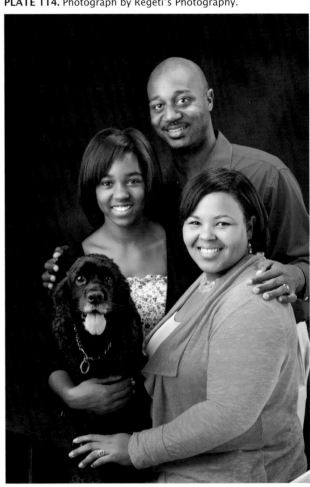

PLATE 115. Photograph by Jennifer George.

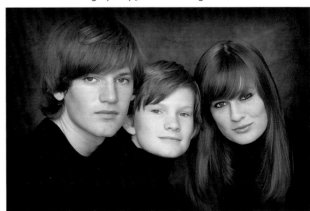

PLATE 116 (TOP RIGHT).
Photograph by Jennifer George.

PLATE 117 (CENTER RIGHT).
Photograph by Jennifer George.

PLATE 118 (BOTTOM RIGHT).
Photograph by Jennifer George.

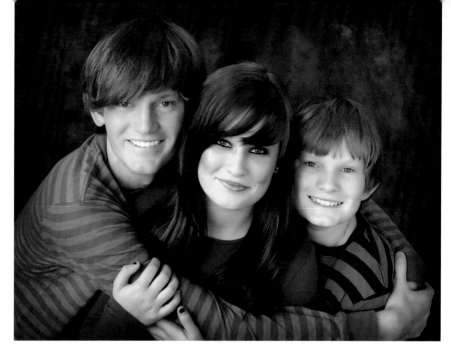

PLATE 119. Photograph by Jennifer George.

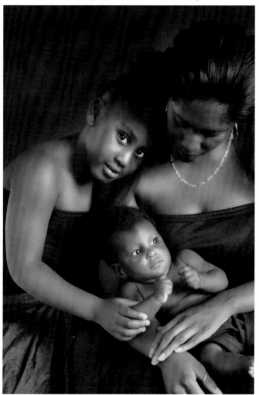

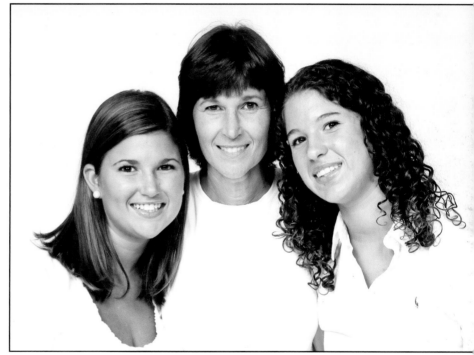

PLATE 120. Photograph by Jennifer George.

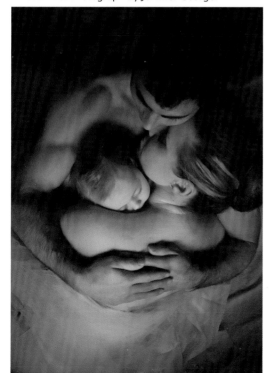

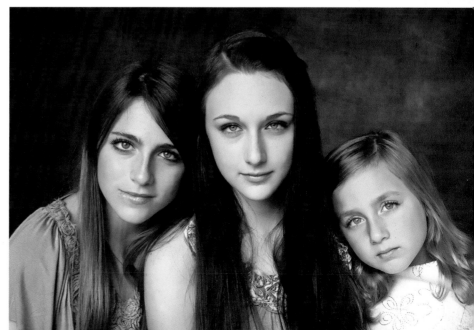

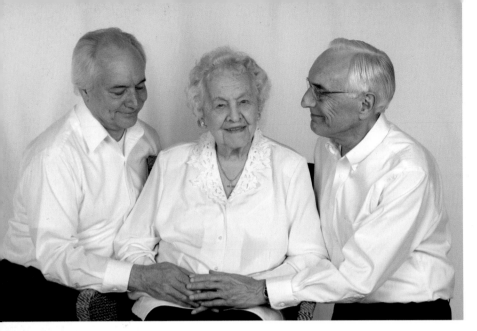

PLATE 121 (TOP LEFT).
Photograph by Tracy Dorr.

PLATE 122 (CENTER LEFT).
Photograph by Regeti's Photography.

PLATE 123 (BOTTOM LEFT).
Photograph by Regeti's Photography.

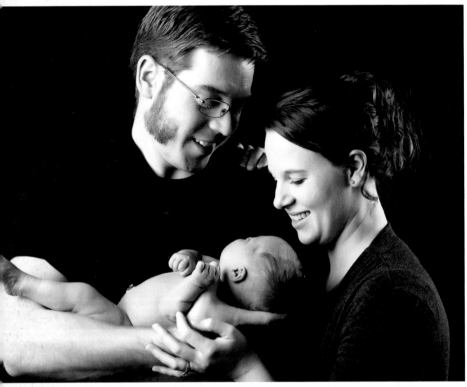

PLATE 124. Photograph by Ellie Vayo.

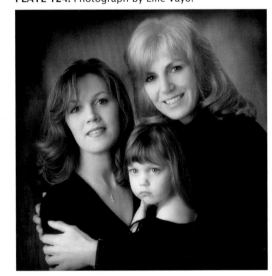

PLATE 125. Photograph by Damon Tucci.

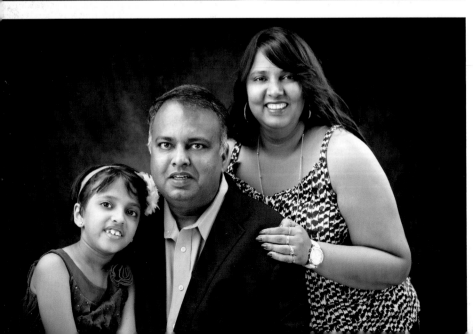

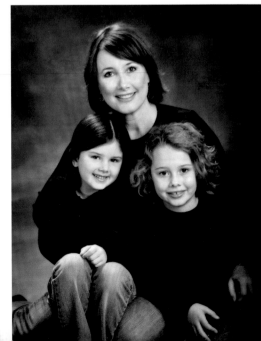

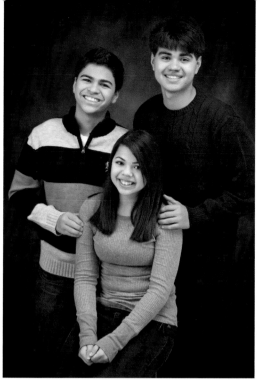

PLATE 126. Photograph by Regeti's Photography.

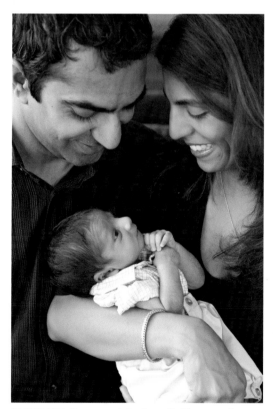

PLATE 127. Photograph by Regeti's Photography.

PLATE 128 (TOP RIGHT).
Photograph by Regeti's Photography.

PLATE 129 (BOTTOM RIGHT).
Photograph by Regeti's Photography.

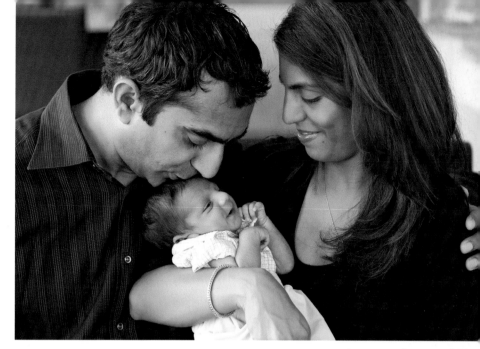

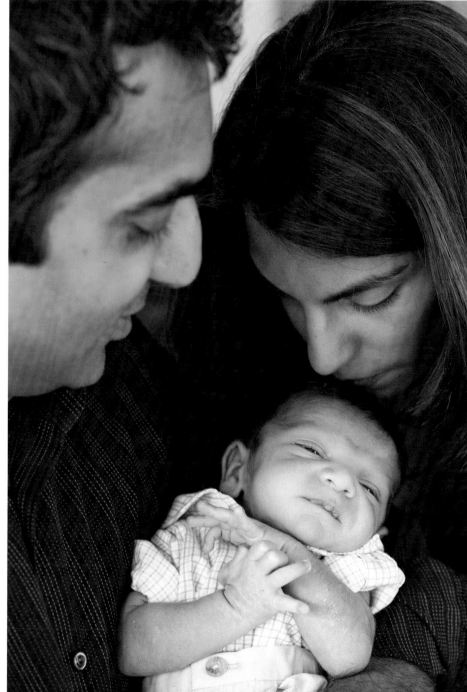

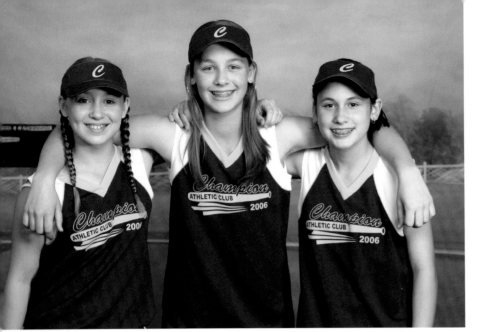

PLATE 130 (TOP LEFT).
Photograph by James Williams.

PLATE 131 (CENTER LEFT).
Photograph by Marc Weisberg.

PLATE 132 (BOTTOM LEFT).
Photograph by Ellie Vayo.

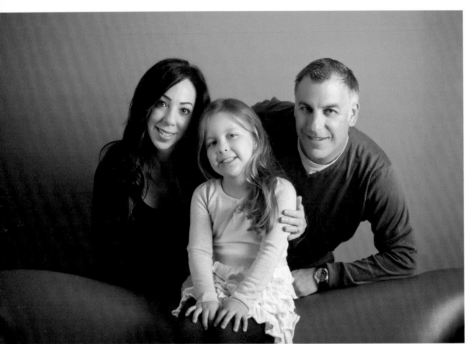

PLATE 133. Photograph by Jennifer George.

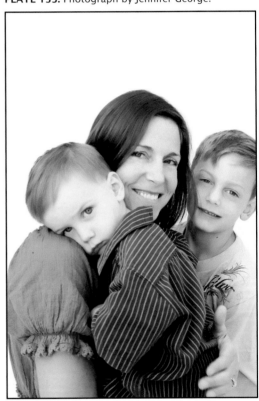

PLATE 134. Photograph by Regeti's Photography.

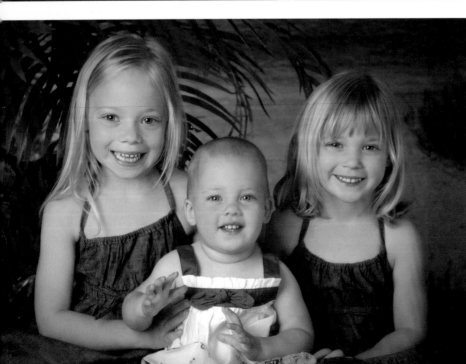

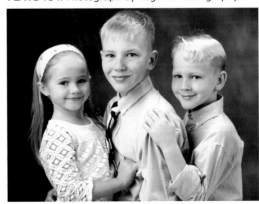

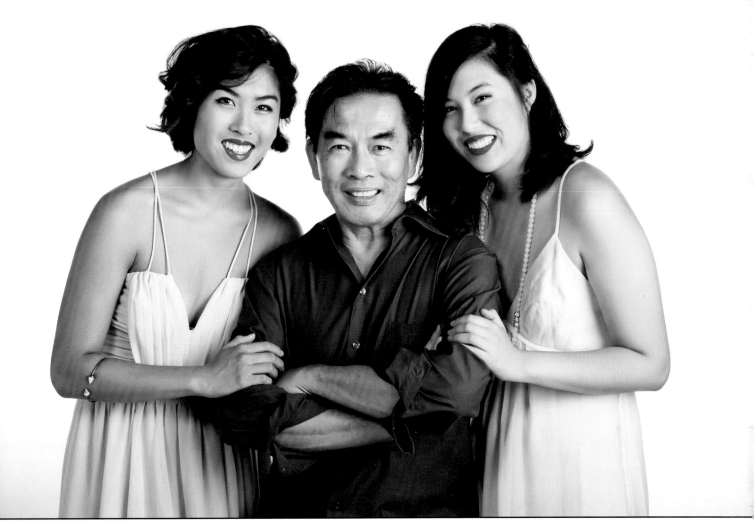

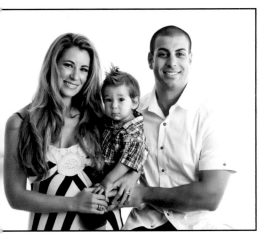

PLATE 135 (TOP).
Photograph by Marc Weisberg.

PLATE 136 (ABOVE).
Photograph by Marc Weisberg.

PLATE 137 (RIGHT).
Photograph by Marc Weisberg.

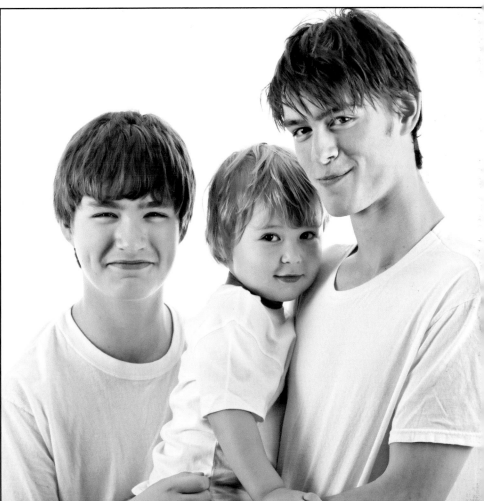

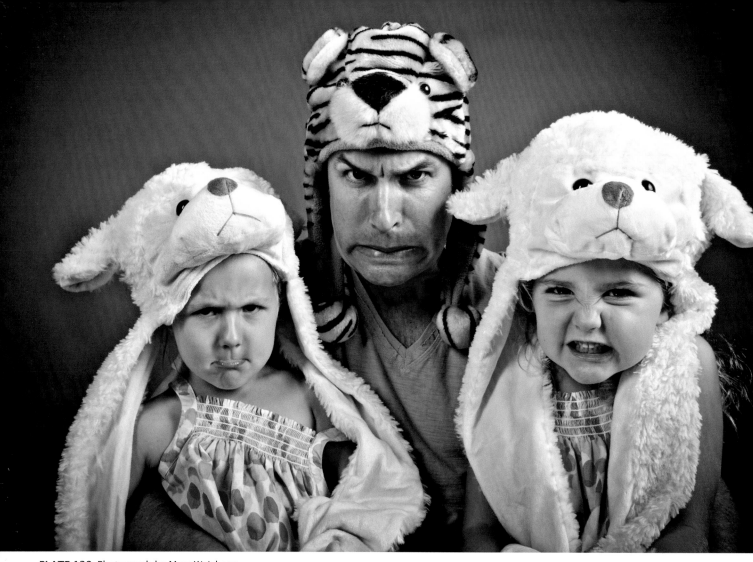

PLATE 138. Photograph by Marc Weisberg.

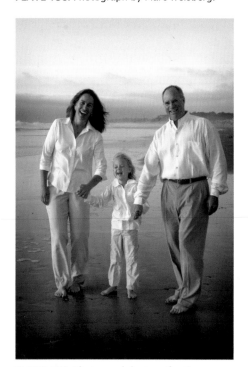

PLATE 139. Photograph by Jennifer George.

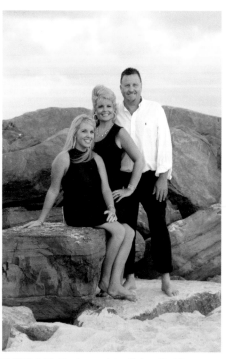

PLATE 140. Photograph by Krista Smith.

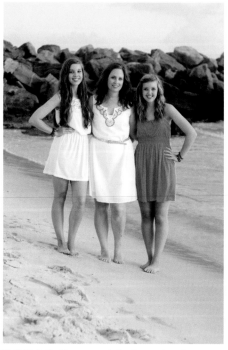

PLATE 141. Photograph by Krista Smith.

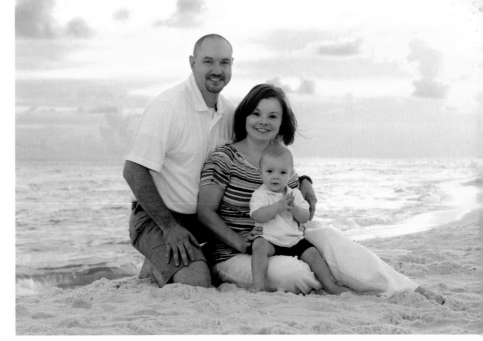

PLATE 142 (TOP RIGHT).
Photograph by Krista Smith.

PLATE 143 (CENTER RIGHT).
Photograph by Krista Smith.

PLATE 144 (BOTTOM RIGHT).
Photograph by Krista Smith.

PLATE 145. Photograph by Jennifer George.

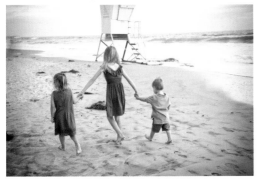

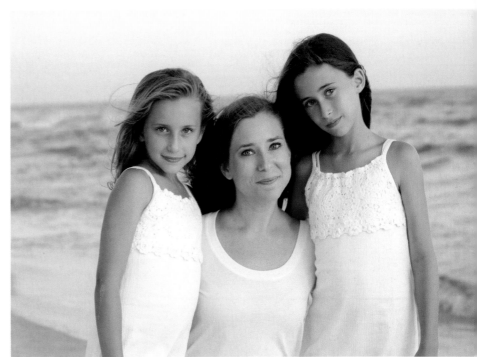

PLATE 146. Photograph by Krista Smith.

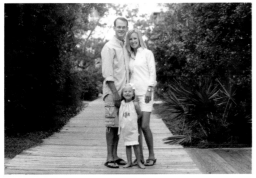

PLATE 147. Photograph by Krista Smith.

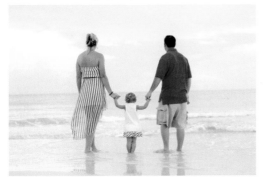

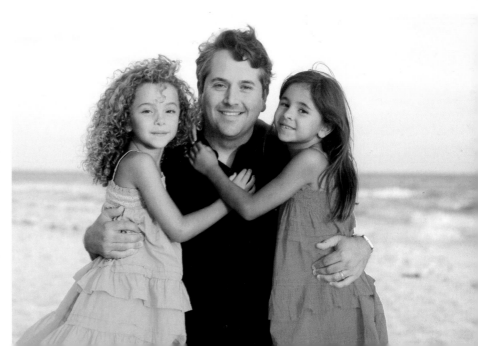

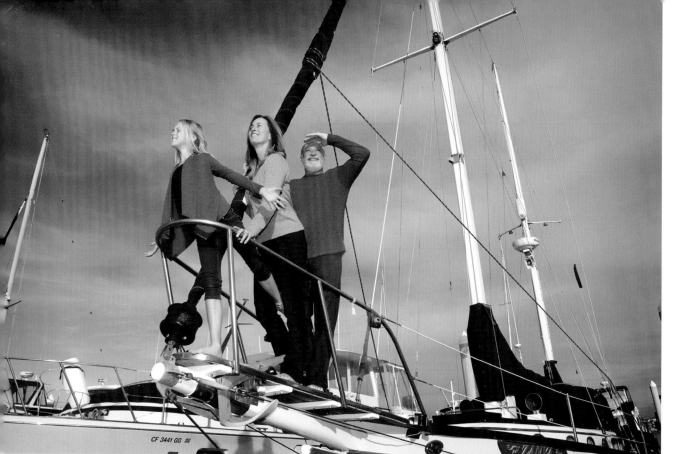

PLATE 148.
Photograph
by Jennifer
George.

PLATE 149. Photograph by Jennifer George.

PLATE 150. Photograph by Jennifer George.

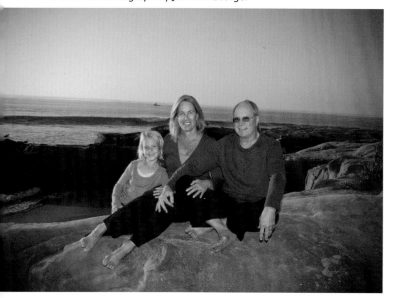

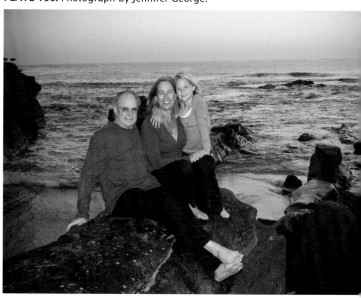

PLATE 151. Photograph by Jennifer George.

PLATE 152. Photograph by Jennifer George.

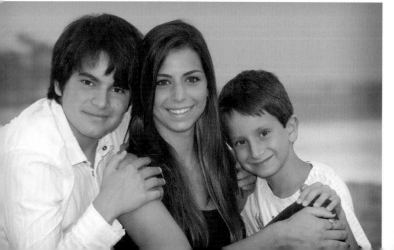

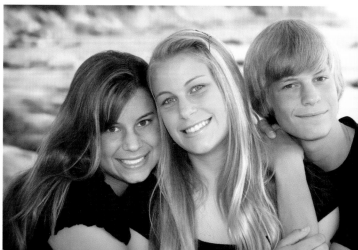

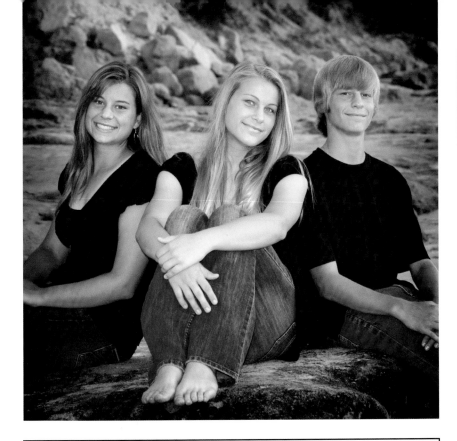

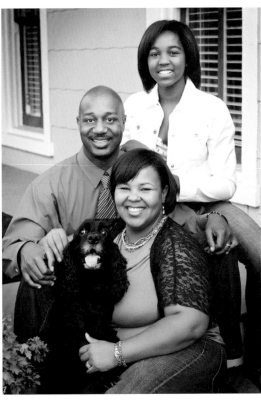

PLATE 153. Photograph by Regeti's Photography.

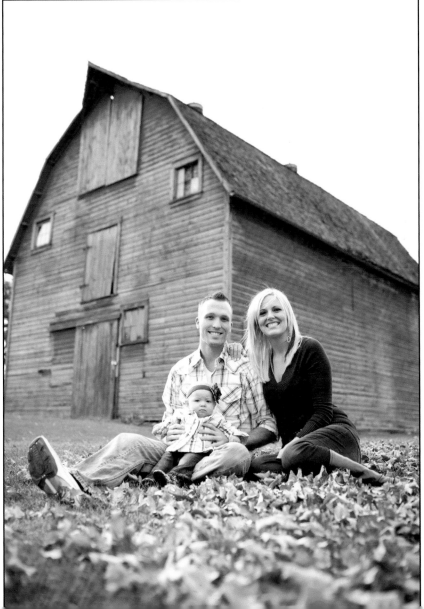

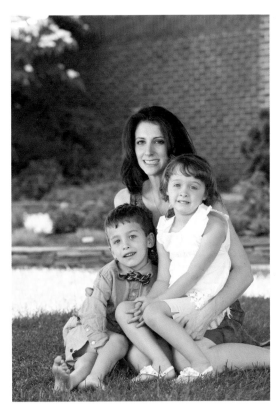

PLATE 154. Photograph by Regeti's Photography.

PLATE 155 (TOP LEFT).
Photograph by Jennifer George.

PLATE 156 (BOTTOM LEFT). Photograph by Ryan Klos.

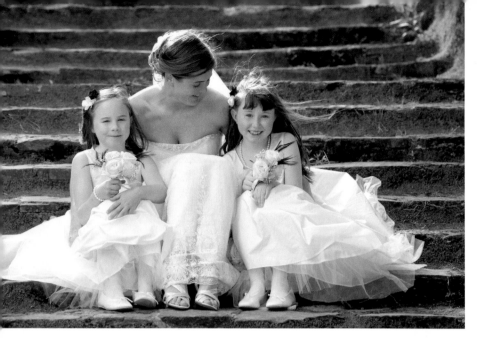

PLATE 157 (TOP LEFT).
Photograph by Brett Florens.

PLATE 158 (CENTER LEFT).
Photograph by Brett Florens.

PLATE 159 (BOTTOM LEFT).
Photograph by Alyn Stafford.

PLATE 160. Photograph by Brett Florens.

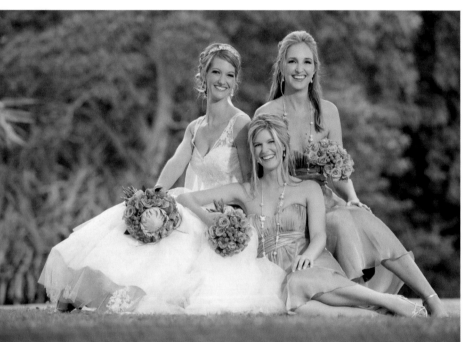

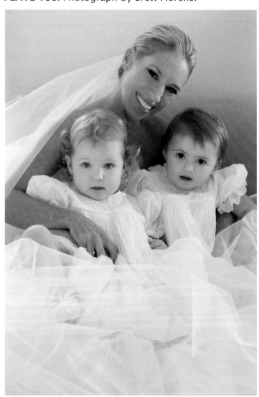

PLATE 161. Photograph by Alyn Stafford.

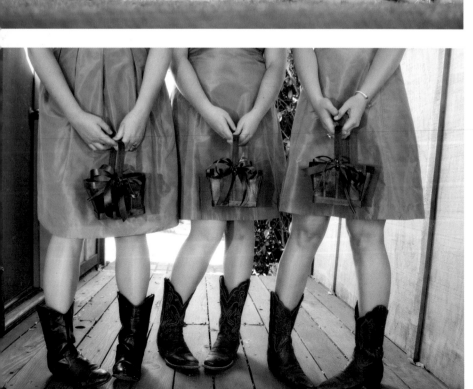

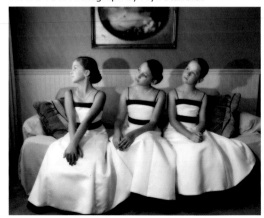

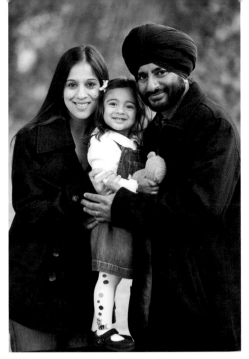

PLATE 162. Photograph by Regeti's Photography.

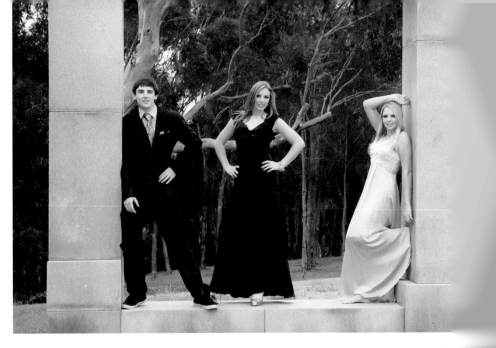

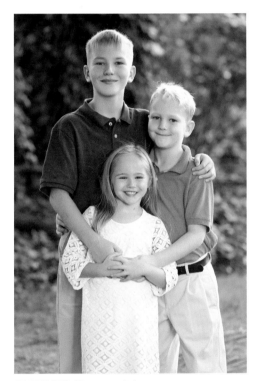

PLATE 163. Photograph by Regeti's Photography.

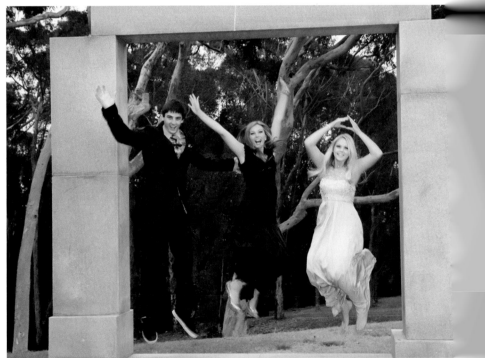

PLATE 164 (TOP RIGHT).
Photograph by Jennifer George.

PLATE 165 (CENTER RIGHT).
Photograph by Jennifer George.

PLATE 166 (BOTTOM RIGHT).
Photograph by Jennifer George.

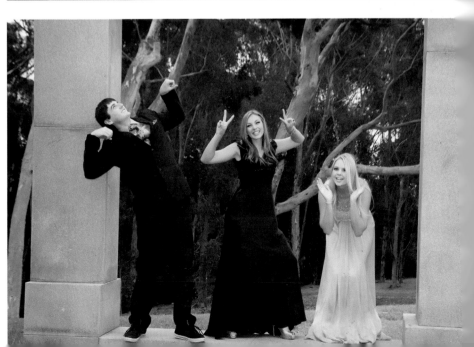

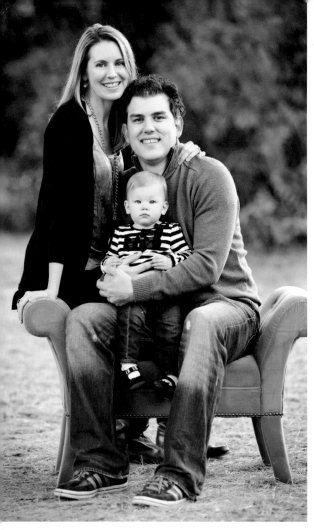

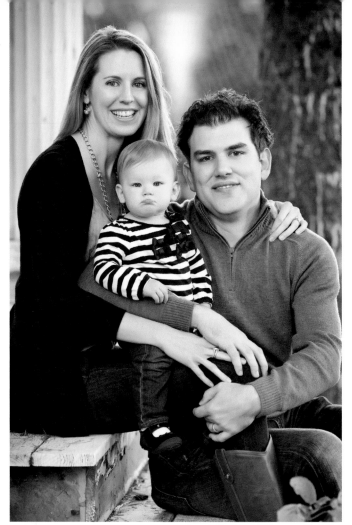

PLATE 167 (FAR LEFT). Photograph by Regeti's Photography.

PLATE 168 (LEFT). Photograph by Regeti's Photography.

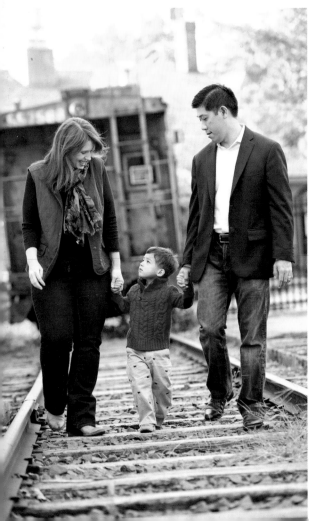

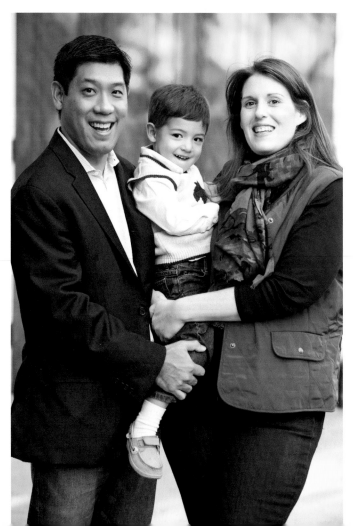

PLATE 169 (FAR LEFT). Photograph by Regeti's Photography.

PLATE 170 (LEFT). Photograph by Regeti's Photography.

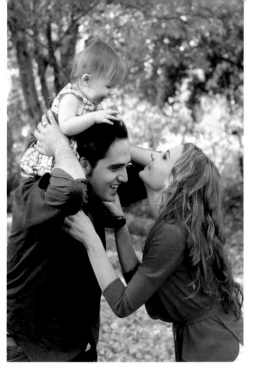

PLATE 171. Photograph by Alyn Stafford.

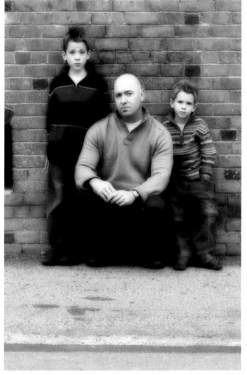

PLATE 172. Photograph by Alyn Stafford.

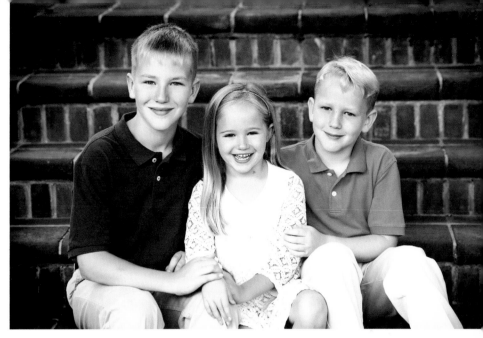

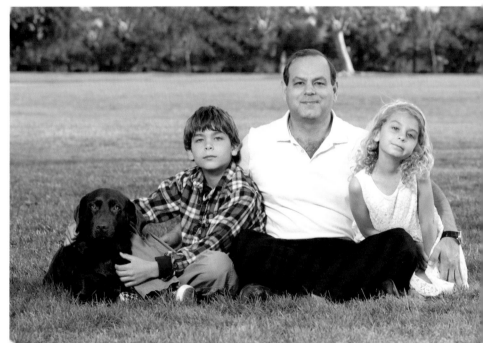

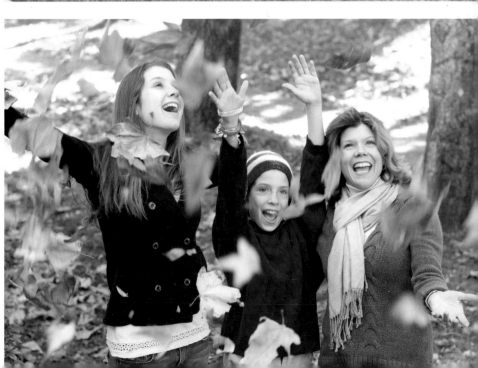

PLATE 173 (TOP RIGHT).
Photograph by Regeti's Photography.

PLATE 174 (CENTER RIGHT).
Photograph by Alyn Stafford.

PLATE 175 (BOTTOM RIGHT).
Photograph by Alyn Stafford.

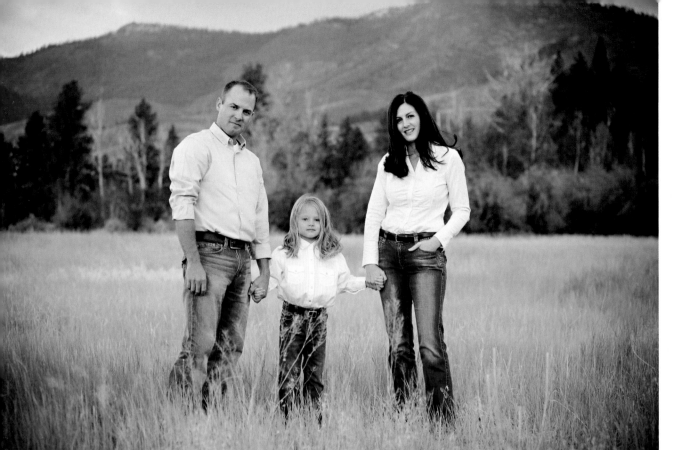

PLATE 176. Photograph by Christie Mumm.

PLATE 177. Photograph by Christie Mumm.

PLATE 178. Photograph by Christie Mumm.

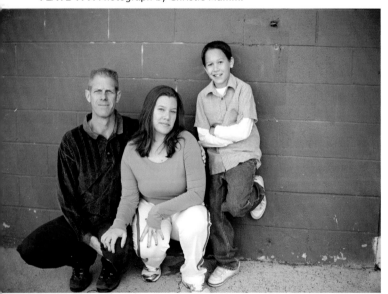

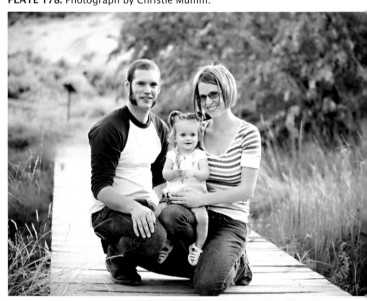

PLATE 179. Photograph by Christie Mumm.

PLATE 180. Photograph by Christie Mumm.

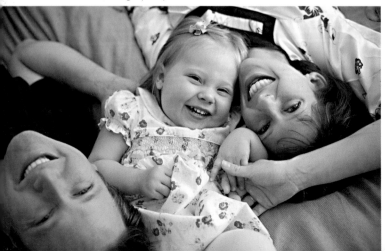

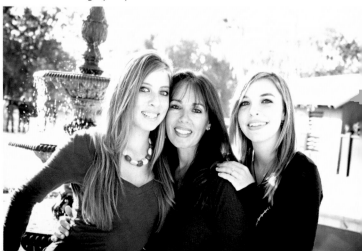

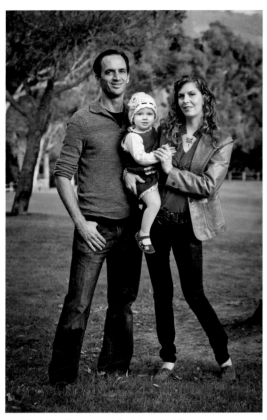

PLATE 181. Photograph by Marc Weisberg.

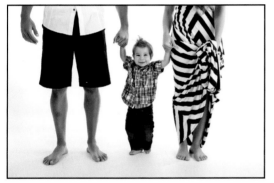

PLATE 182. Photograph by Marc Weisberg.

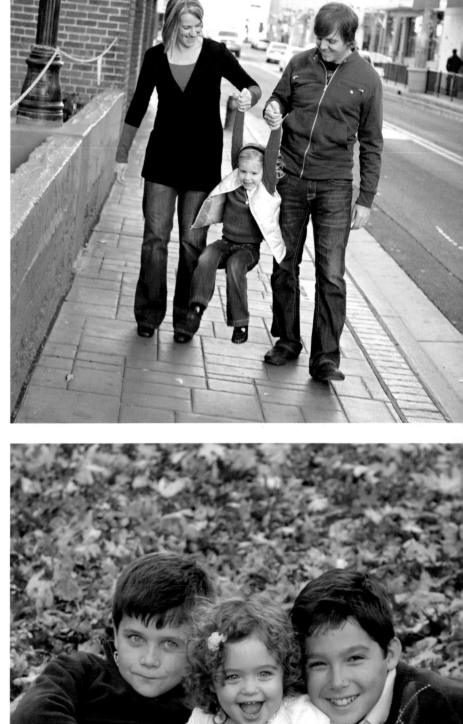

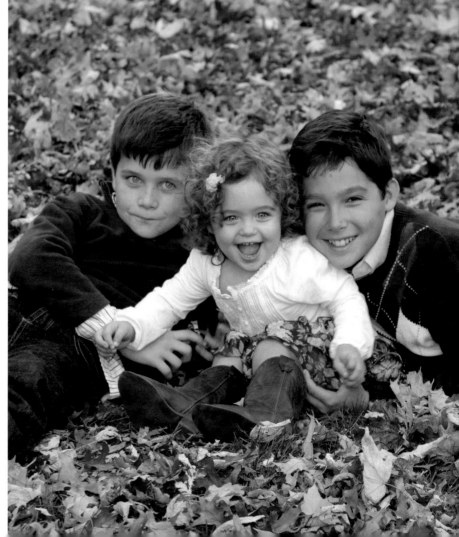

PLATE 183 (TOP RIGHT).
Photograph by Christie Mumm.

PLATE 184 (BOTTOM RIGHT).
Photograph by Ellie Vayo.

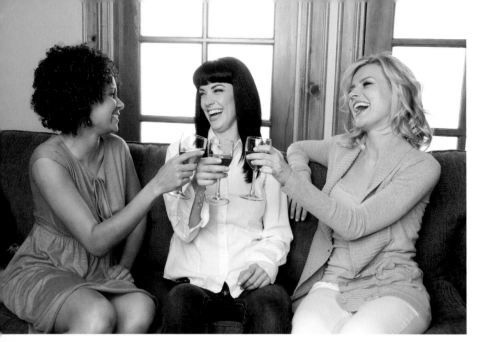

PLATE 185 (TOP LEFT).
Photograph by Alyn Stafford.

PLATE 186 (CENTER LEFT).
Photograph by Alyn Stafford.

PLATE 187 (BOTTOM LEFT).
Photograph by Alyn Stafford.

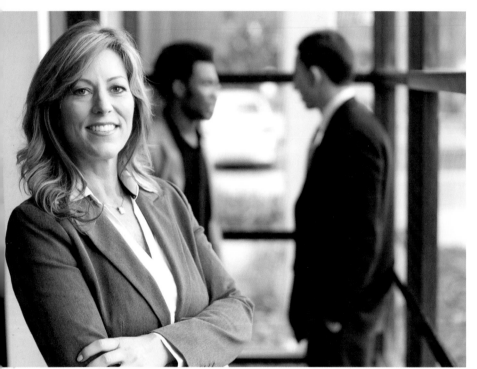

PLATE 188. Photograph by Alyn Stafford.

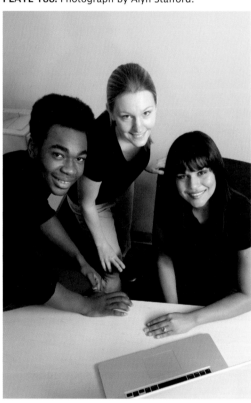

PLATE 189. Photograph by Alyn Stafford.

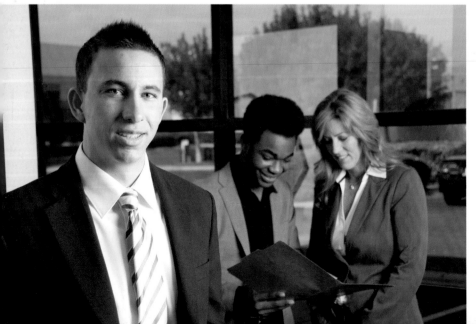

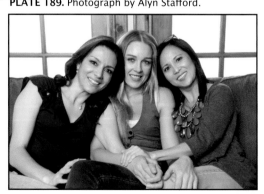

PLATE 190. Photograph by Hernan Rodriguez.

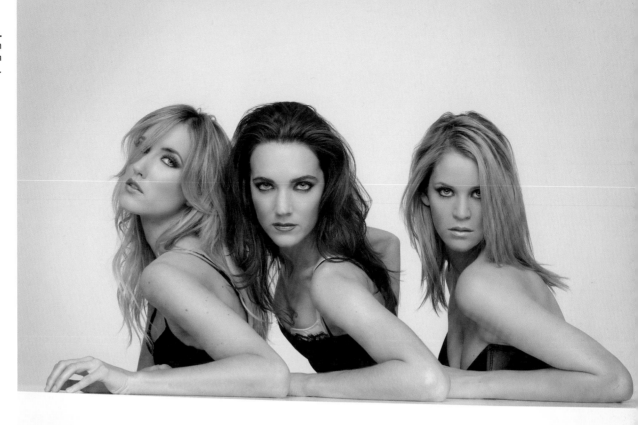

PLATE 191. Photograph by Alyn Stafford.

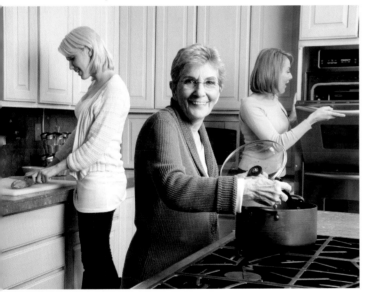

PLATE 192. Photograph by Alyn Stafford.

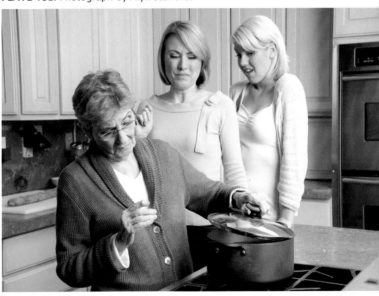

PLATE 193. Photograph by Alyn Stafford.

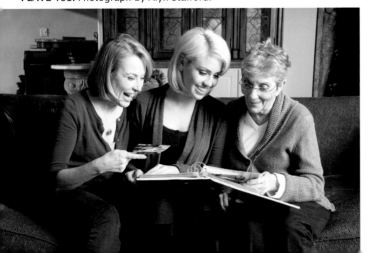

PLATE 194. Photograph by Alyn Stafford.

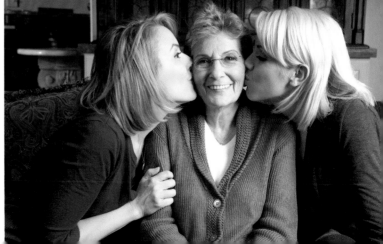

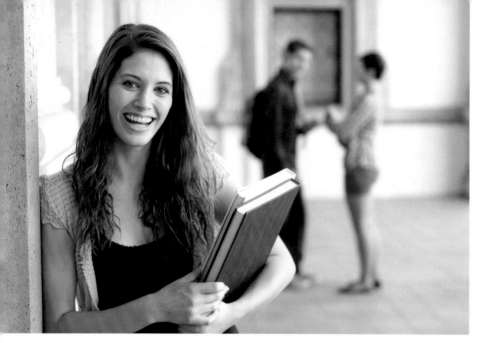

PLATE 195 (TOP LEFT).
Photograph by Alyn Stafford.

PLATE 196 (CENTER LEFT).
Photograph by Alyn Stafford.

PLATE 197 (BOTTOM LEFT).
Photograph by Alyn Stafford.

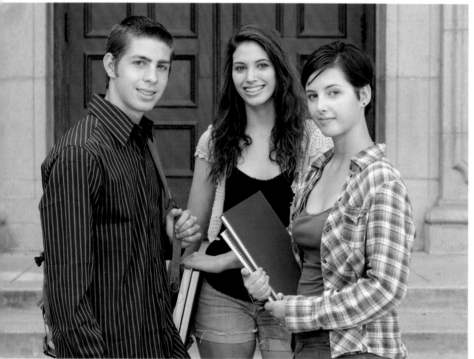

PLATE 198. Photograph by Alyn Stafford.

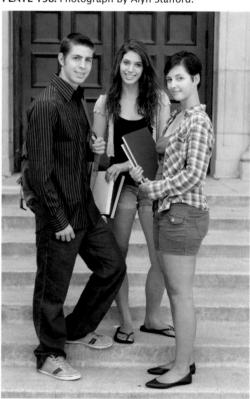

PLATE 199. Photograph by Christie Mumm.

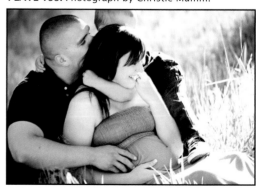

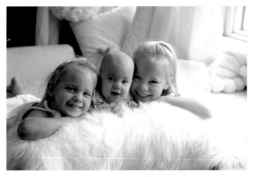

PLATE 200. Photograph by Ellie Vayo.

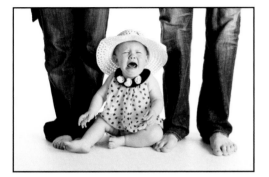

PLATE 201. Photograph by Marc Weisberg.

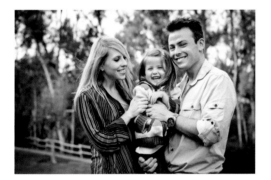

PLATE 202. Photograph by Marc Weisberg.

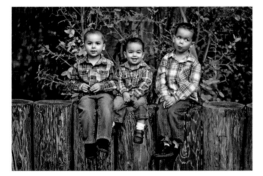

PLATE 203. Photograph by Marc Weisberg.

PLATE 204 (TOP RIGHT).
Photograph by Neil van Niekerk.

PLATE 205 (CENTER RIGHT).
Photograph by Neil van Niekerk.

PLATE 206 (BOTTOM RIGHT).
Photograph by Neil van Niekerk.

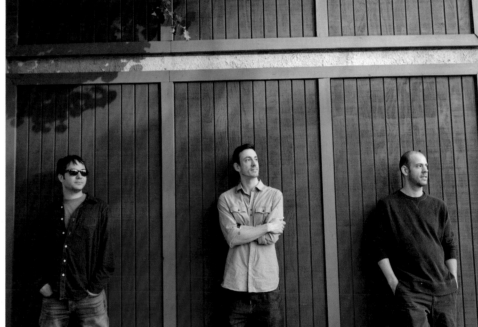

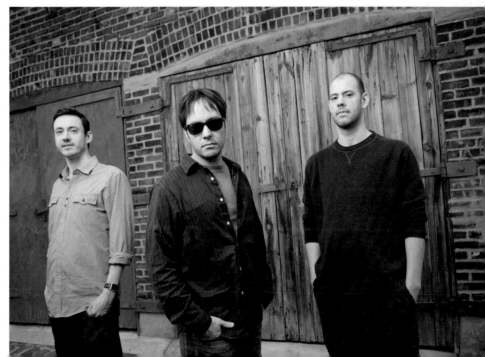

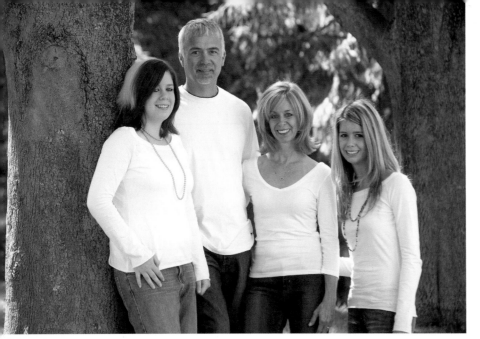

PLATE 207 (TOP LEFT).
Photograph by Doug Box.

PLATE 208 (CENTER LEFT).
Photograph by Jennifer George.

PLATE 209 (BOTTOM LEFT).
Photograph by Jennifer George.

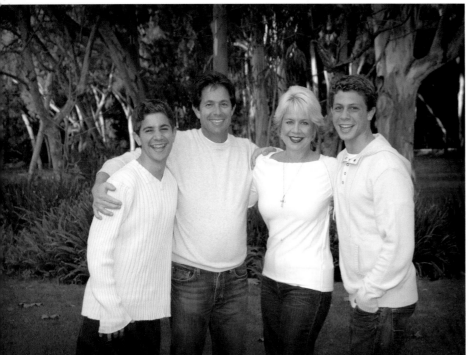

PLATE 210. Photograph by Jennifer George.

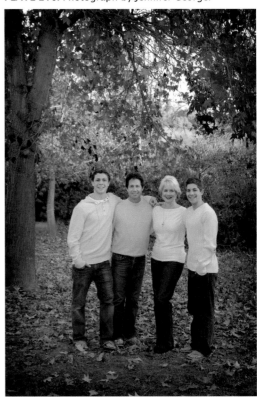

PLATE 211. Photograph by Jennifer George.

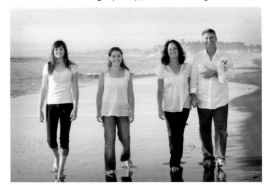

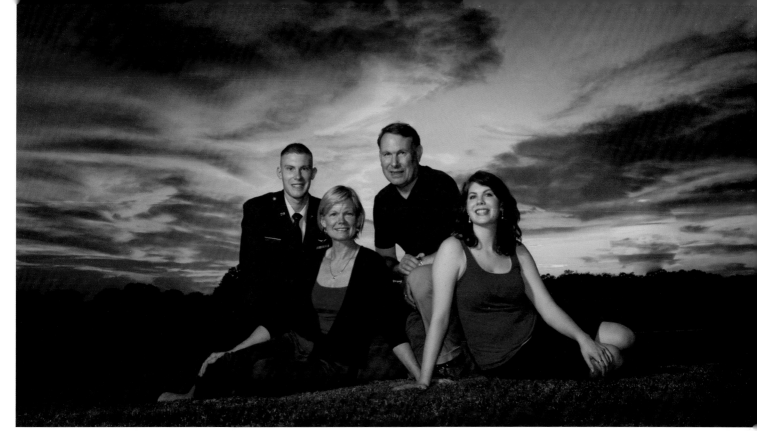

PLATE 212. Photograph by Doug Box.

PLATE 213. Photograph by Doug Box.

PLATE 214. Photograph by Doug Box.

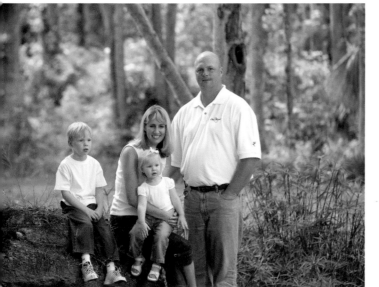

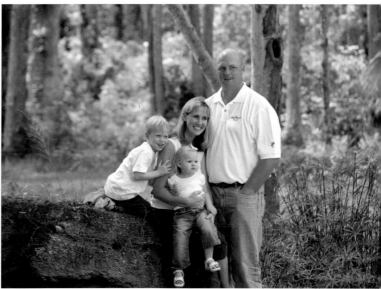

PLATE 215. Photograph by Doug Box.

PLATE 216. Photograph by Doug Box.

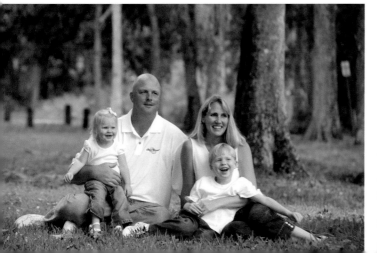

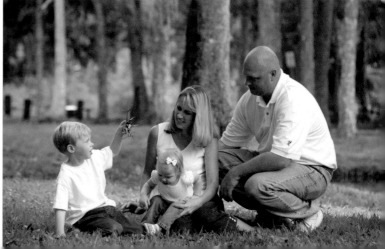

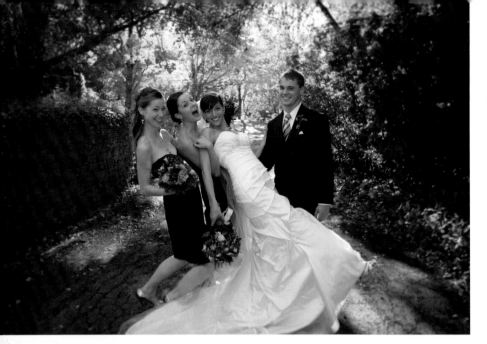

PLATE 217 (TOP LEFT).
Photograph by Tracy Dorr.

PLATE 218 (BOTTOM LEFT).
Photograph by Brett Florens.

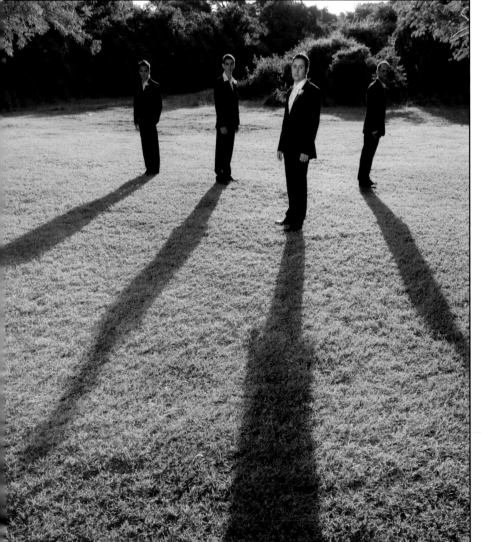

PLATE 219. Photograph by Brett Florens.

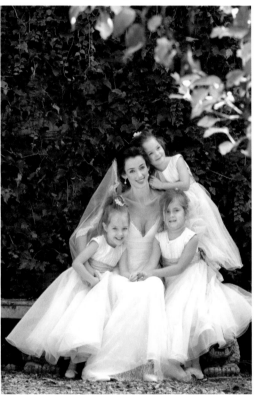

PLATE 220. Photograph by Brett Florens.

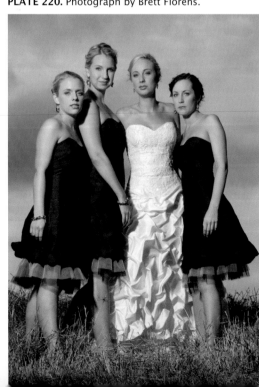

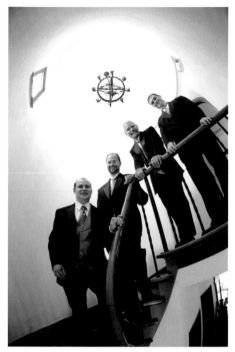

PLATE 221. Photograph by Damon Tucci.

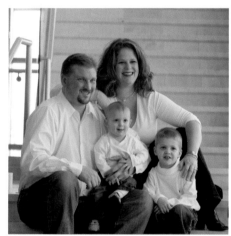

PLATE 222. Photograph by Doug Box.

PLATE 223 (RIGHT).
Photograph by Allison Earnest.

PLATE 224 (BELOW).
Photograph by Brett Florens.

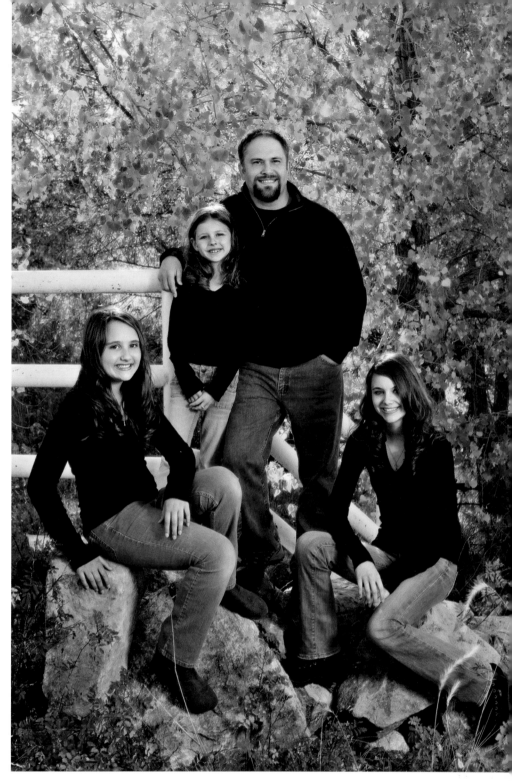

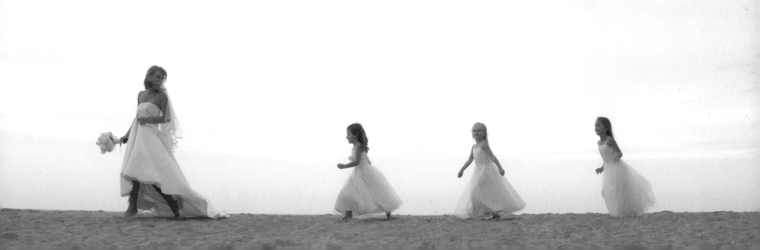

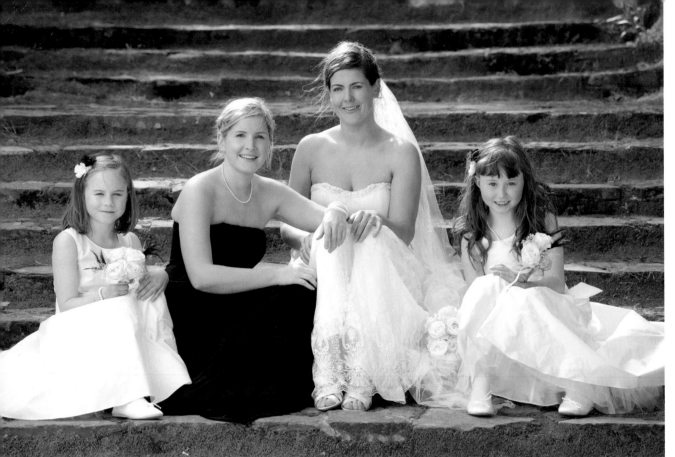

PLATE 225. Photograph by Brett Florens.

PLATE 226. Photograph by Jennifer George.

PLATE 227. Photograph by Jennifer George.

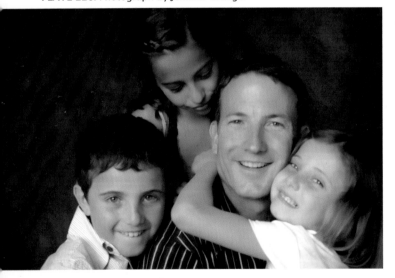

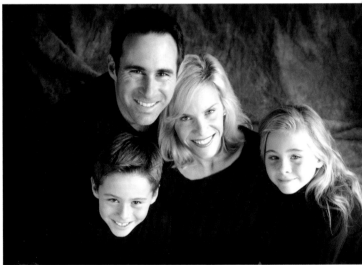

PLATE 228. Photograph by Jennifer George.

PLATE 229. Photograph by Jennifer George.

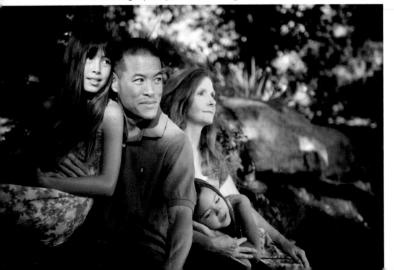

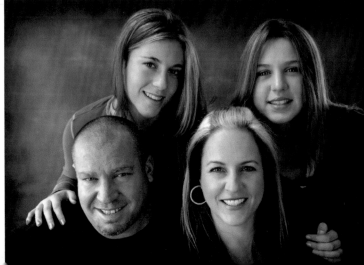

PLATE 230. Photograph by Jennifer George.

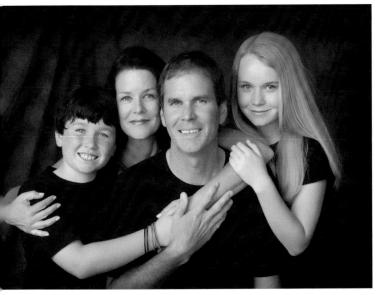

PLATE 231. Photograph by Jennifer George.

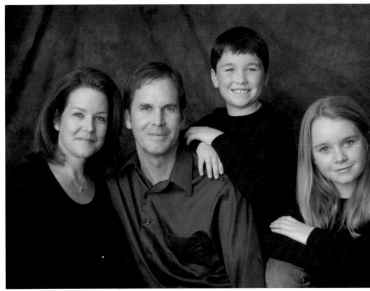

PLATE 232. Photograph by Jennifer George.

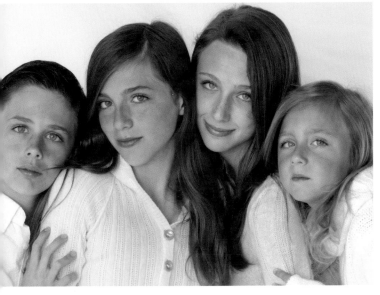

PLATE 233. Photograph by Jennifer George.

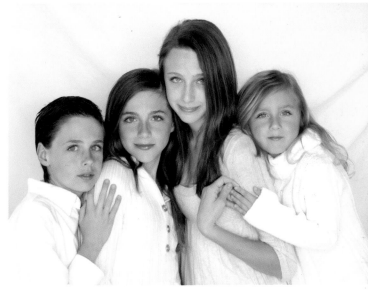

PLATE 234. Photograph by Jennifer George.

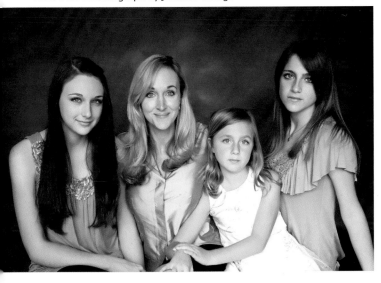

PLATE 235. Photograph by Jennifer George.

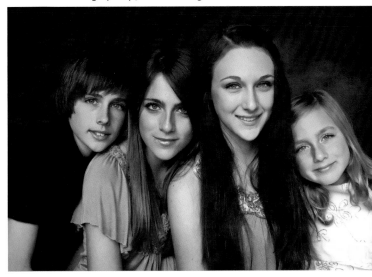

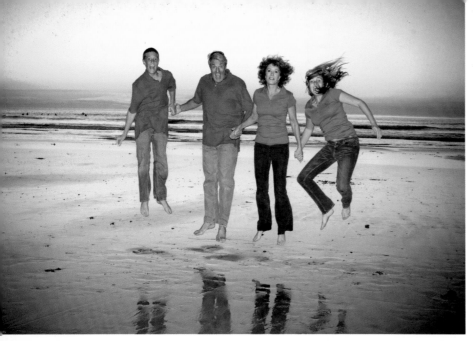

PLATE 236 (TOP LEFT).
Photograph by Jennifer George.

PLATE 237 (BOTTOM LEFT).
Photograph by Jennifer George.

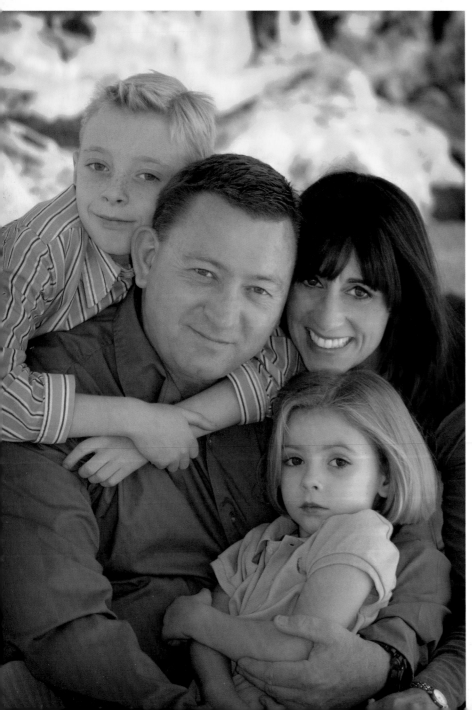

PLATE 238. Photograph by Jennifer George.

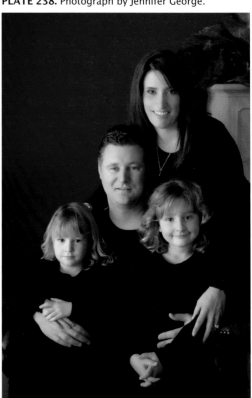

PLATE 239. Photograph by Jennifer George.

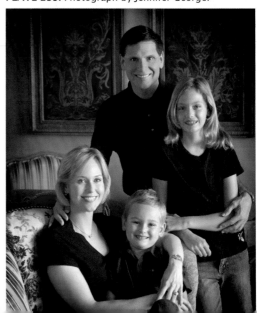

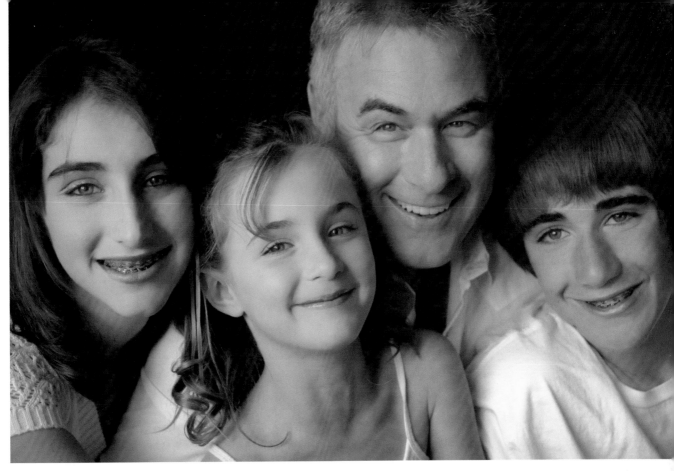

PLATE 240. Photograph by Jennifer George.

PLATE 241. Photograph by Jennifer George.

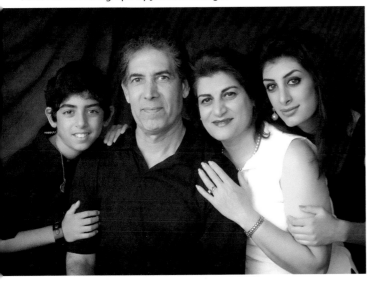

PLATE 242. Photograph by Jennifer George.

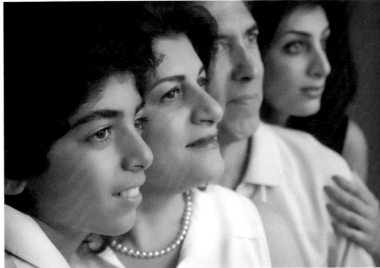

PLATE 243. Photograph by Jennifer George.

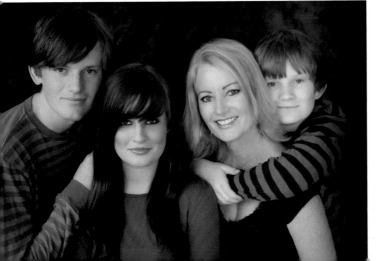

PLATE 244. Photograph by Jennifer George.

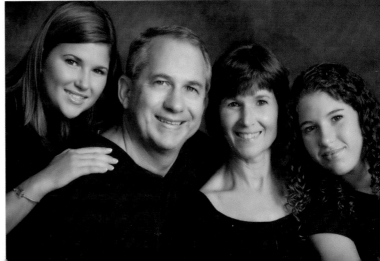

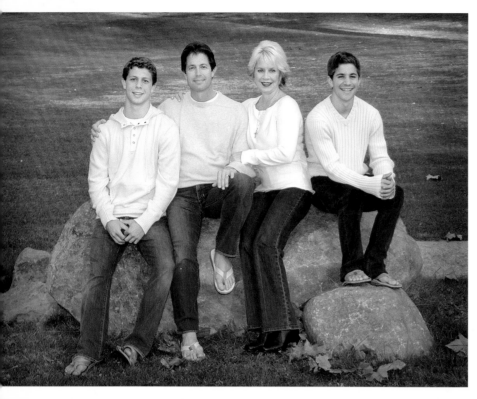

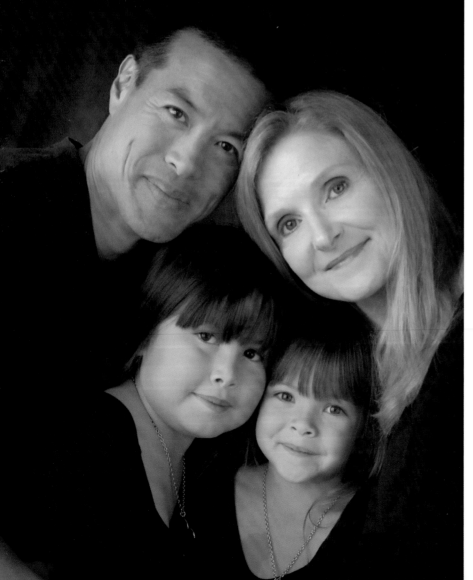

PLATE 245 (TOP LEFT).
Photograph by Jennifer George.

PLATE 246 (BOTTOM LEFT).
Photograph by Jennifer George.

PLATE 247. Photograph by Jennifer George.

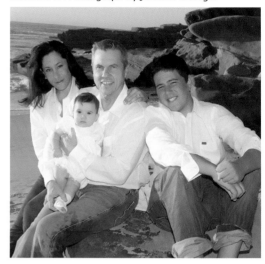

PLATE 248. Photograph by Jennifer George.

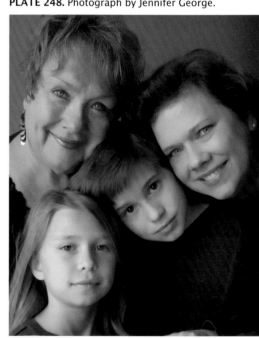

PLATE 249. Photograph by Jennifer George.

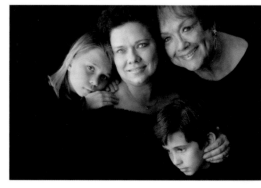

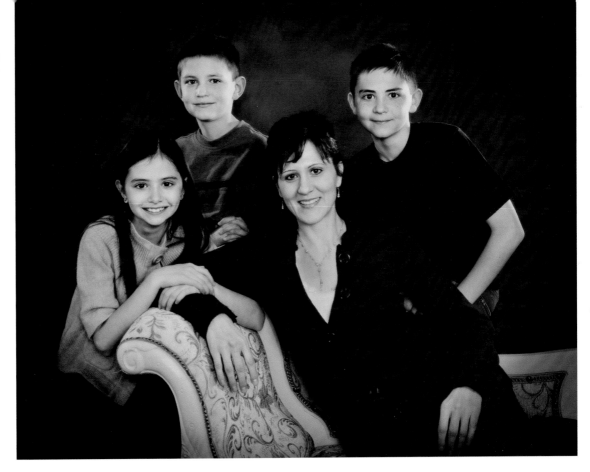

PLATE 250. Photograph by Allison Earnest.

PLATE 251. Photograph by Jennifer George.

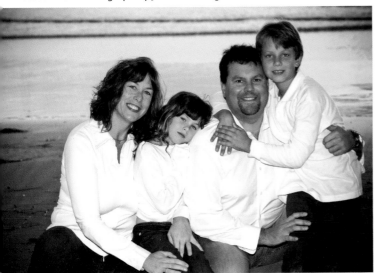

PLATE 252. Photograph by Jennifer George.

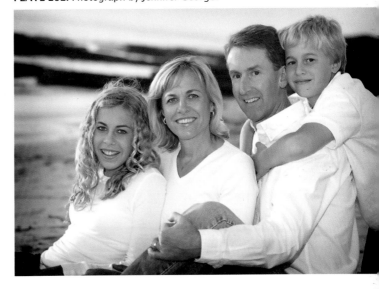

PLATE 253. Photograph by Jennifer George.

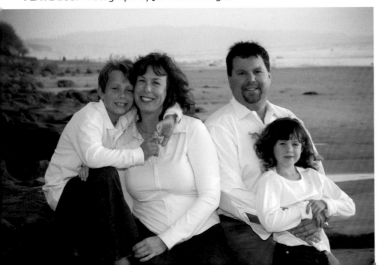

PLATE 254. Photograph by Jennifer George.

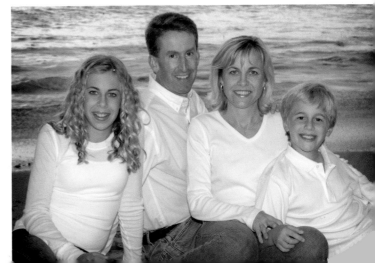

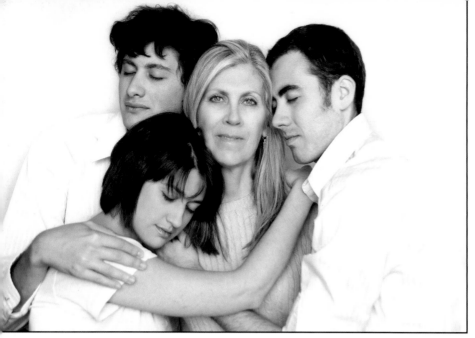

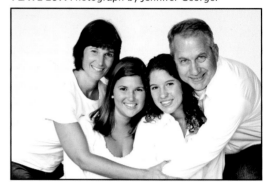

PLATE 255 (TOP LEFT).
Photograph by Jennifer George.

PLATE 256 (BOTTOM LEFT).
Photograph by Christie Mumm.

PLATE 257. Photograph by Jennifer George.

PLATE 258. Photograph by Jennifer George.

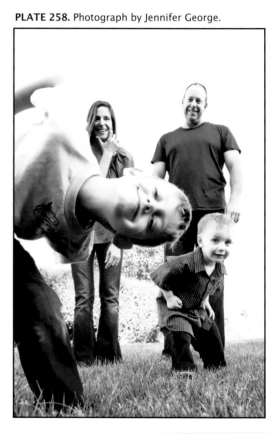

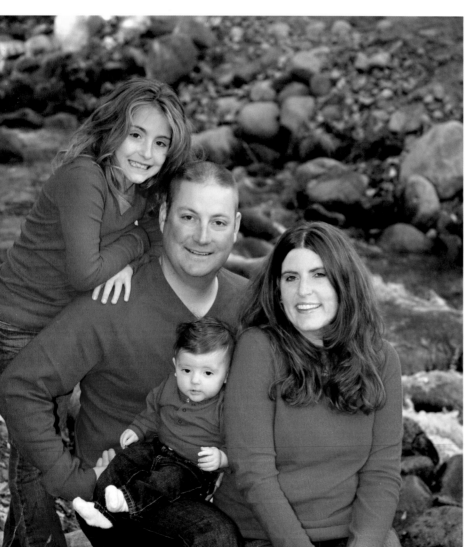

PLATE 259. Photograph by Christie Mumm.

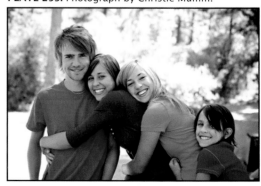

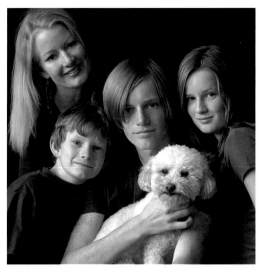

PLATE 260. Photograph by Jennifer George.

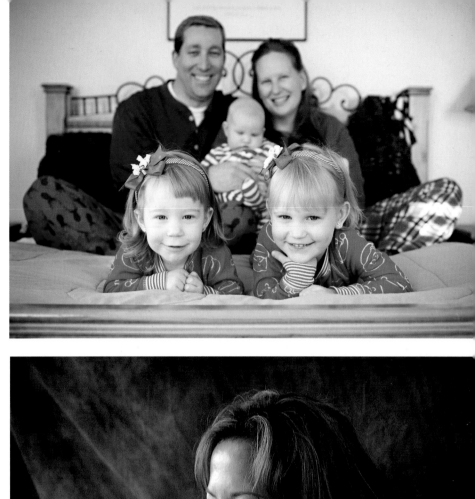

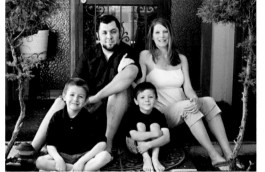

PLATE 261. Photograph by Christie Mumm.

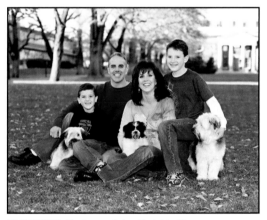

PLATE 262. Photograph by Christie Mumm.

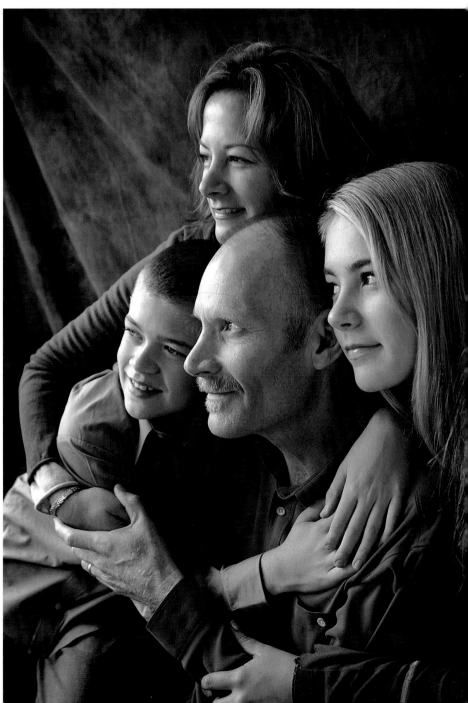

PLATE 263 (TOP RIGHT).
Photograph by Christie Mumm.

PLATE 264 (BOTTOM RIGHT).
Photograph by Jennifer George.

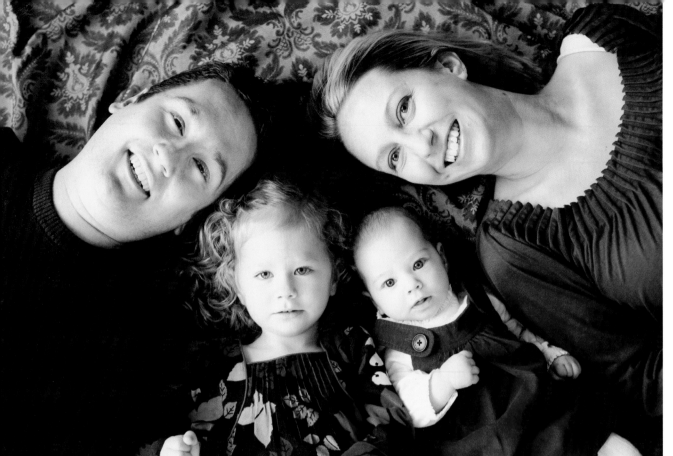

PLATE 265. Photograph by Christie Mumm.

PLATE 266. Photograph by Christie Mumm.

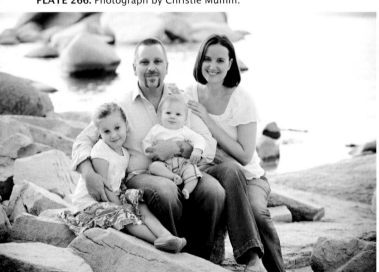

PLATE 267. Photograph by Christie Mumm.

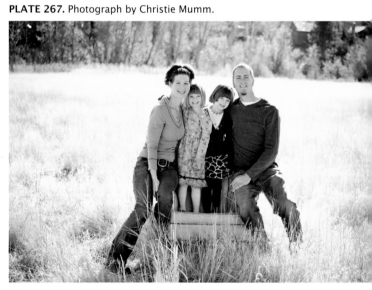

PLATE 268. Photograph by Christie Mumm.

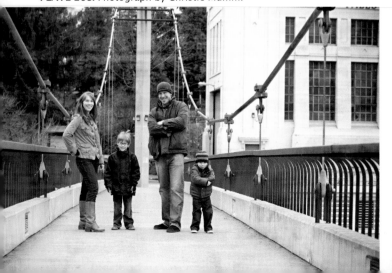

PLATE 269. Photograph by Christie Mumm.

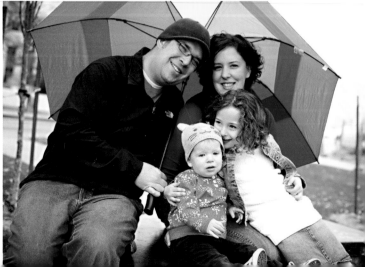

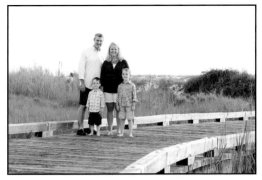

PLATE 270. Photograph by Krista Smith.

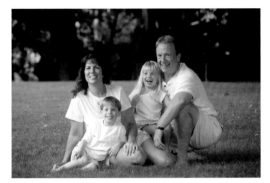

PLATE 271. Photograph by Doug Box.

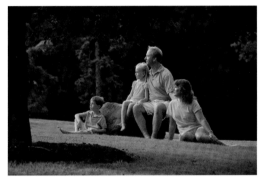

PLATE 272. Photograph by Doug Box.

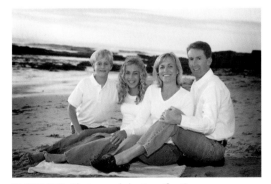

PLATE 273. Photograph by Jennifer George.

PLATE 274 (TOP RIGHT).
Photograph by Krista Smith.

PLATE 275 (BOTTOM RIGHT).
Photograph by Christie Mumm.

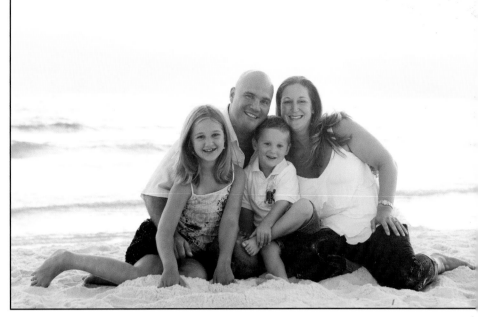

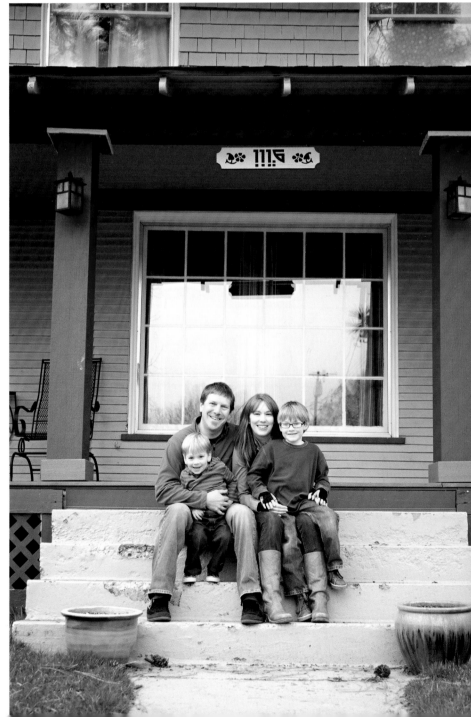

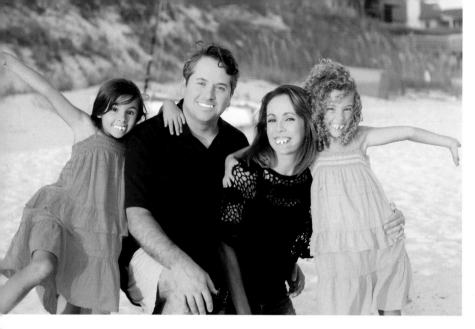

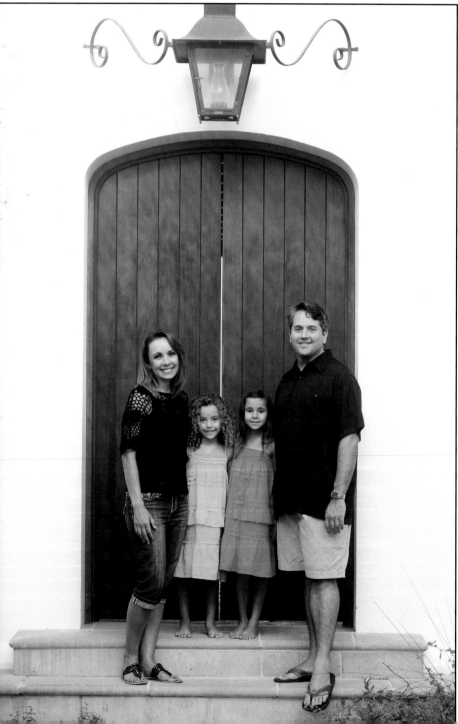

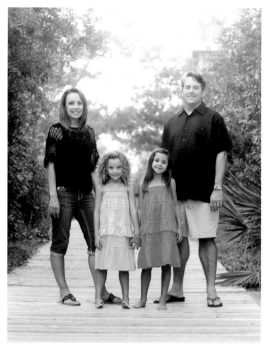

PLATE 276. Photograph by Krista Smith.

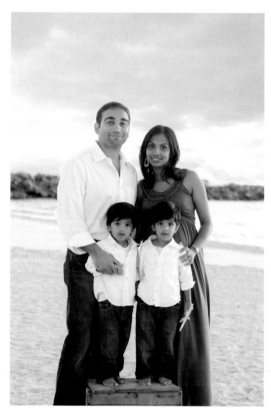

PLATE 277. Photograph by Krista Smith.

PLATE 278 (TOP LEFT). Photograph by Krista Smith.

PLATE 279 (BOTTOM LEFT).
Photograph by Krista Smith.

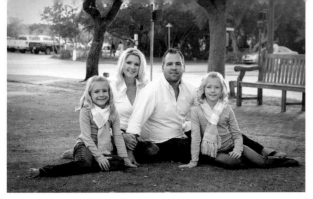

PLATE 280. Photograph by Krista Smith.

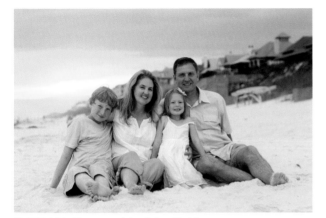

PLATE 281. Photograph by Krista Smith.

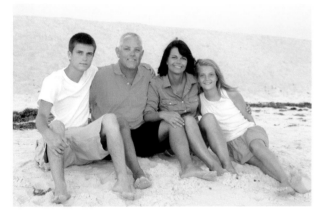

PLATE 282. Photograph by Krista Smith.

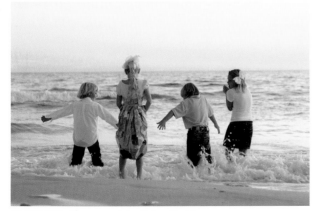

PLATE 283. Photograph by Krista Smith.

PLATE 284 (TOP RIGHT). Photograph by Krista Smith.

PLATE 285 (BOTTOM RIGHT). Photograph by Krista Smith.

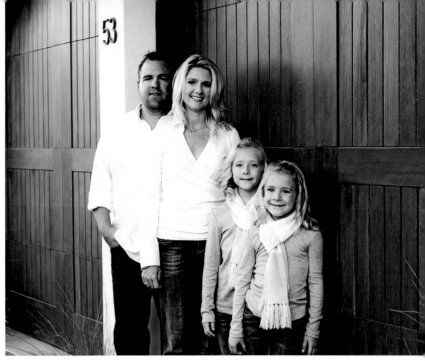

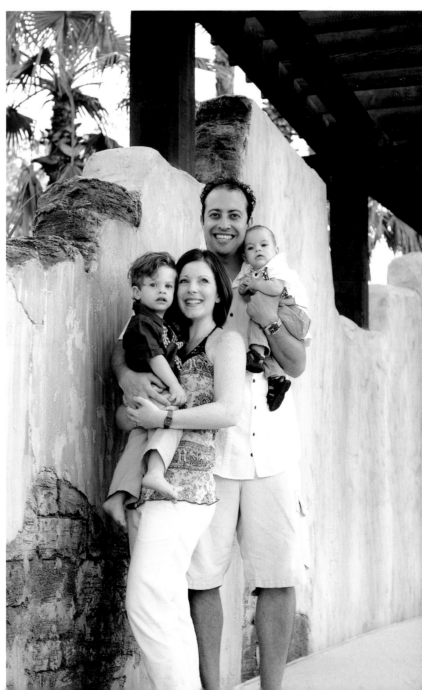

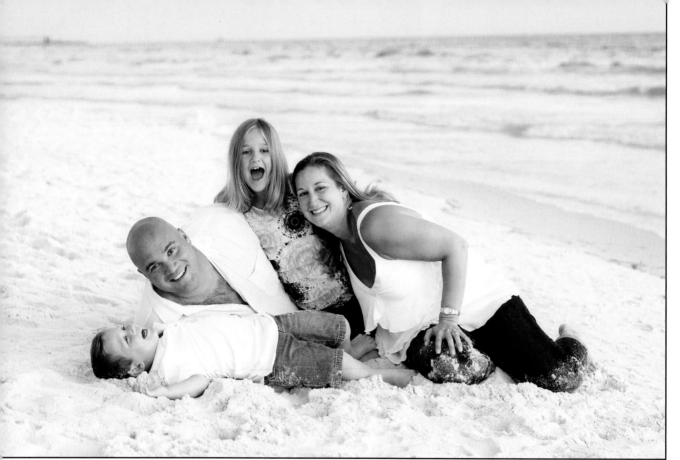

PLATE 286. Photograph by Krista Smith.

PLATE 287. Photograph by Krista Smith.

PLATE 288. Photograph by Krista Smith.

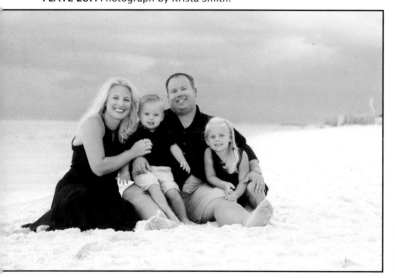

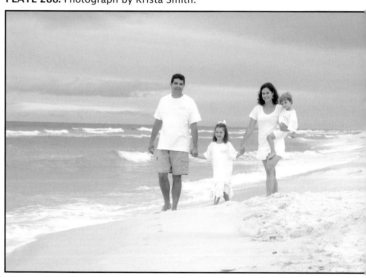

PLATE 289. Photograph by Krista Smith.

PLATE 290. Photograph by Krista Smith.

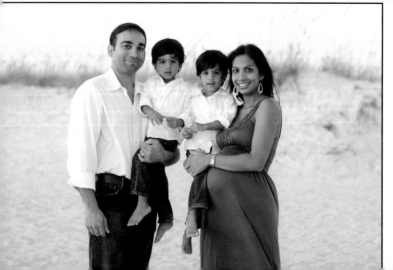

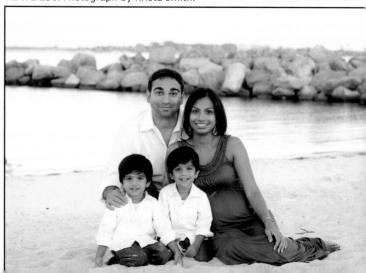

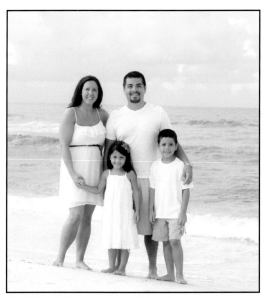

PLATE 291. Photograph by Krista Smith.

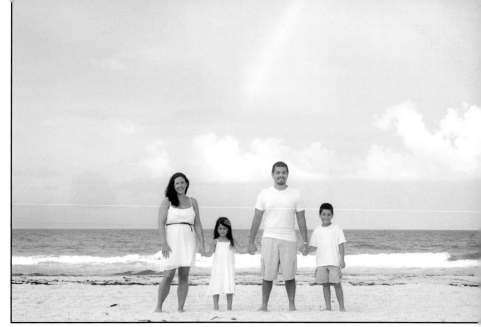

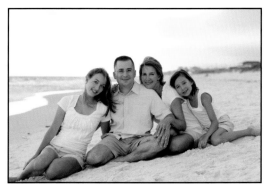

PLATE 292. Photograph by Krista Smith.

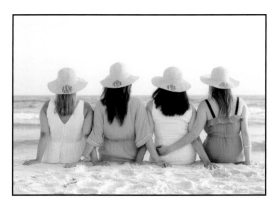

PLATE 293. Photograph by Krista Smith.

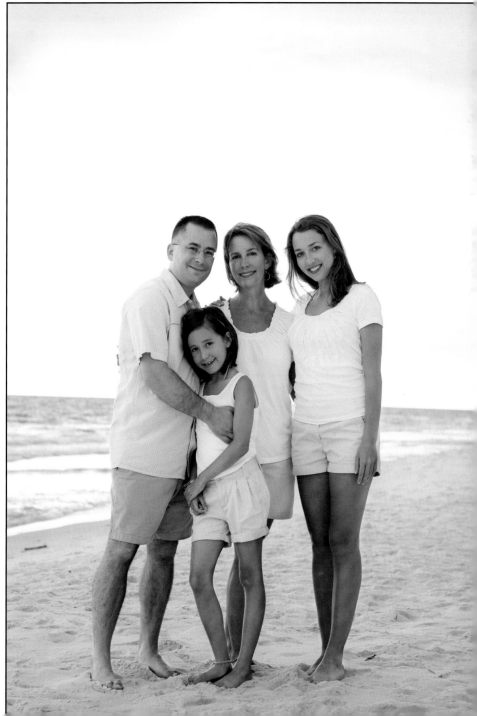

PLATE 294 (TOP RIGHT).
Photograph by Krista Smith.

PLATE 295 (BOTTOM RIGHT).
Photograph by Krista Smith.

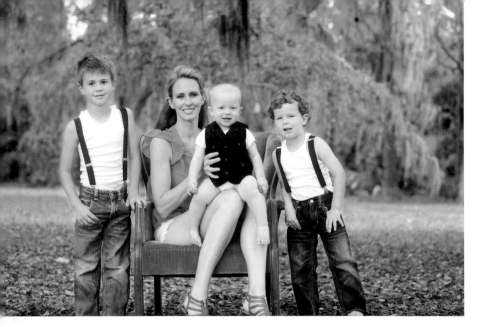

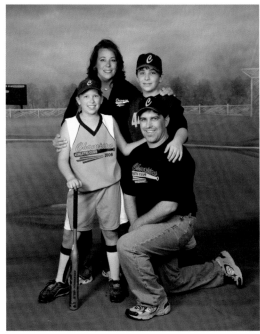

PLATE 296. Photograph by James Williams.

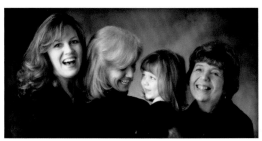

PLATE 297. Photograph by Ellie Vayo.

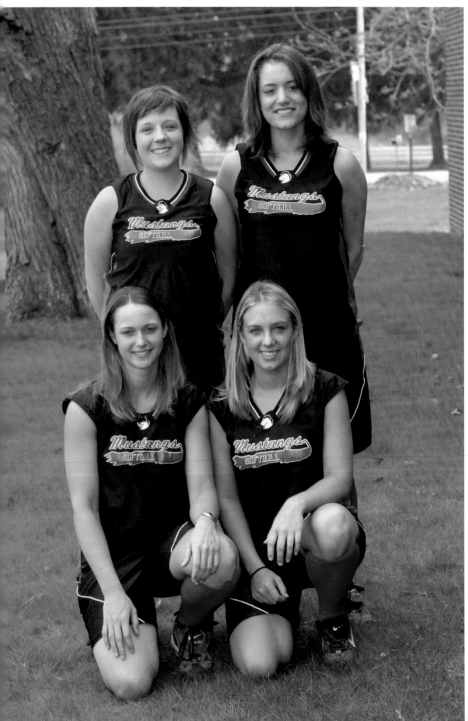

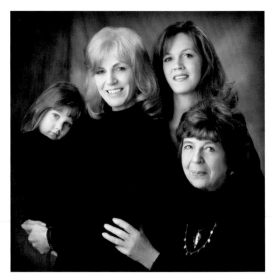

PLATE 298. Photograph by Ellie Vayo.

PLATE 299 (TOP LEFT). Photograph by Krista Smith.

PLATE 300 (BOTTOM LEFT).
Photograph by James Williams.

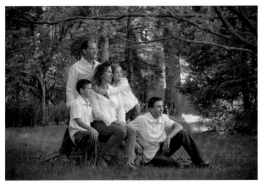

PLATE 301. Photograph by Doug Box.

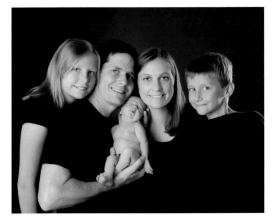

PLATE 302. Photograph by Mimika Cooney.

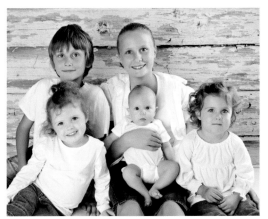

PLATE 303. Photograph by Mimika Cooney.

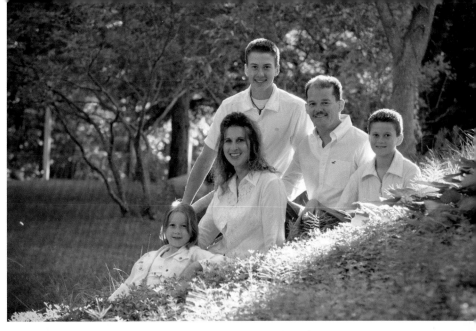

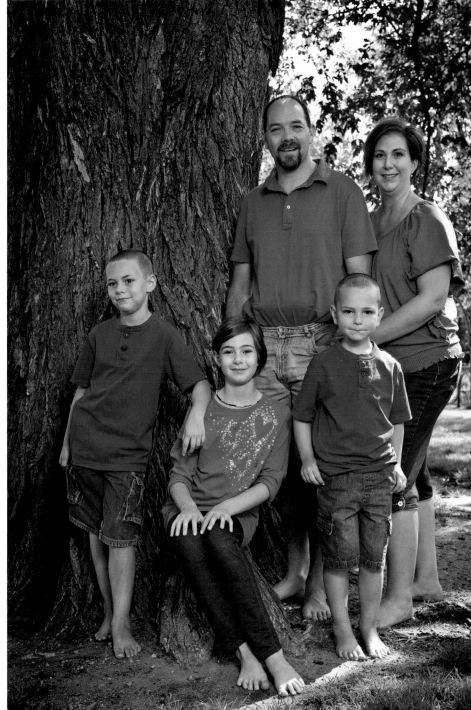

PLATE 304 (TOP RIGHT).
Photograph by Doug Box.

PLATE 305 (BOTTOM RIGHT).
Photograph by Allison Earnest.

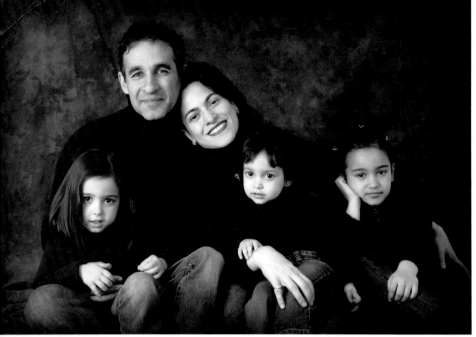

PLATE 306 (TOP LEFT).
Photograph by Jennifer George.

PLATE 307 (CENTER LEFT).
Photograph by Jennifer George.

PLATE 308 (BOTTOM LEFT).
Photograph by Jennifer George.

PLATE 309. Photograph by Jennifer George.

PLATE 310. Photograph by Jennifer George.

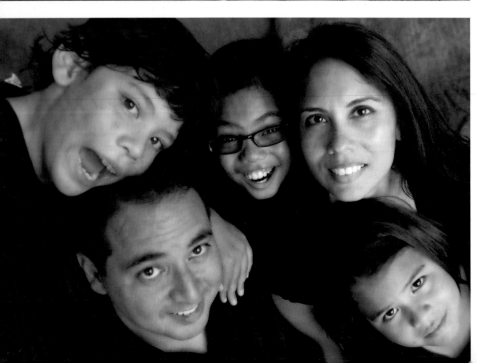

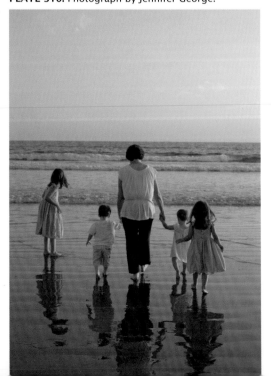

PLATE 311. Photograph by Jennifer George.

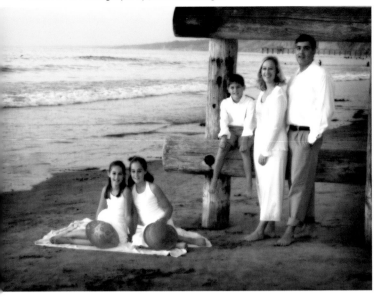

PLATE 312. Photograph by Jennifer George.

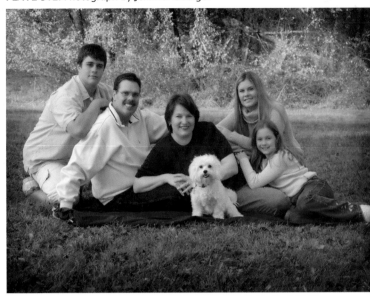

PLATE 313. Photograph by Jennifer George.

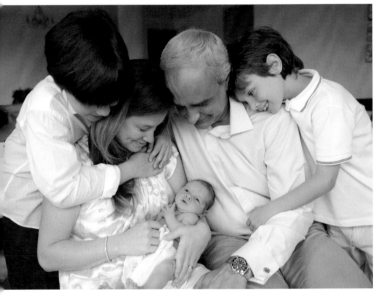

PLATE 314. Photograph by Jennifer George.

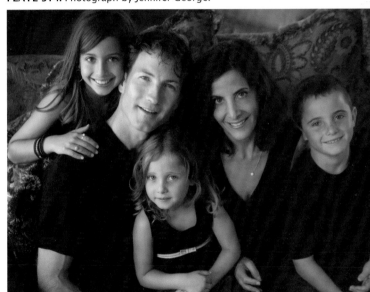

PLATE 315. Photograph by Jennifer George.

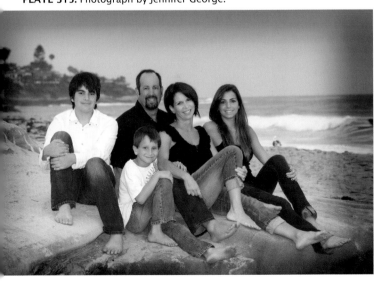

PLATE 316. Photograph by Jennifer George.

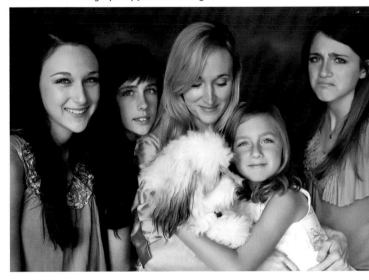

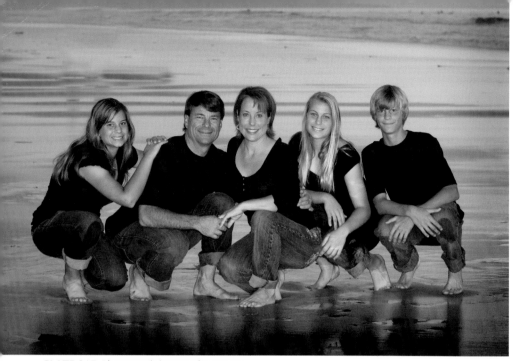

PLATE 317. Photograph by Jennifer George.

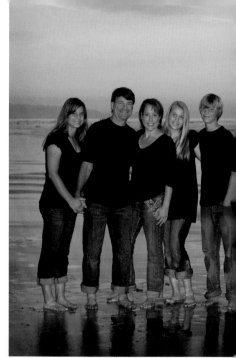

PLATE 318. Photograph by Jennifer George.

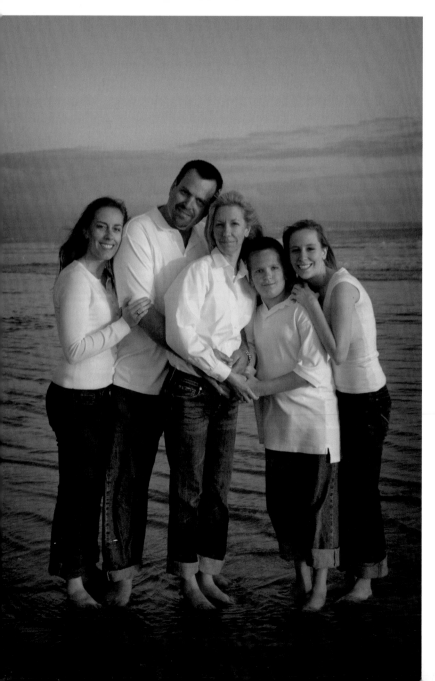

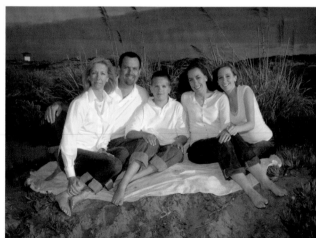

PLATE 319. Photograph by Jennifer George.

PLATE 320. Photograph by Jennifer George.

PLATE 321. Photograph by Jennifer George.

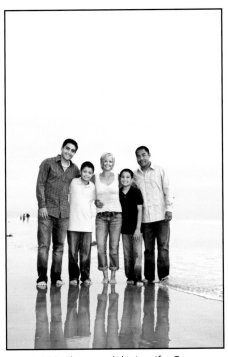

PLATE 322. Photograph by Jennifer George.

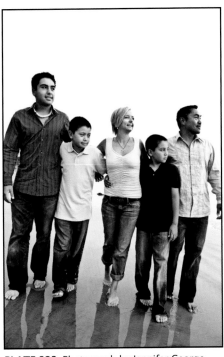

PLATE 323. Photograph by Jennifer George.

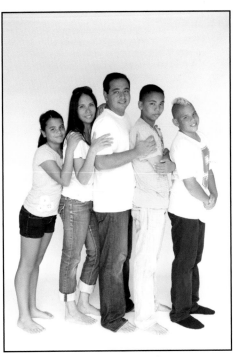

PLATE 324. Photograph by Jennifer George.

PLATE 325. Photograph by Jennifer George.

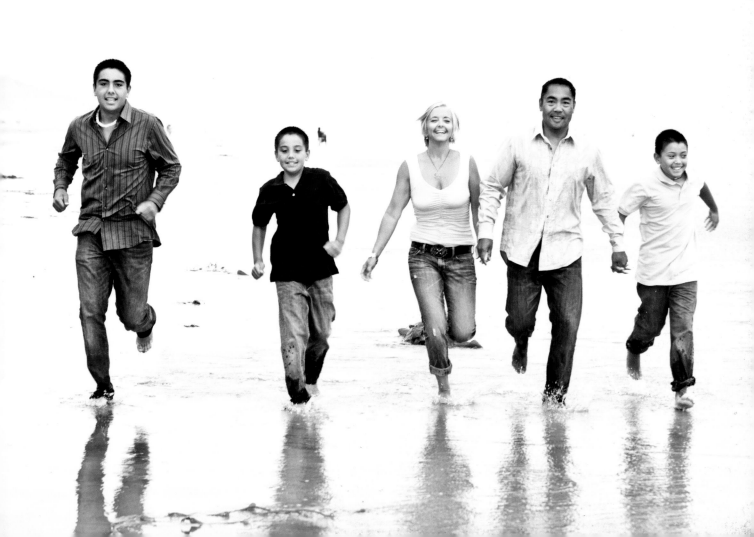

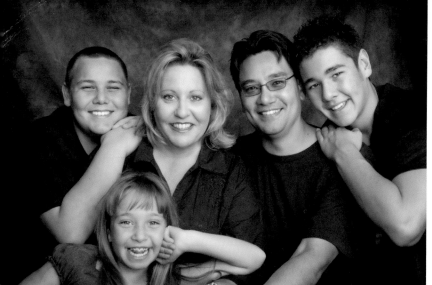

PLATE 326. Photograph by Jennifer George.

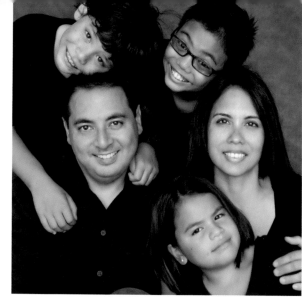

PLATE 327. Photograph by Jennifer George.

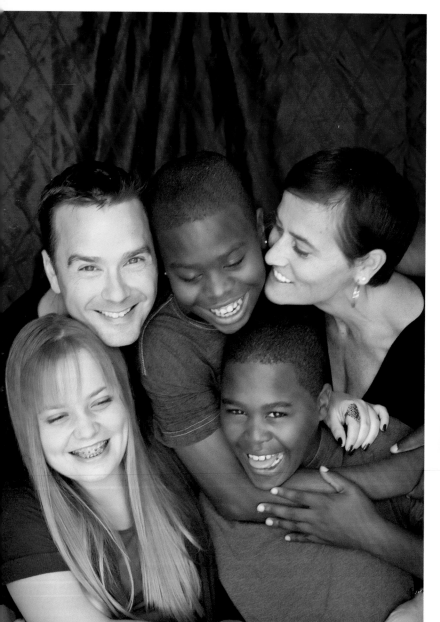

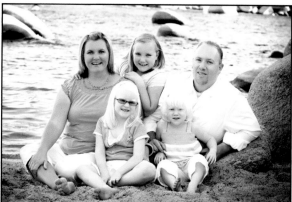

PLATE 328. Photograph by Jennifer George.

PLATE 329. Photograph by Christie Mumm.

PLATE 330. Photograph by Jennifer George.

PLATE 331 (TOP RIGHT).
Photograph by Ryan Klos.

PLATE 332 (BOTTOM RIGHT).
Photograph by Ryan Klos.

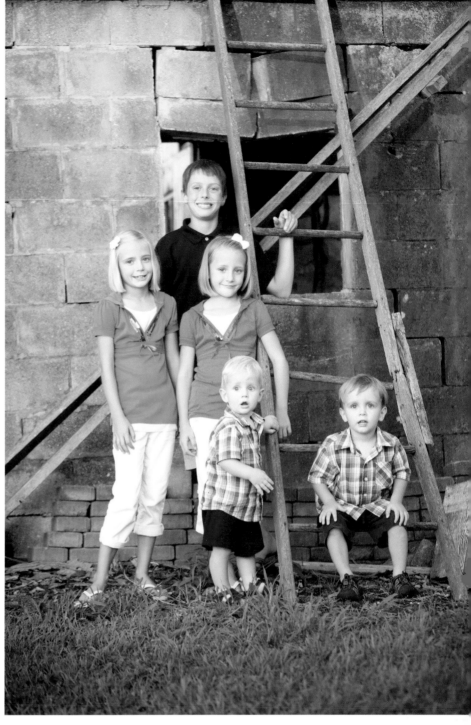

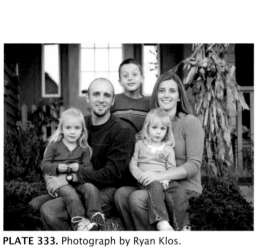

PLATE 333. Photograph by Ryan Klos.

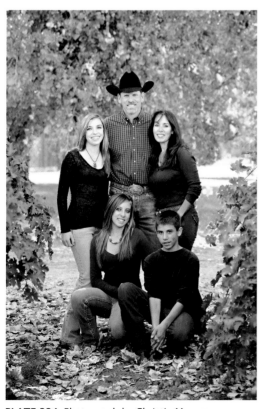

PLATE 334. Photograph by Christie Mumm.

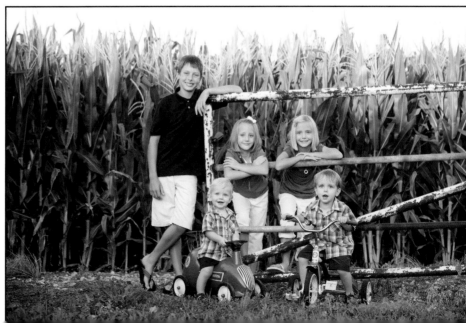

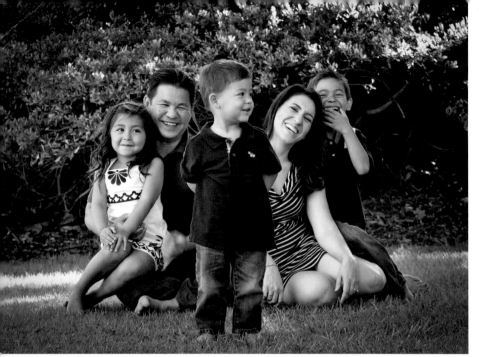

PLATE 335 (TOP LEFT).
Photograph by Marcus Weisberg.

PLATE 336 (CENTER LEFT).
Photograph by Christie Mumm.

PLATE 337 (BOTTOM LEFT).
Photograph by Christie Mumm.

PLATE 338. Photograph by Ryan Klos.

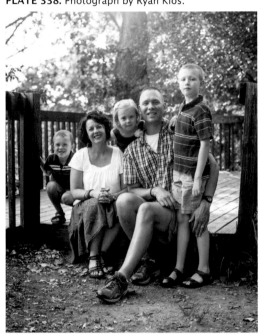

PLATE 339. Photograph by Jennifer George.

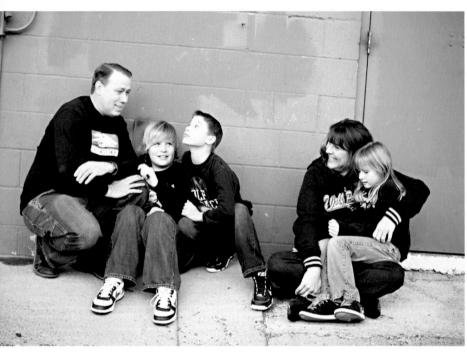

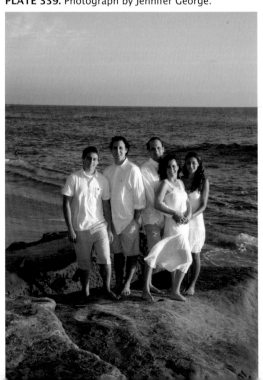

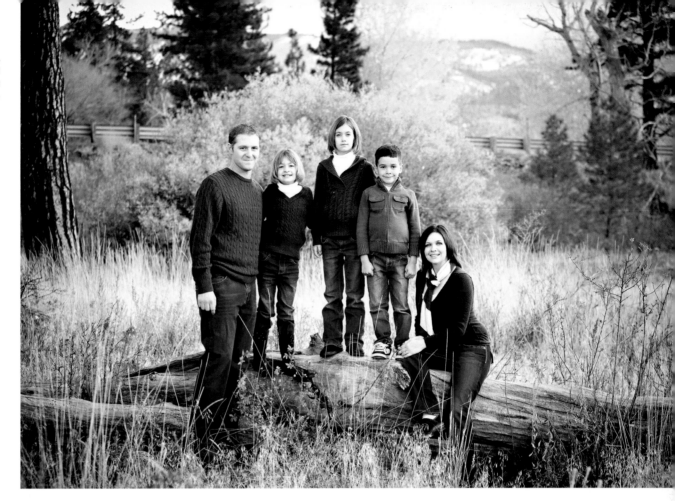

PLATE 340. Photograph by Christie Mumm.

PLATE 341. Photograph by Allison Earnest.

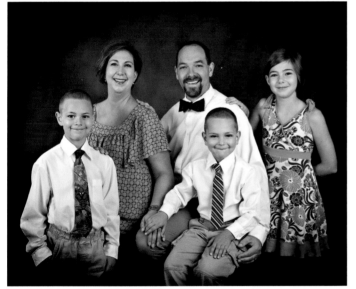

PLATE 342. Photograph by Allison Earnest.

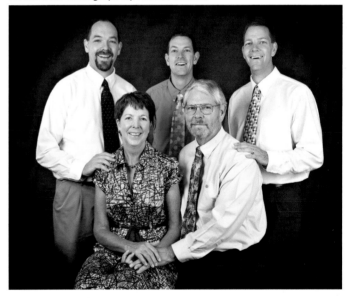

PLATE 343. Photograph by Christie Mumm.

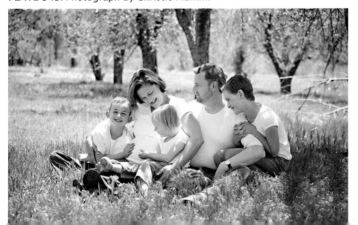

PLATE 344. Photograph by Krista Smith.

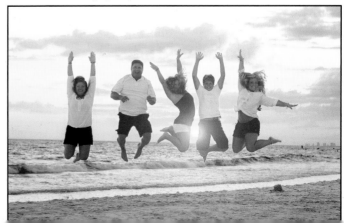

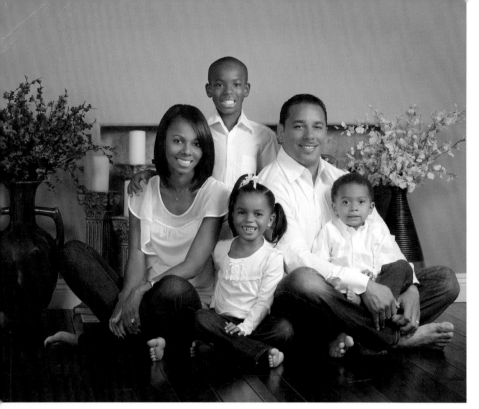

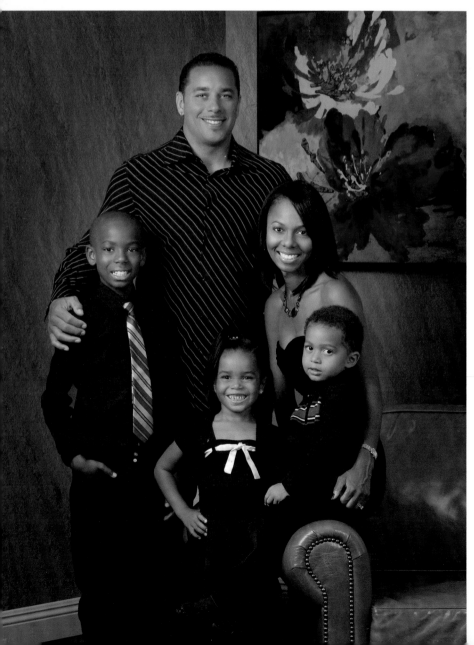

PLATE 345 (TOP LEFT).
Photograph by Hernan Rodriguez.

PLATE 346 (BOTTOM LEFT).
Photograph by Hernan Rodriguez.

PLATE 347. Photograph by Hernan Rodriguez.

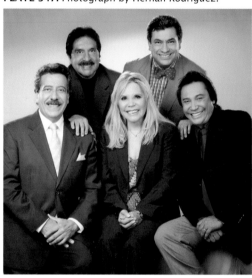

PLATE 348. Photograph by Hernan Rodriguez.

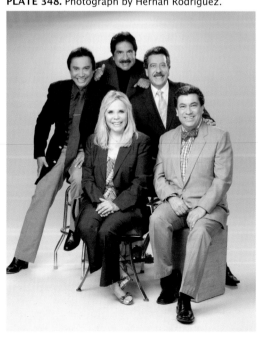

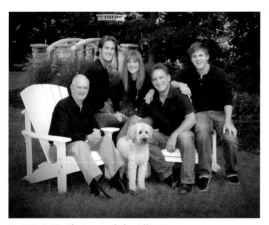

PLATE 349. Photograph by Ellie Vayo.

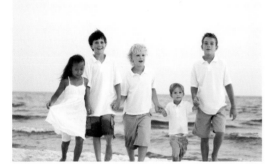

PLATE 350. Photograph by Krista Smith.

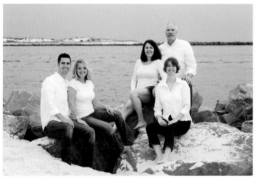

PLATE 351. Photograph by Krista Smith.

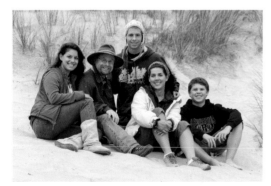

PLATE 352. Photograph by Alyn Stafford.

PLATE 353 (TOP RIGHT).
Photograph by Krista Smith.

PLATE 354 (BOTTOM RIGHT).
Photograph by Krista Smith.

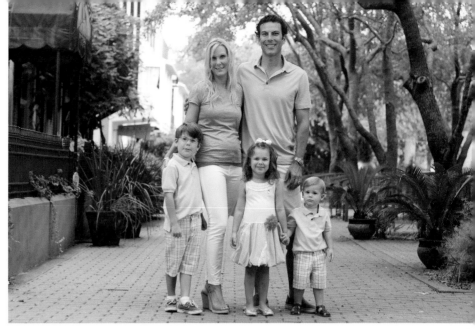

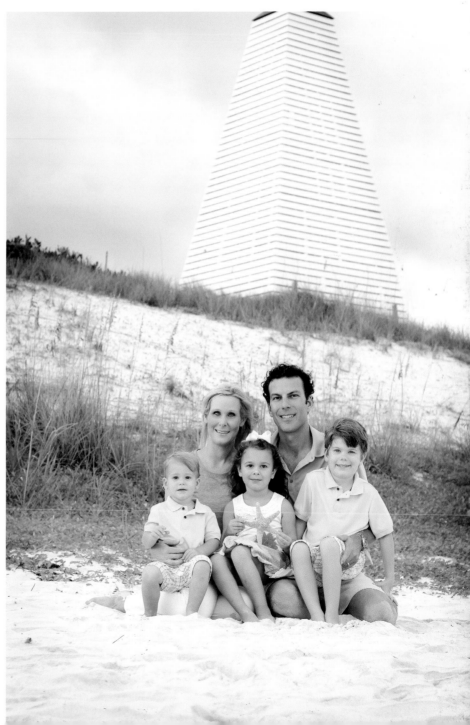

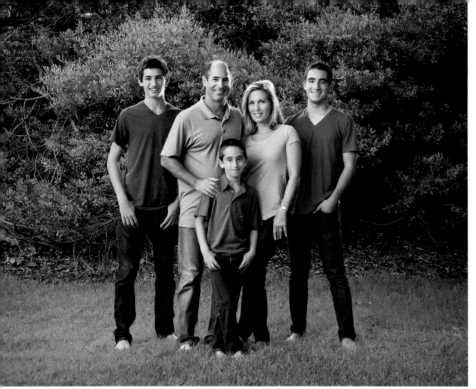

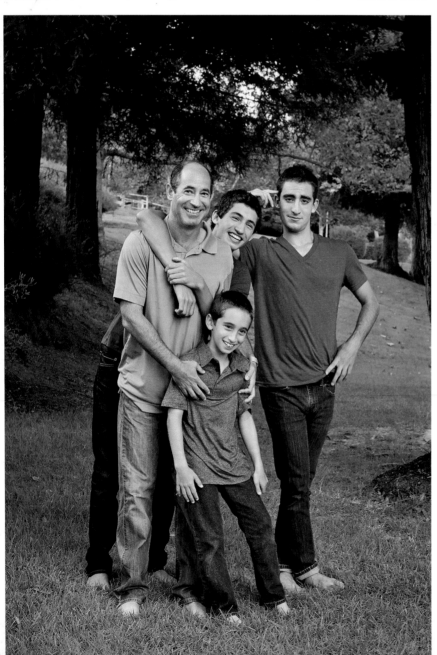

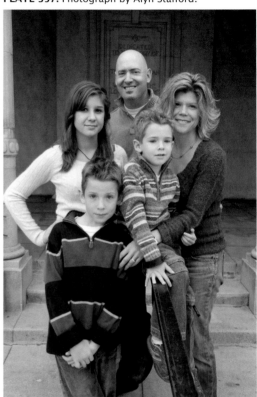

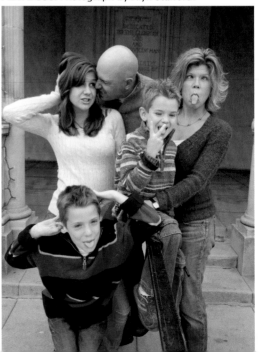

PLATE 355 (TOP LEFT).
Photograph by Marc Weisberg.

PLATE 356 (BOTTOM LEFT).
Photograph by Marc Weisberg.

PLATE 357. Photograph by Alyn Stafford.

PLATE 358. Photograph by Alyn Stafford.

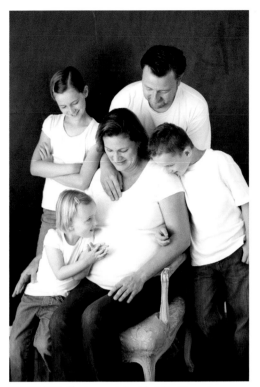

PLATE 359. Photograph by Christie Mumm.

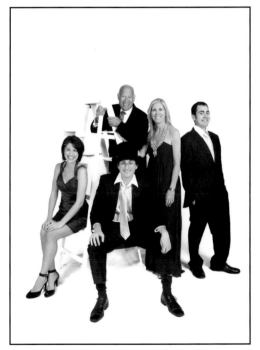

PLATE 360. Photograph by Jennifer George.

PLATE 361 (TOP RIGHT).
Photograph by Marc Weisberg.

PLATE 362 (CENTER RIGHT).
Photograph by Marc Weisberg.

PLATE 363 (BOTTOM RIGHT).
Photograph by James WIlliams.

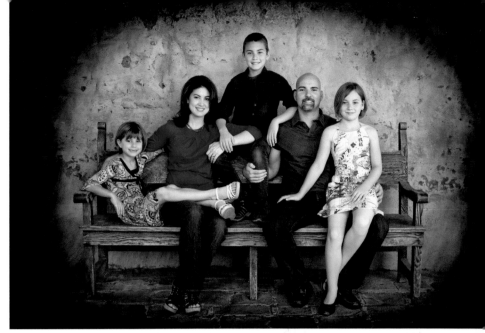

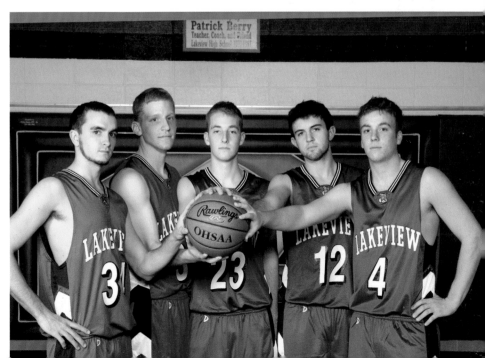

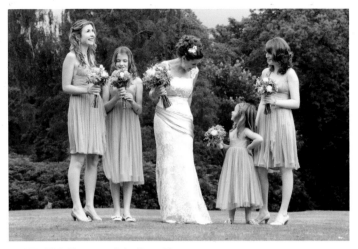

PLATE 364. Photograph by Brett Florens.

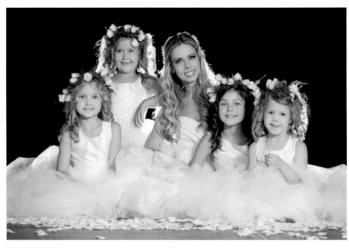

PLATE 365. Photograph by Brett Florens.

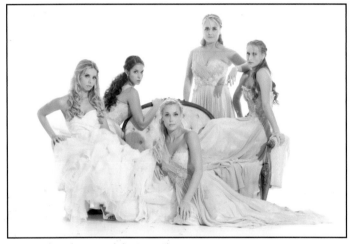

PLATE 366. Photograph by Brett Florens.

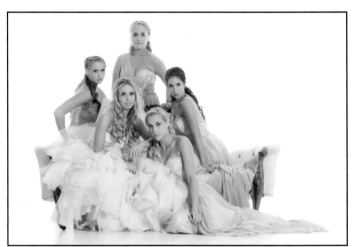

PLATE 367. Photograph by Brett Florens.

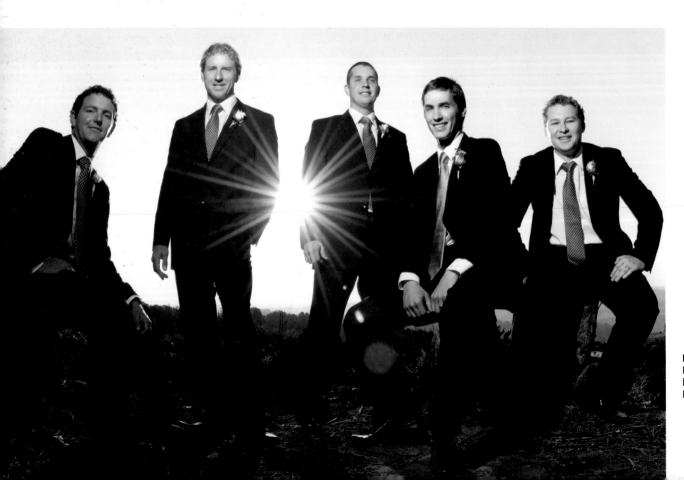

PLATE 368. Photograph by Brett Florens.

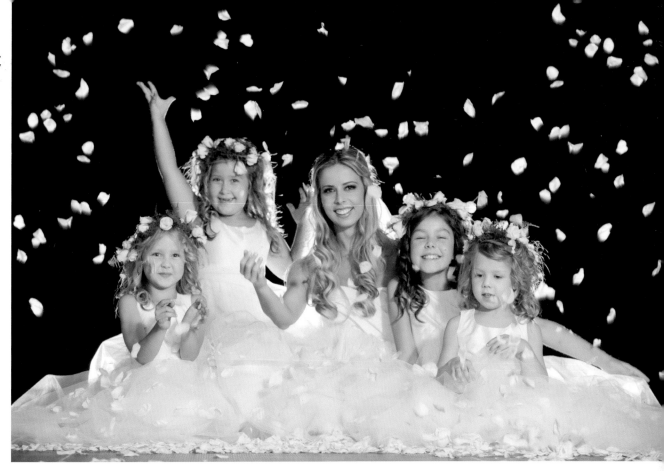

PLATE 369.
Photograph by
Brett Florens.

PLATE 370. Photograph by Jennifer George.

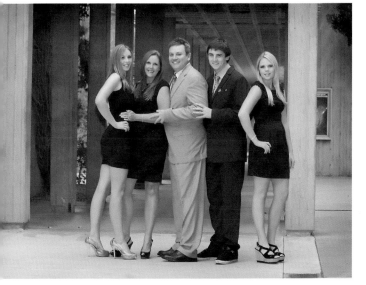

PLATE 371. Photograph by Jennifer George.

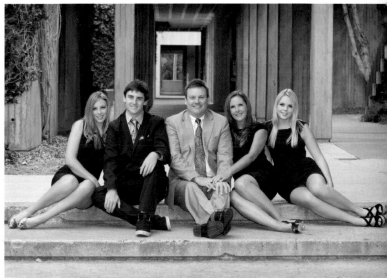

PLATE 372. Photograph by Brett Florens.

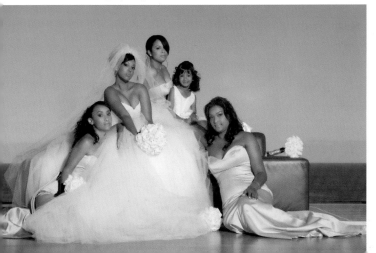

PLATE 373. Photograph by Brett Florens.

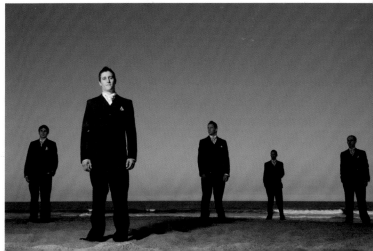

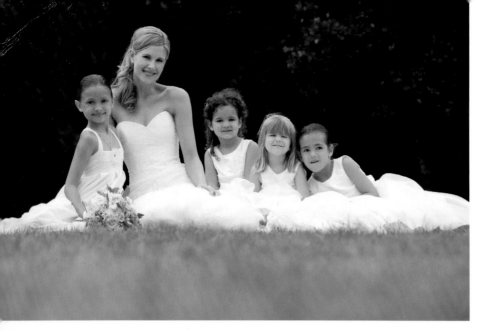

PLATE 374 (TOP LEFT).
Photograph by Brett Florens.

PLATE 375 (CENTER LEFT).
Photograph by Brett Florens.

PLATE 376 (BOTTOM LEFT).
Photograph by Brett Florens.

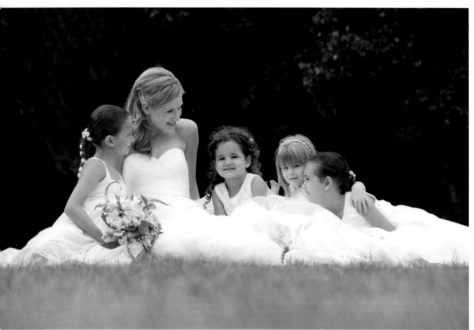

PLATE 377. Photograph by Brett Florens.

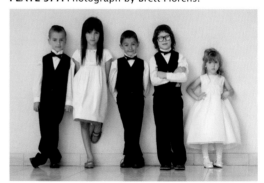

PLATE 378. Photograph by Tracy Dorr.

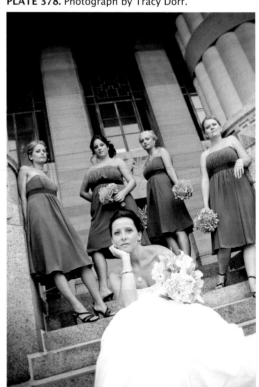

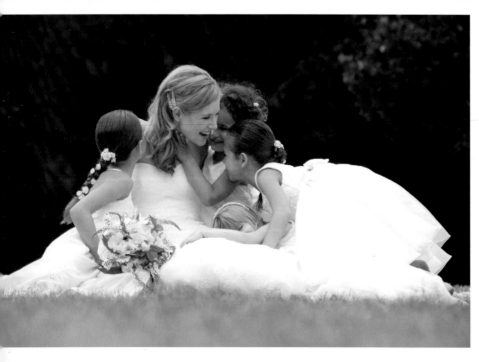

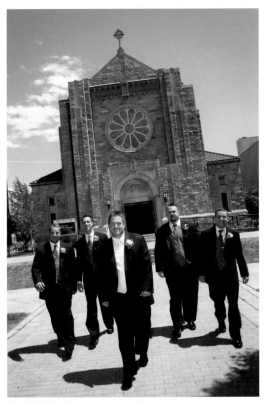

PLATE 379. Photograph by Tracy Dorr.

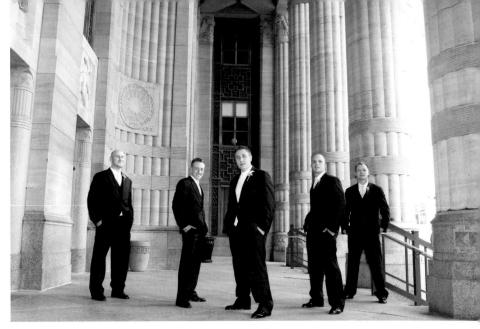

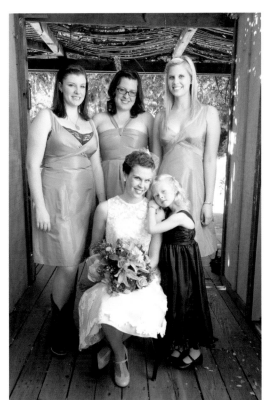

PLATE 380. Photograph by Alyn Stafford.

PLATE 381 (TOP RIGHT).
Photograph by Tracy Dorr.

PLATE 382 (BOTTOM RIGHT).
Photograph by Tracy Dorr.

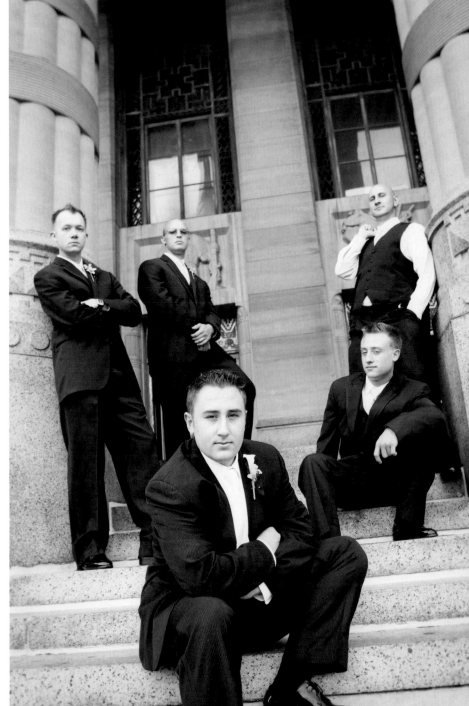

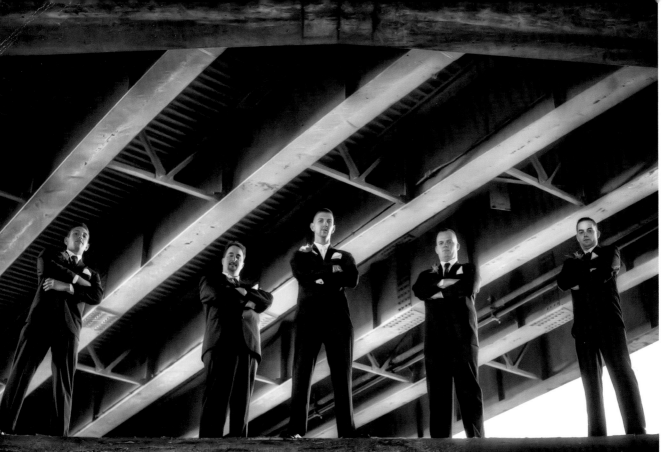

PLATE 383. Photograph by Neal Urban.

PLATE 384. Photograph by Alyn Stafford.

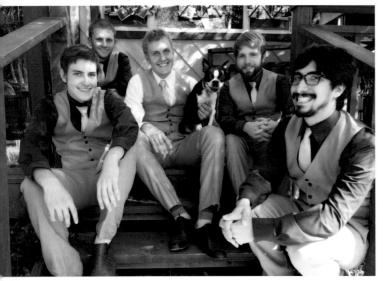

PLATE 385. Photograph by Brett Florens.

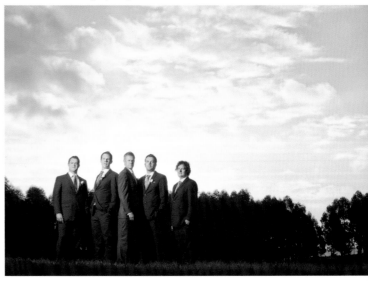

PLATE 386. Photograph by Alyn Stafford.

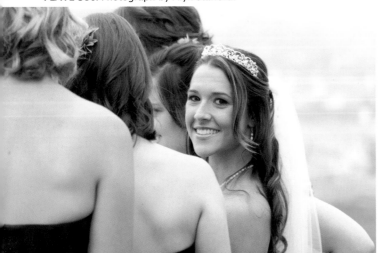

PLATE 387. Photograph by Damon Tucci.

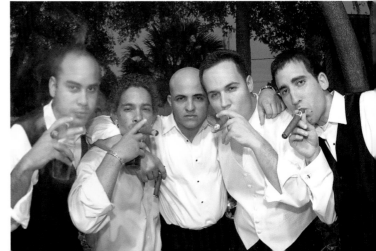

PLATE 388.
Photograph
by Neal
Urban.

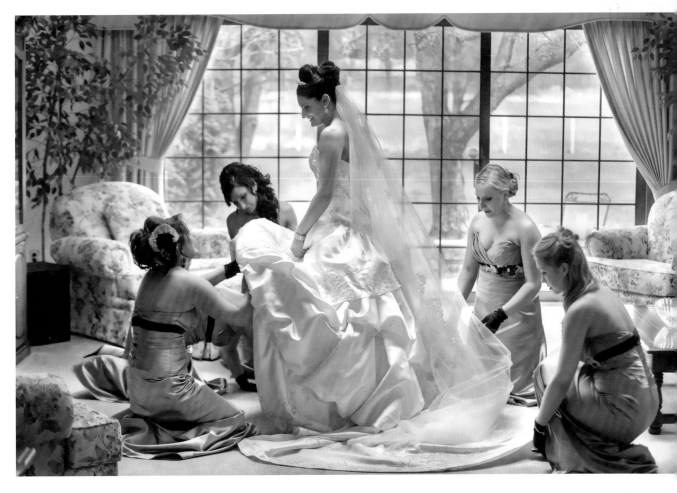

PLATE 389. Photograph by Ryan Klos.

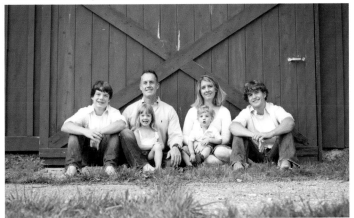

PLATE 390. Photograph by Krista Smith.

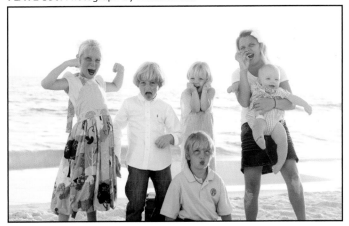

PLATE 391. Photograph by Krista Smith.

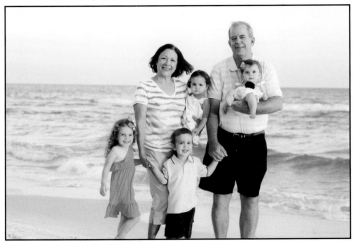

PLATE 392. Photograph by Krista Smith.

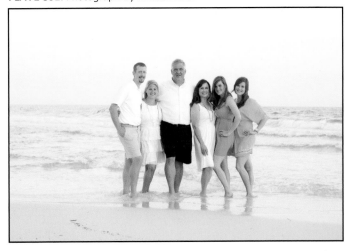

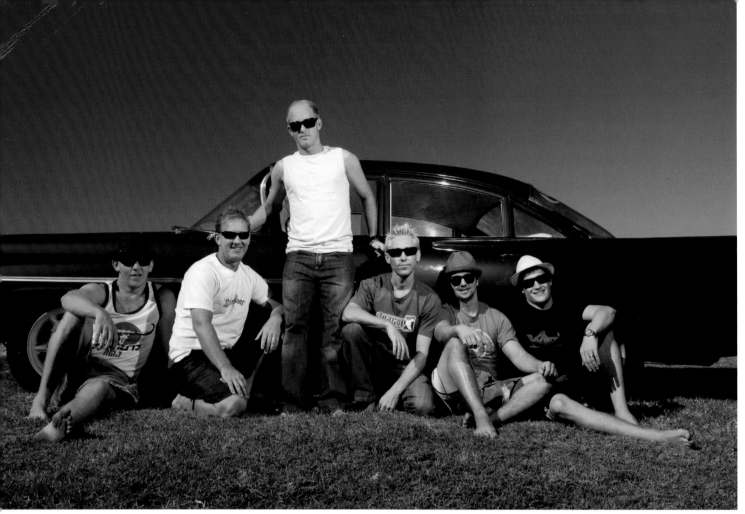

PLATE 393. Photograph by Brett Florens.

PLATE 394. Photograph by Brett Florens.

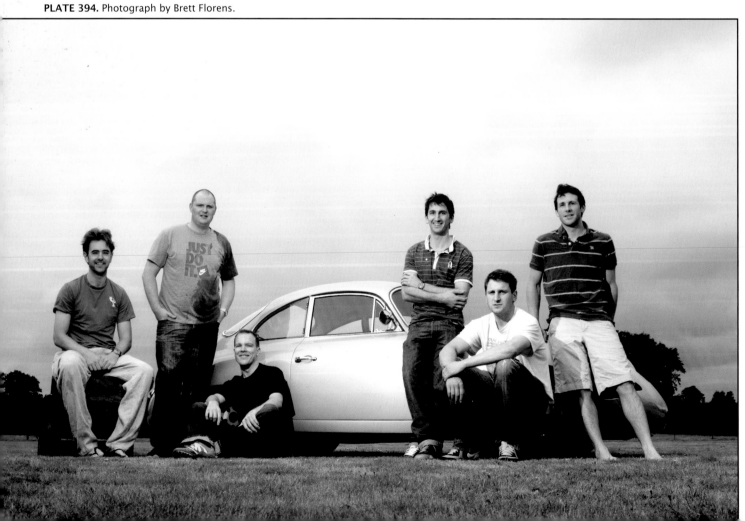

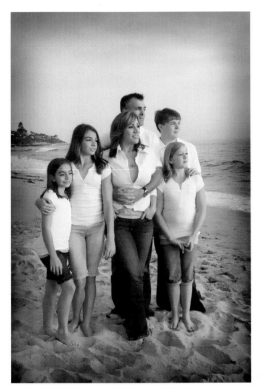

PLATE 395. Photograph by Jennifer George.

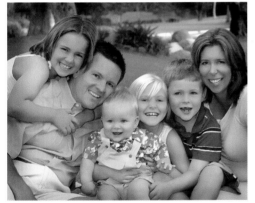

PLATE 396. Photograph by Jennifer George.

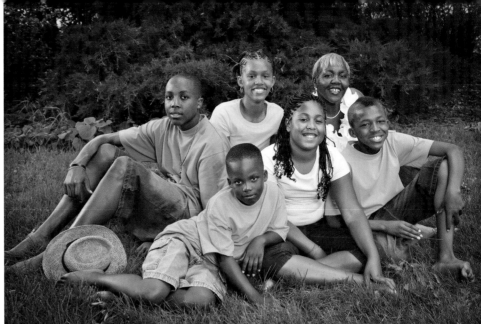

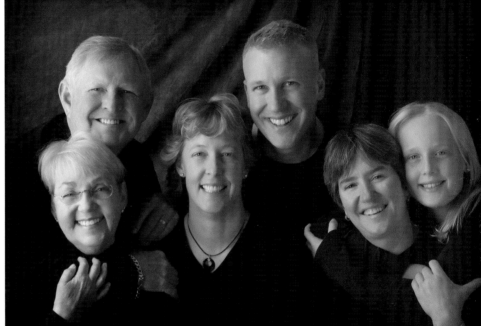

PLATE 397 (TOP RIGHT).
Photograph by Allison Earnest.

PLATE 398 (CENTER RIGHT).
Photograph by Jennifer George.

PLATE 399 (BOTTOM RIGHT).
Photograph by Christie Mumm.

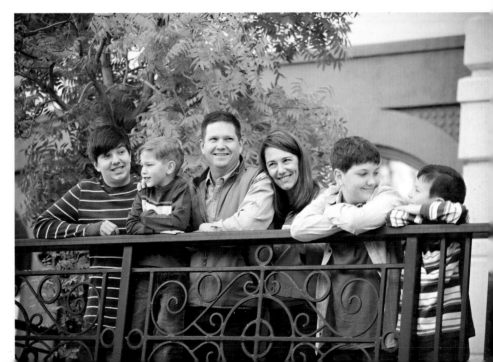

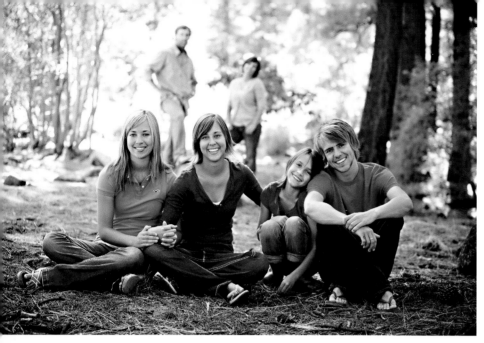

PLATE 400. Photograph by Christie Mumm.

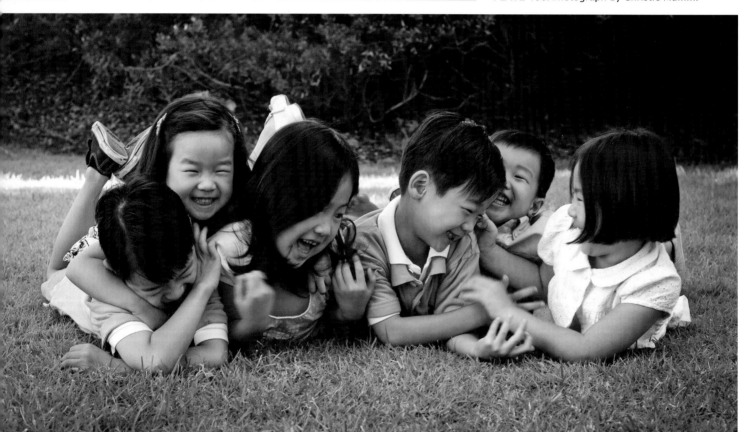

PLATE 401 (ABOVE) AND PLATE 402 (BELOW). Photographs by Marc Weisberg.

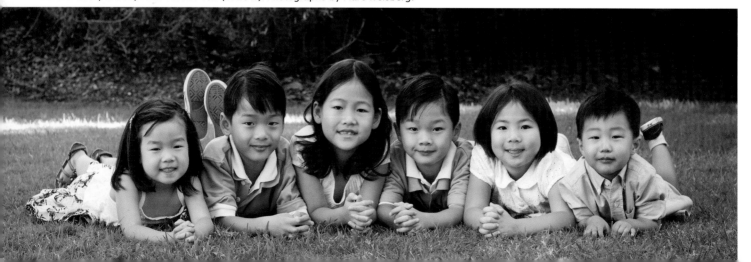

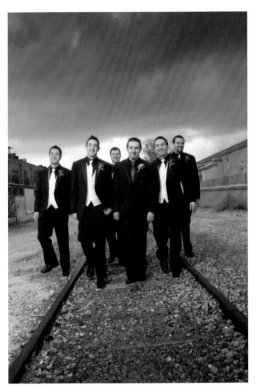

PLATE 403. Photograph by Alyn Stafford.

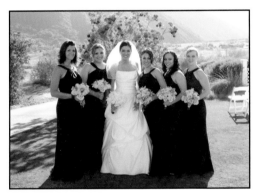

PLATE 404. Photograph by Alyn Stafford.

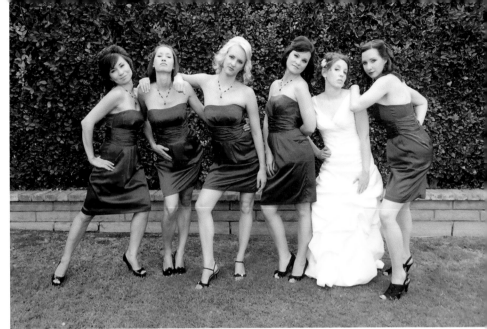

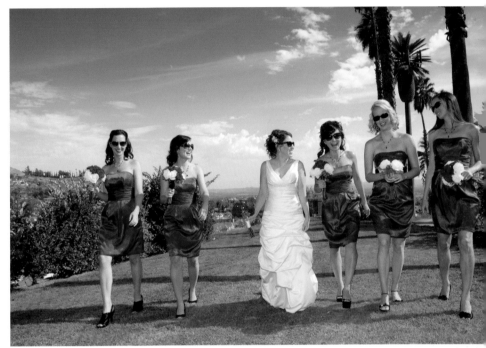

PLATE 405 (TOP RIGHT).
Photograph by Alyn Stafford.

PLATE 406 (CENTER RIGHT).
Photograph by Alyn Stafford.

PLATE 407 (BOTTOM RIGHT).
Photograph by Damon Tucci.

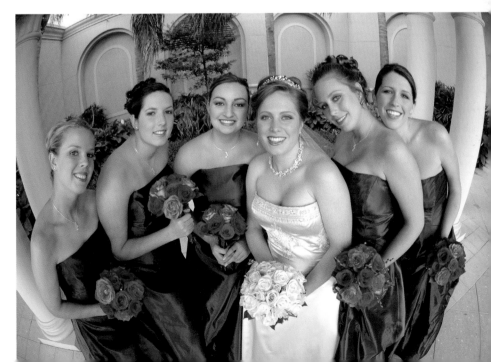

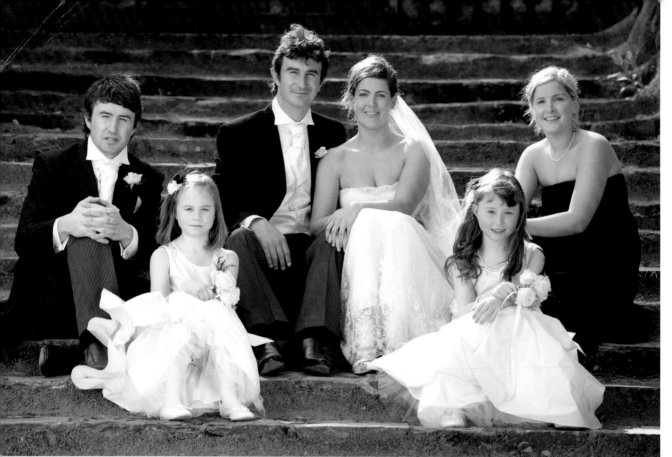

PLATE 408.
Photograph
by Brett
Florens.

PLATE 409. Photograph by Brett Florens.

PLATE 410. Photograph by Neil van Niekerk.

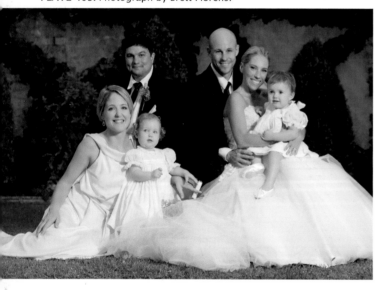

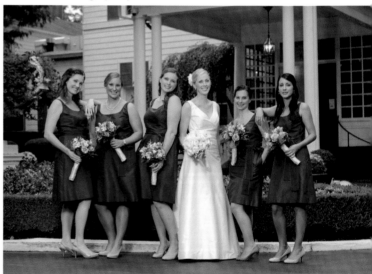

PLATE 411. Photograph by Brett Florens.

PLATE 412. Photograph by Brett Florens.

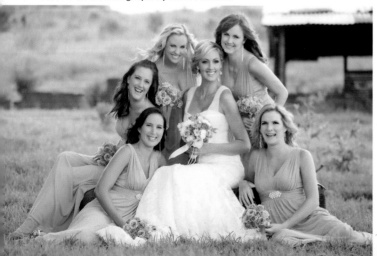

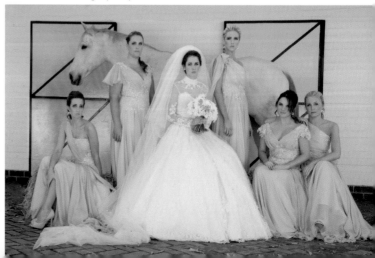

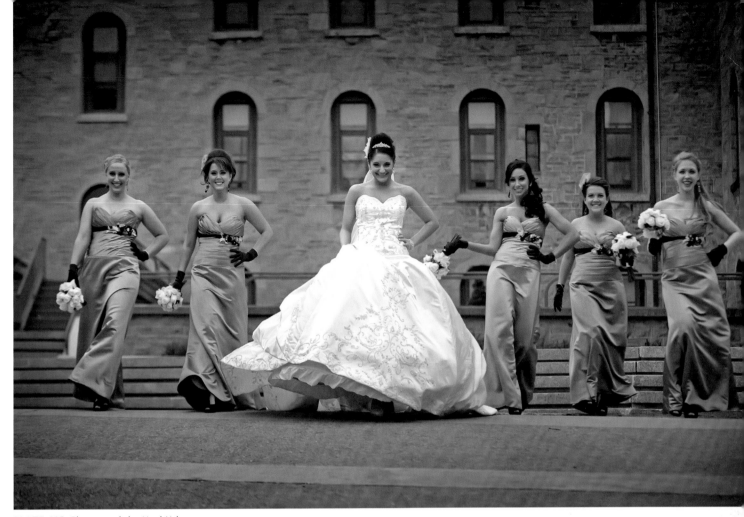

PLATE 413. Photograph by Neal Urban.

PLATE 414. Photograph by Neal Urban.

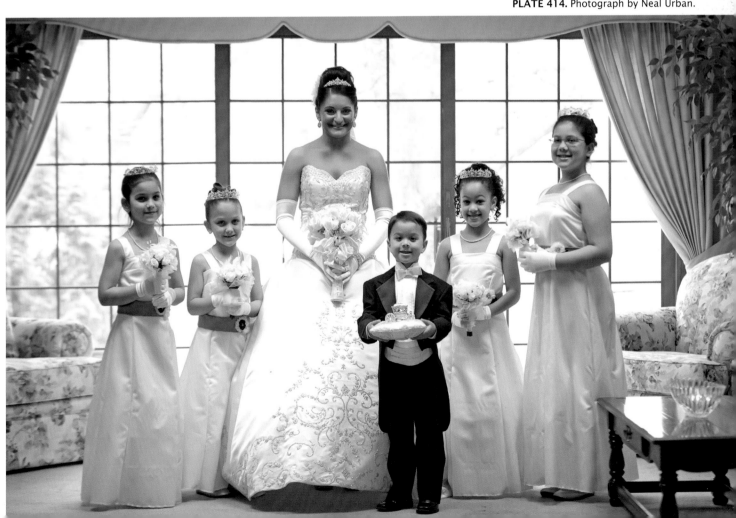

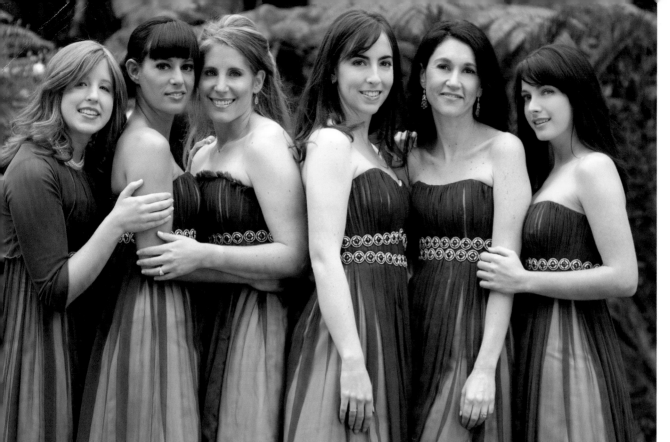

PLATE 415. Photograph by Brett Florens.

PLATE 416. Photograph by Doug Box.

PLATE 417. Photograph by Doug Box.

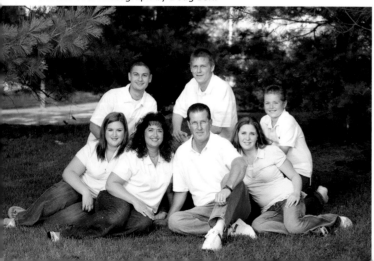

PLATE 418. Photograph by Doug Box.

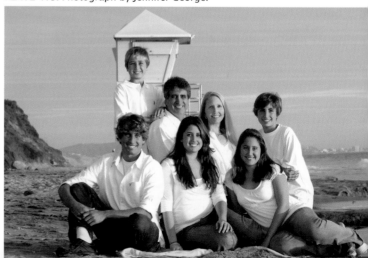

PLATE 419. Photograph by Jennifer George.

PLATE 420. Photograph by Christie Mumm.

PLATE 421. Photograph by Jennifer George.

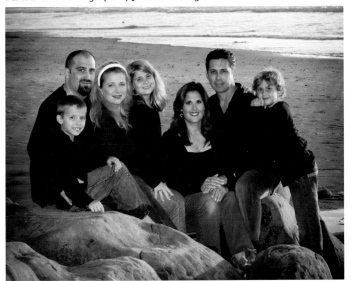

PLATE 422. Photograph by Krista Smith.

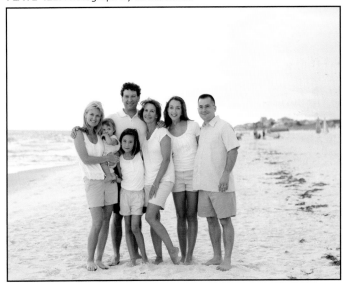

PLATE 423. Photograph by Jennifer George.

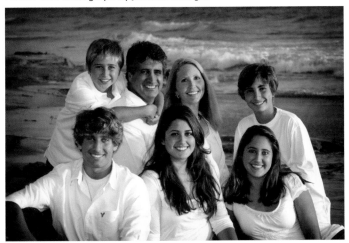

PLATE 424. Photograph by Krista Smith.

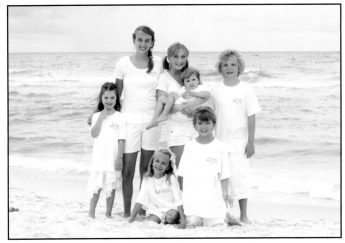

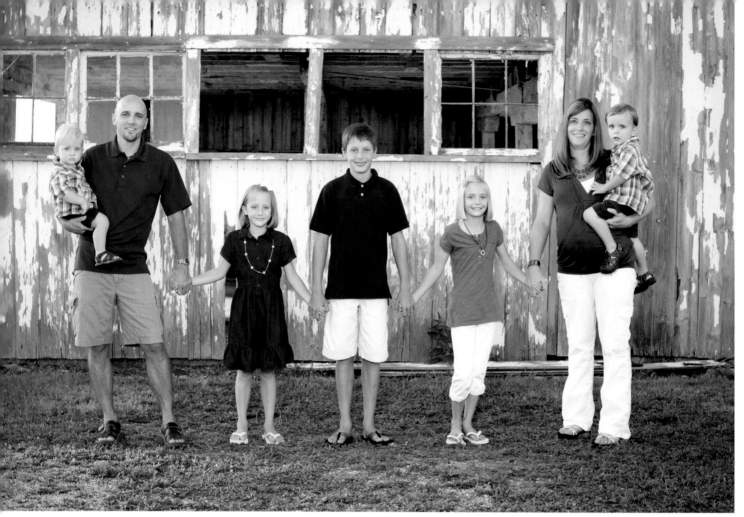

PLATE 425. Photograph by Ryan Klos.

PLATE 426. Photograph by Brett Florens.

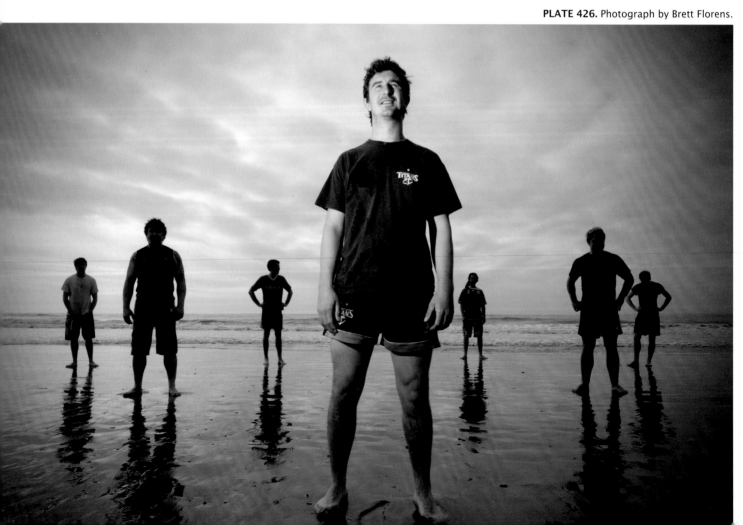

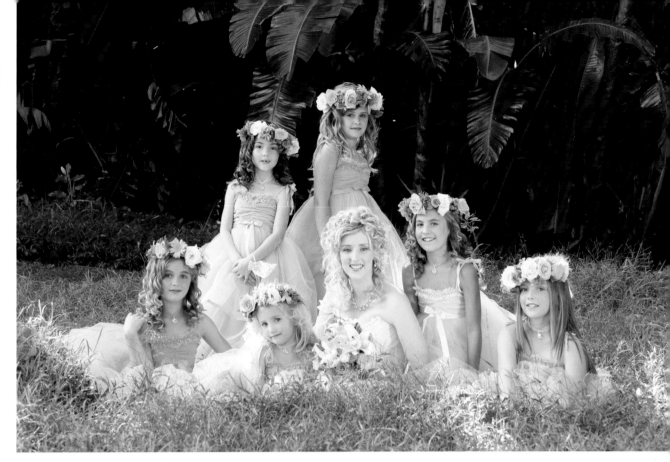

PLATE 427. Photograph by Brett Florens.

PLATE 428. Photograph by Brett Florens.

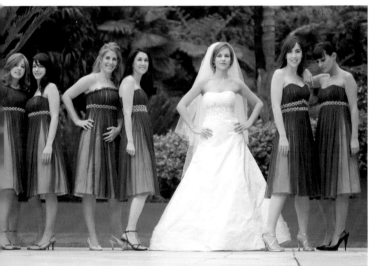

PLATE 429. Photograph by Brett Florens.

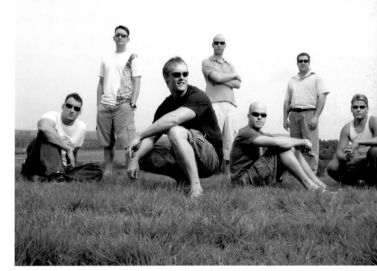

PLATE 430. Photograph by Brett Florens.

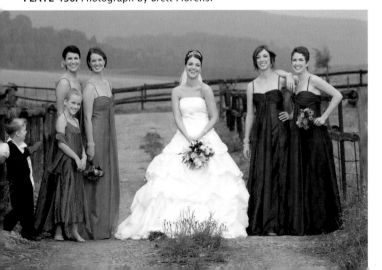

PLATE 431. Photograph by Brett Florens.

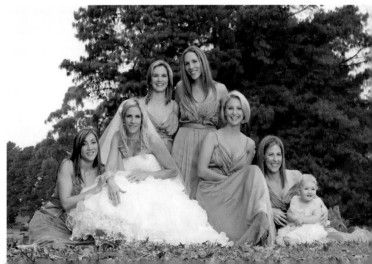

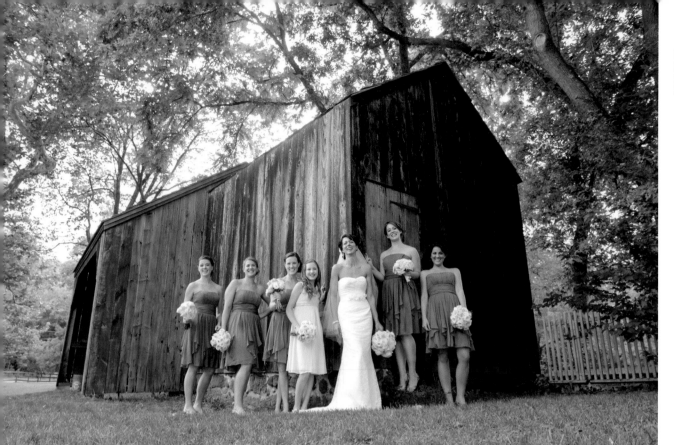

PLATE 432.
Photograph
by Neil van
Niekerk.

PLATE 433. Photograph by Damon Tucci.

PLATE 434. Photograph by Alyn Stafford.

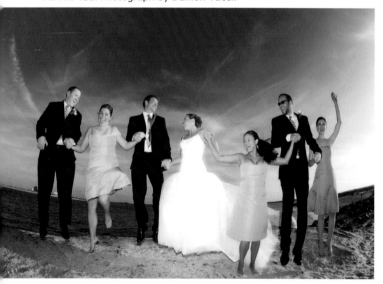

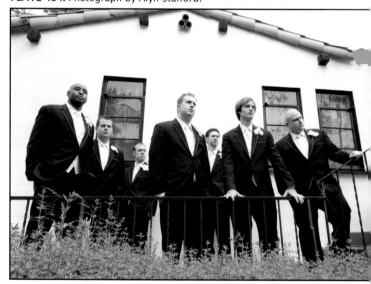

PLATE 435. Photograph by Alyn Stafford.

PLATE 436. Photograph by Neil van Niekerk.

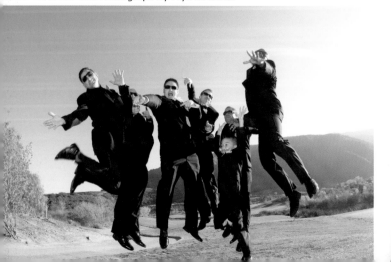

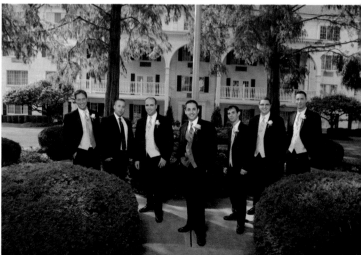

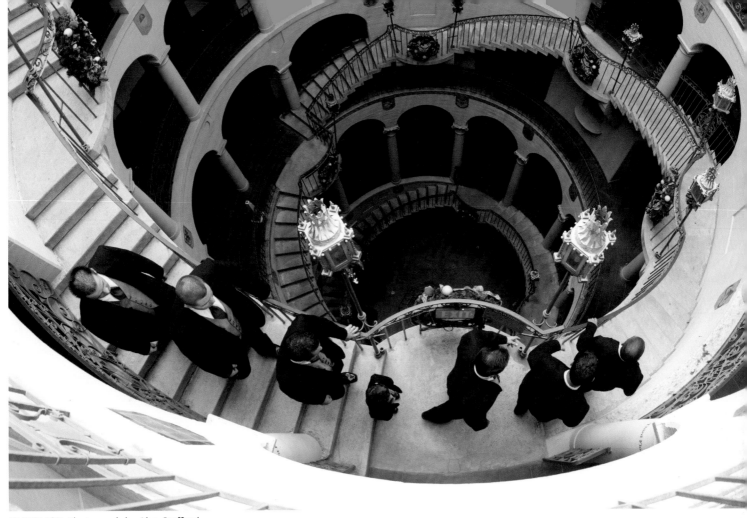

PLATE 437. Photograph by Alyn Stafford.

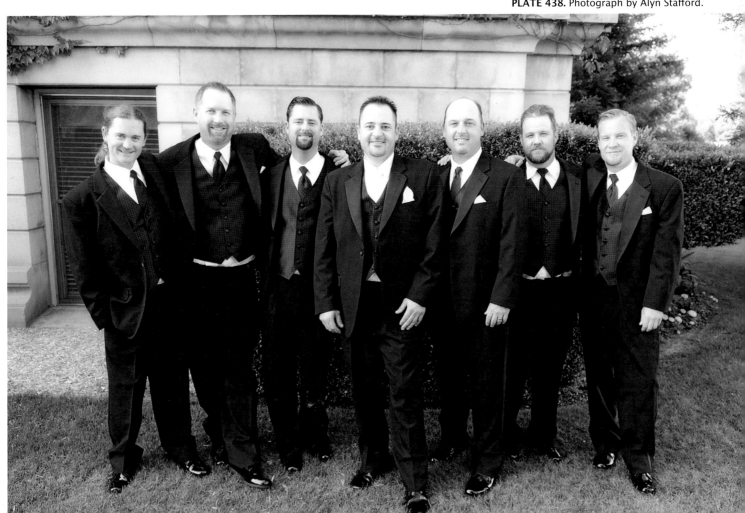

PLATE 438. Photograph by Alyn Stafford.

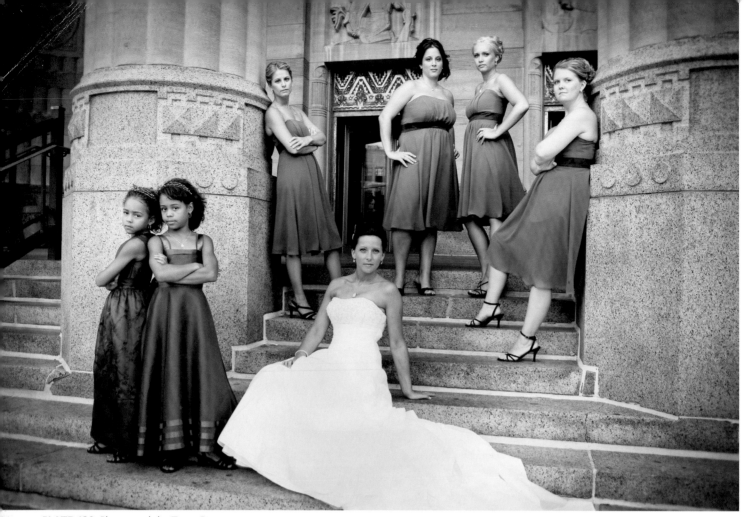

PLATE 439. Photograph by Tracy Dorr.

PLATE 440. Photograph by Tracy Dorr.

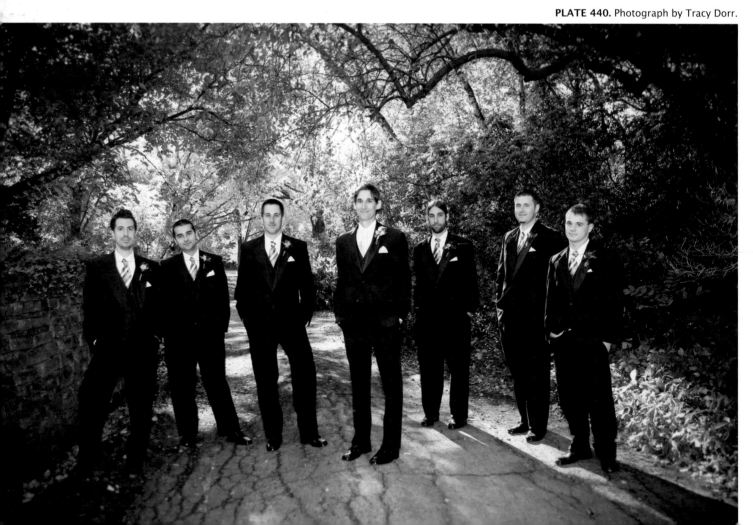

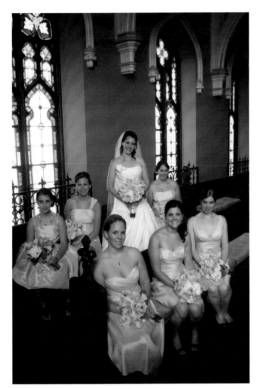

PLATE 441. Photograph by Tracy Dorr.

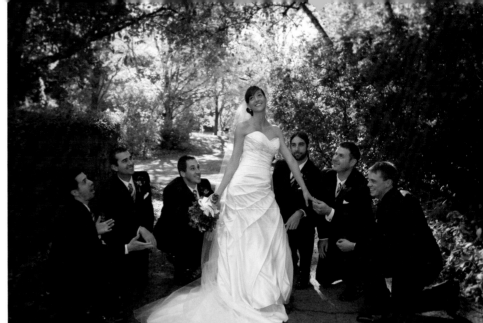

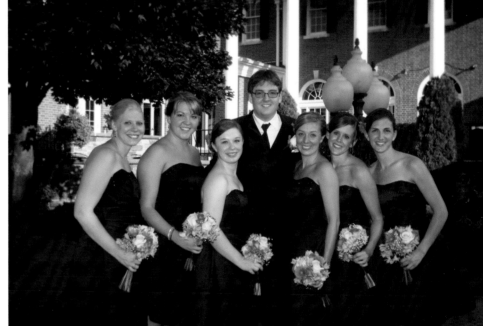

PLATE 442 (TOP RIGHT).
Photograph by Tracy Dorr.

PLATE 443 (CENTER RIGHT).
Photograph by Tracy Dorr.

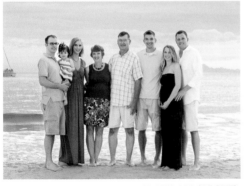

PLATE 444 (ABOVE).
Photograph by Krista Smith.

PLATE 445 (BOTTOM RIGHT).
Photograph by Jennifer George.

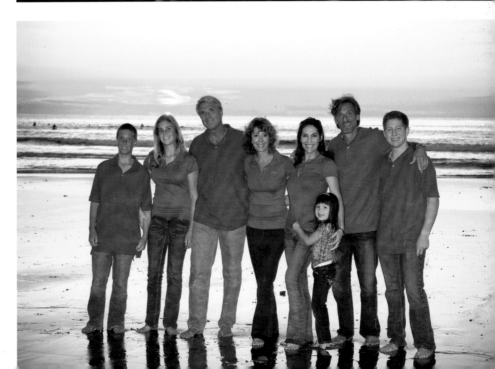

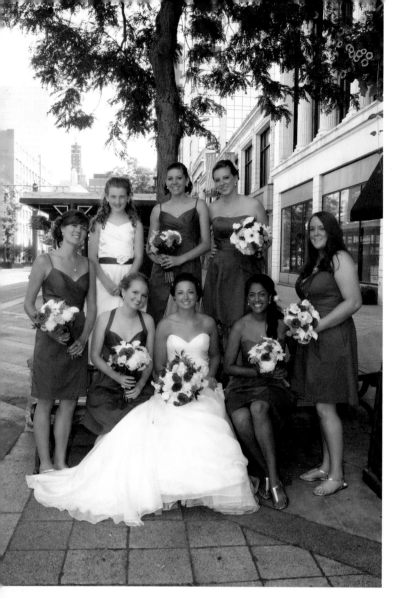

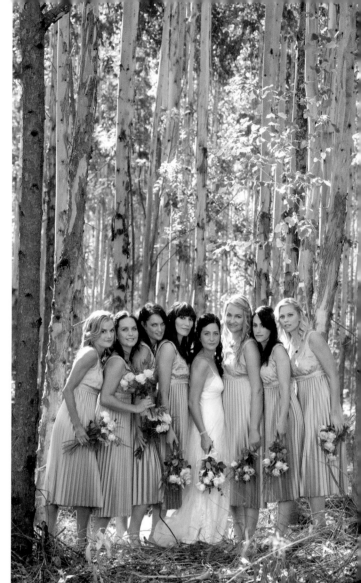

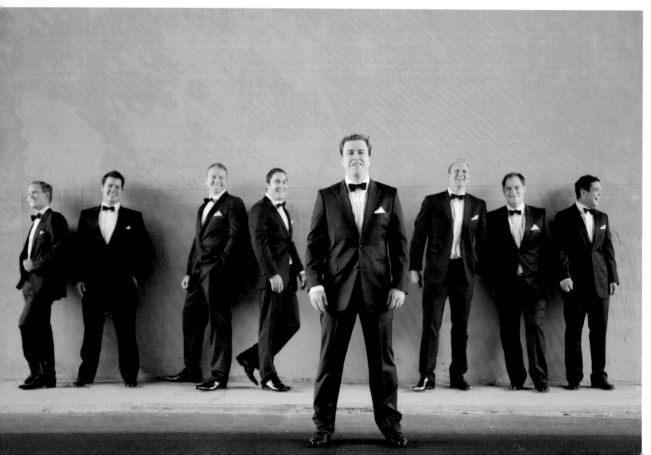

PLATE 446
(TOP LEFT).
Photograph by
Tracy Dorr.

PLATE 447
(TOP RIGHT).
Photograph by
Brett Florens.

PLATE 448
(LEFT).
Photograph by
Brett Florens.

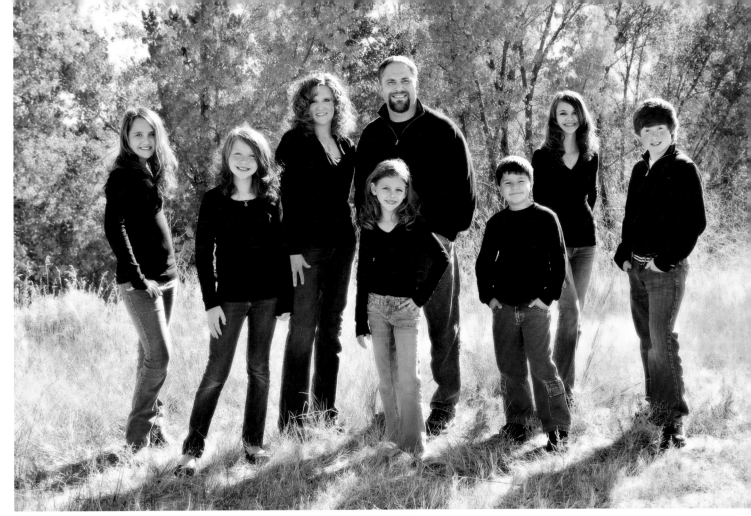

PLATE 449. Photograph by Allison Earnest.

PLATE 450. Photograph by Brett Florens.

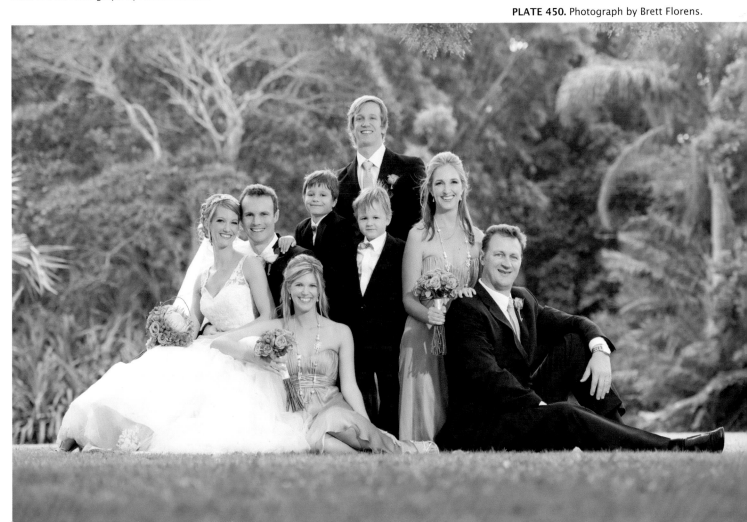

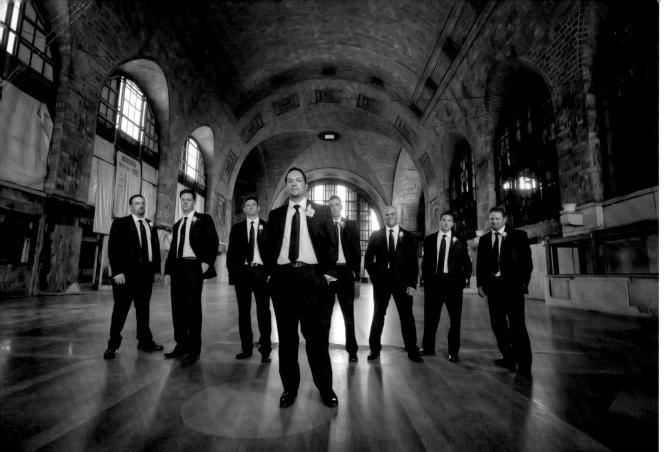

PLATE 451. Photograph by Neal Urban.

PLATE 452. Photograph by Damon Tucci.

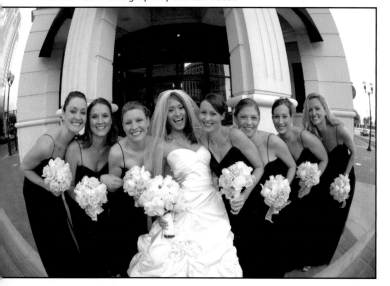

PLATE 453. Photograph by Neil van Niekerk.

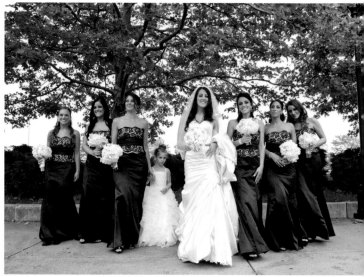

PLATE 454. Photograph by Tracy Dorr.

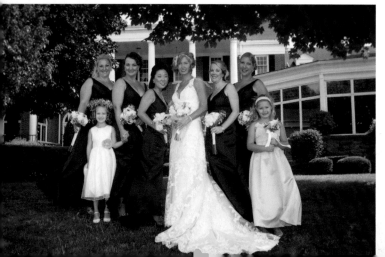

PLATE 455. Photograph by Damon Tucci.

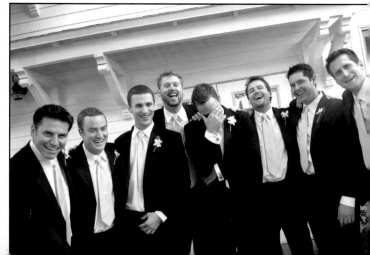

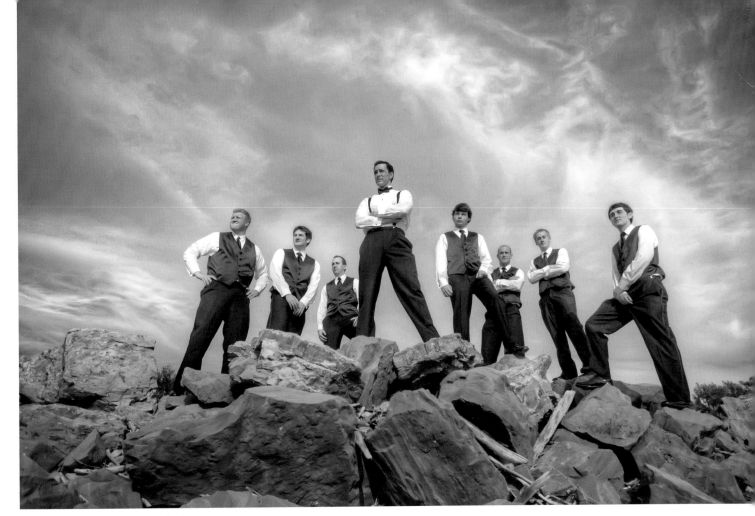

PLATE 456. Photograph by Neal Urban.

PLATE 457. Photograph by Neil van Niekerk.

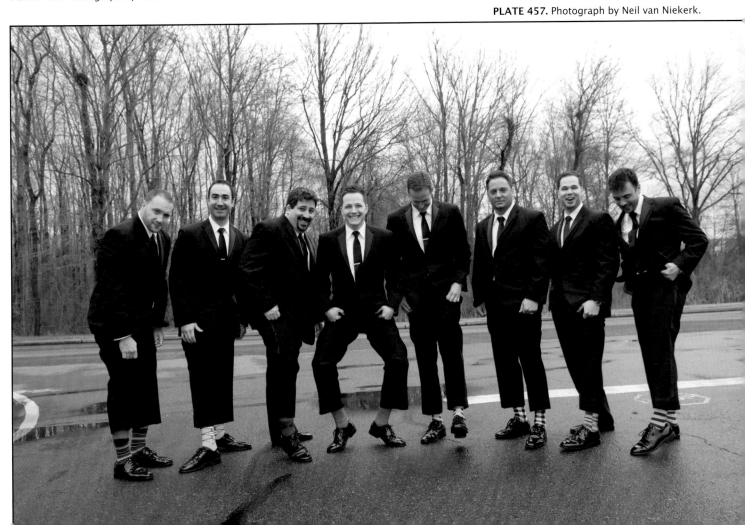

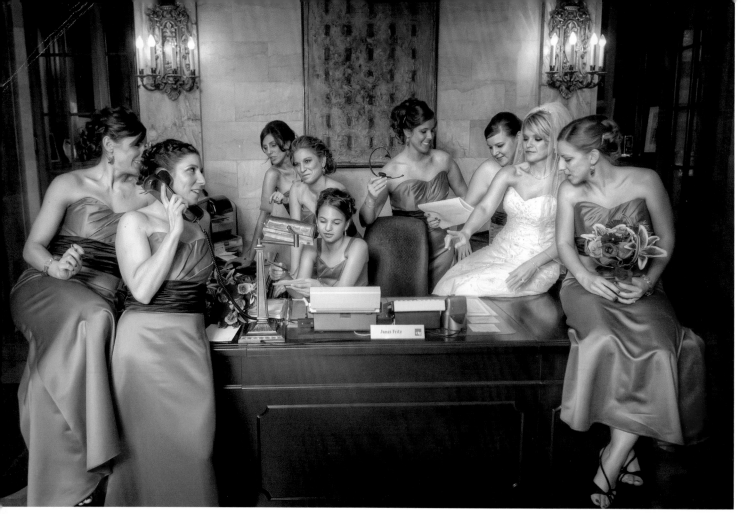

PLATE 458. Photograph by Neal Urban.

PLATE 459. Photograph by Neil van Niekerk.

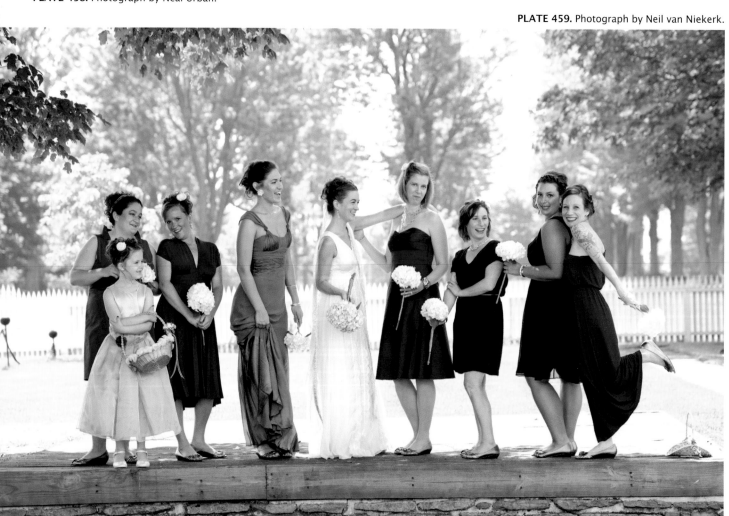

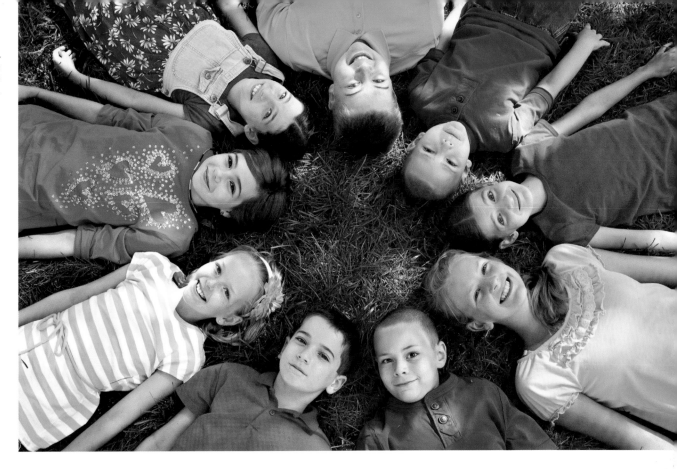

PLATE 460. Photograph by Allison Earnest.

PLATE 461. Photograph by Allison Earnest.

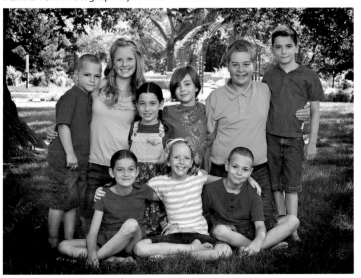

PLATE 462. Photograph by Tracy Dorr.

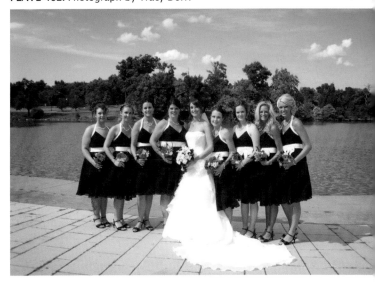

PLATE 463. Photograph by James Williams.

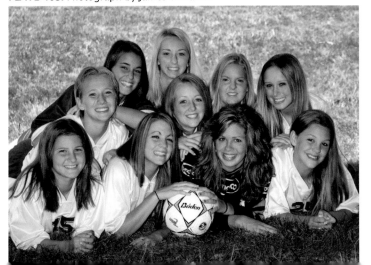

PLATE 464. Photograph by James Williams.

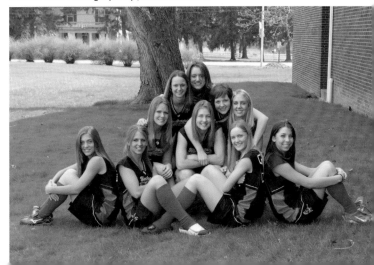

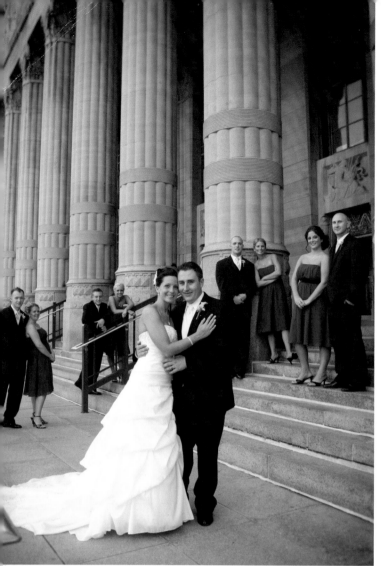

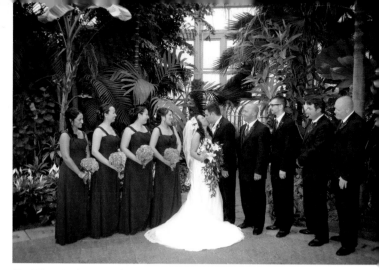

PLATE 466. Photograph by Tracy Dorr.

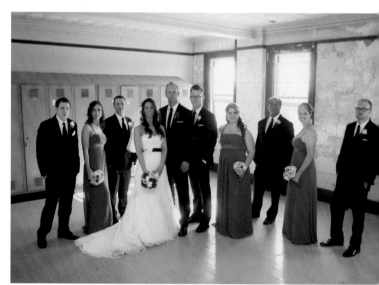

PLATE 465. Photograph by Tracy Dorr.

PLATE 467. Photograph by Tracy Dorr.

PLATE 468. Photograph by Alyn Stafford.

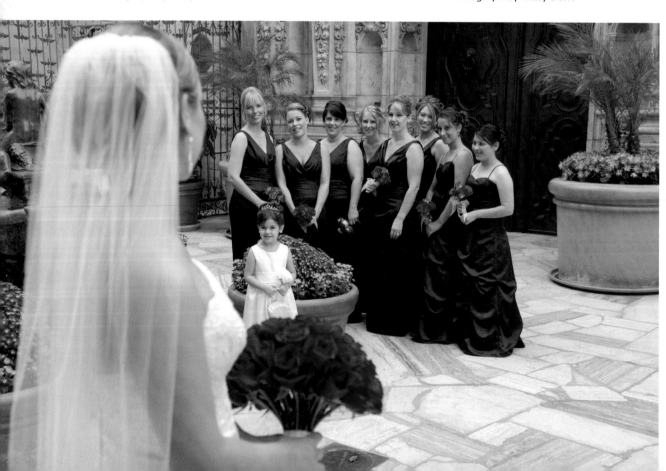

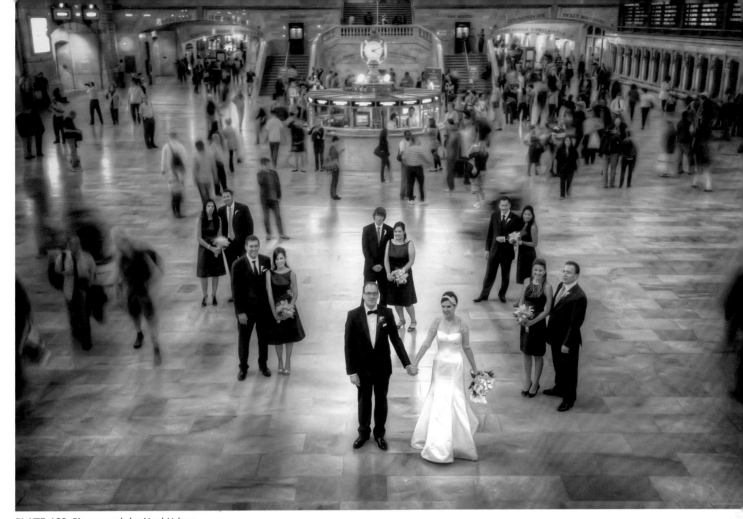

PLATE 469. Photograph by Neal Urban.

PLATE 470. Photograph by Brett Florens.

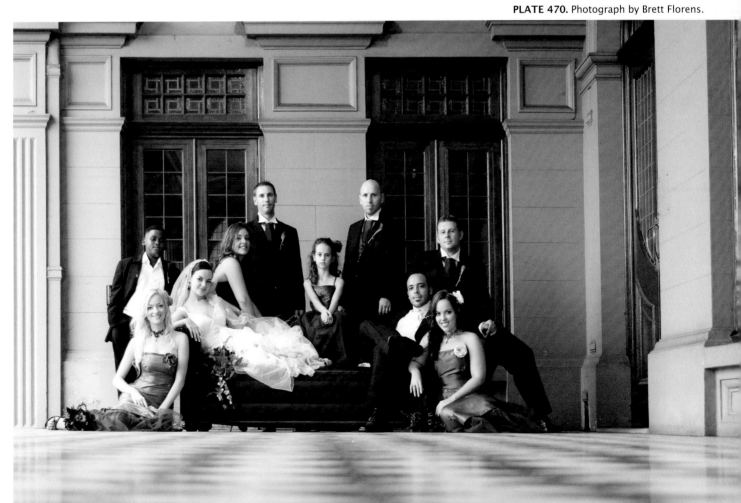

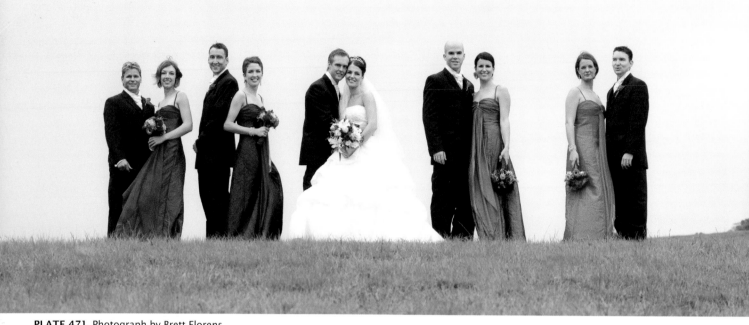

PLATE 471. Photograph by Brett Florens.

PLATE 472. Photograph by Tracy Dorr.

PLATE 473. Photograph by Tracy Dorr.

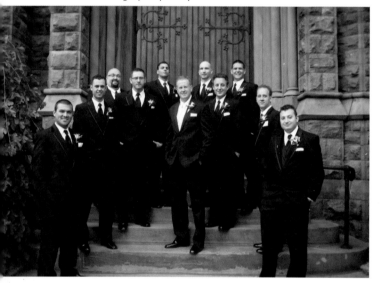

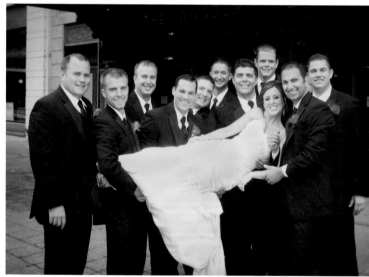

PLATE 474. Photograph by Brett Florens.

PLATE 475. Photograph by Brett Florens.

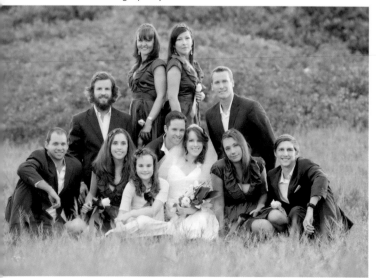

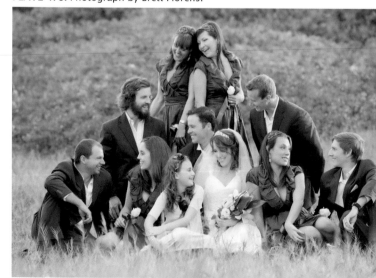

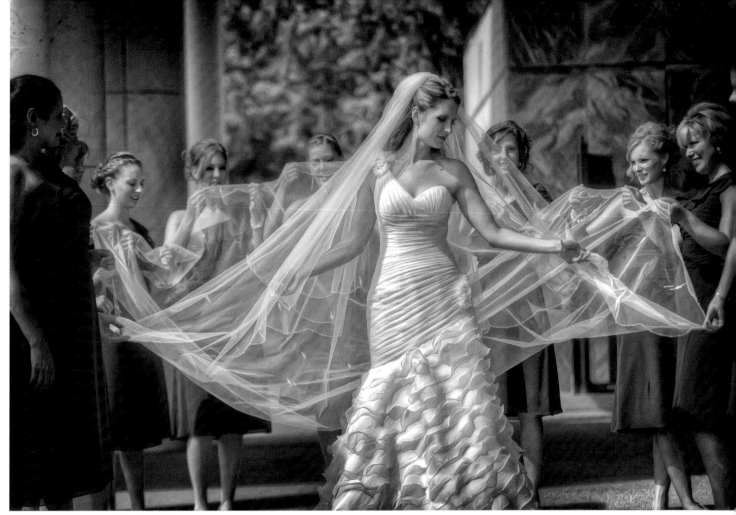

PLATE 476. Photograph by Neal Urban.

PLATE 477. Photograph by Brett Florens.

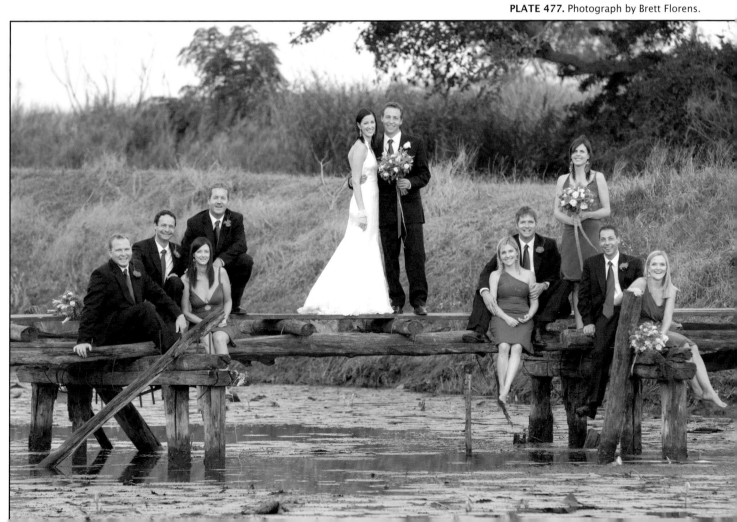

PLATE 478.
Photograph
by Brett
Florens.

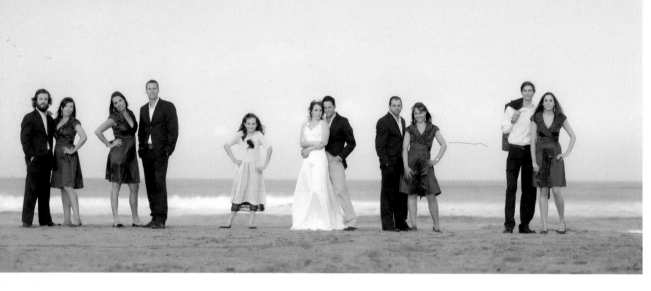

PLATE 479. Photograph by Brett Florens.

PLATE 480. Photograph by Allison Earnest.

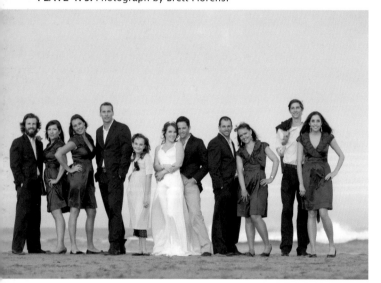

PLATE 481. Photograph by James Williams.

PLATE 482. Photograph by James Williams.

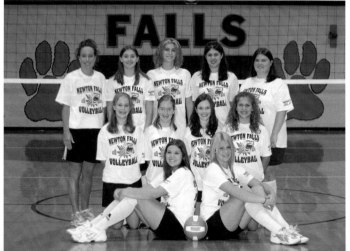

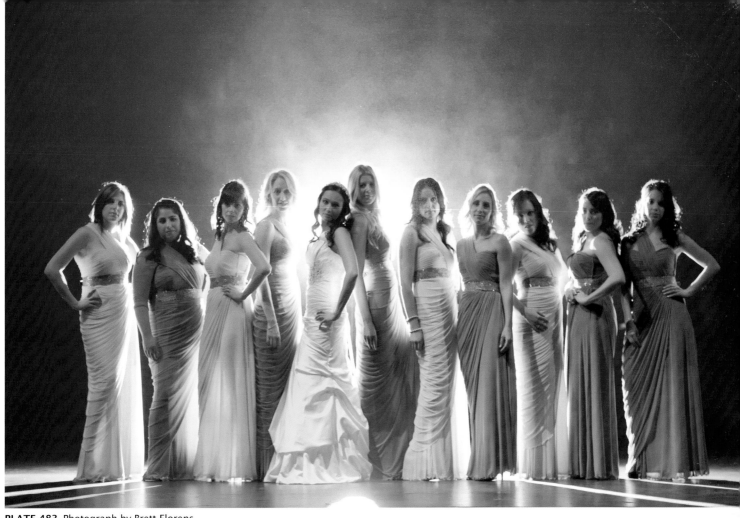

PLATE 483. Photograph by Brett Florens.

PLATE 484. Photograph by Brett Florens.

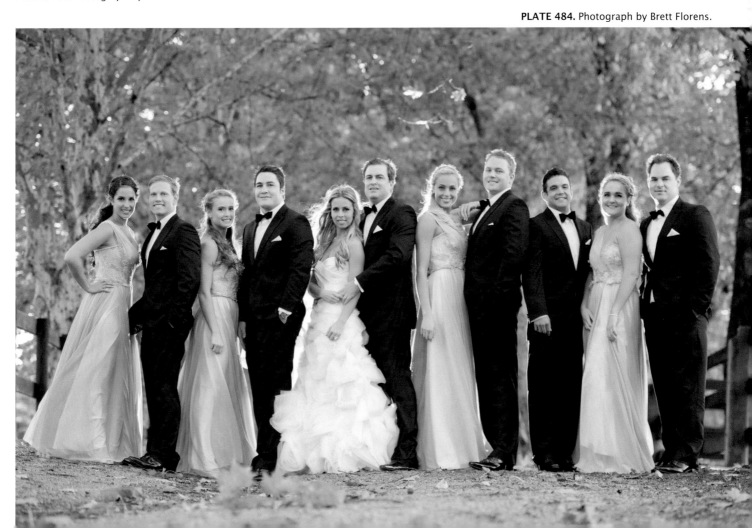

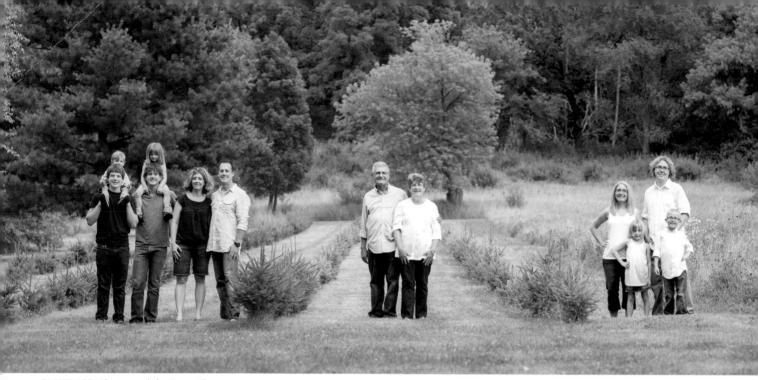

PLATE 485. Photograph by Ryan Klos.

PLATE 486. Photograph by Tracy Dorr.

PLATE 487. Photograph by Neal Urban.

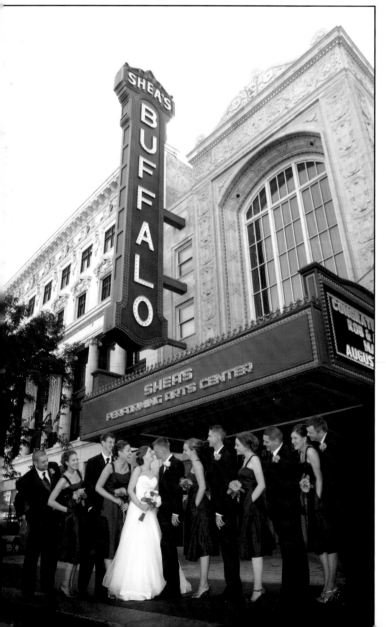

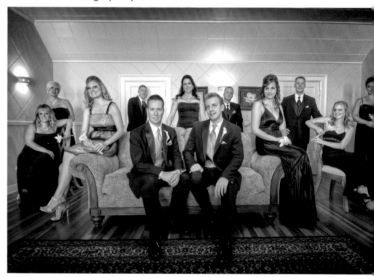

PLATE 488. Photograph by Tracy Dorr.

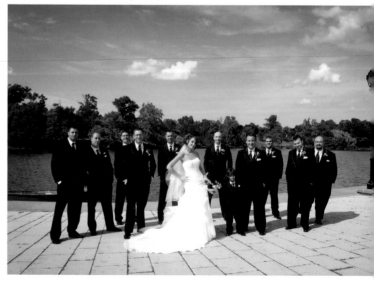

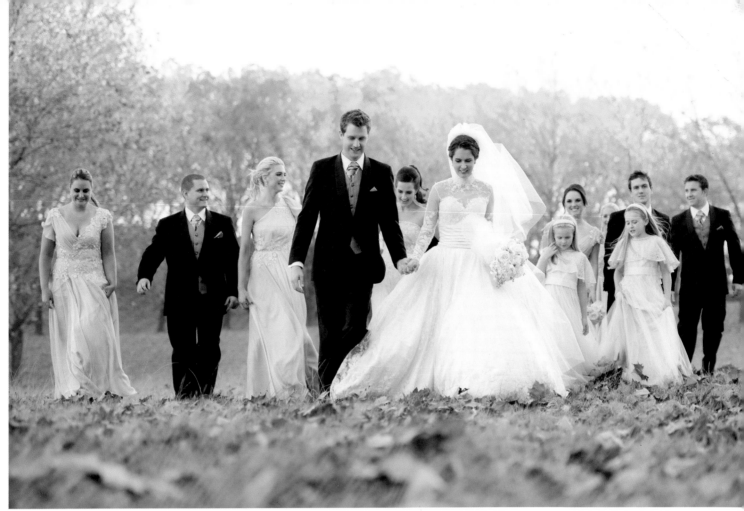

PLATE 489. Photograph by Brett Florens.

PLATE 490. Photograph by Ryan Klos.

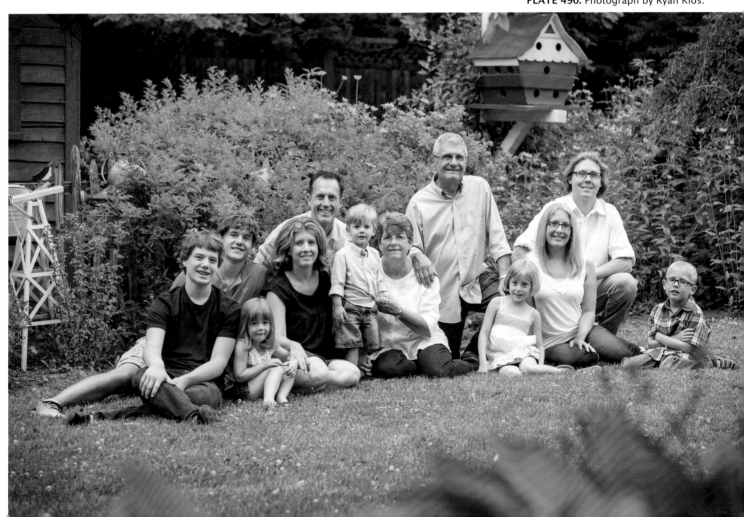

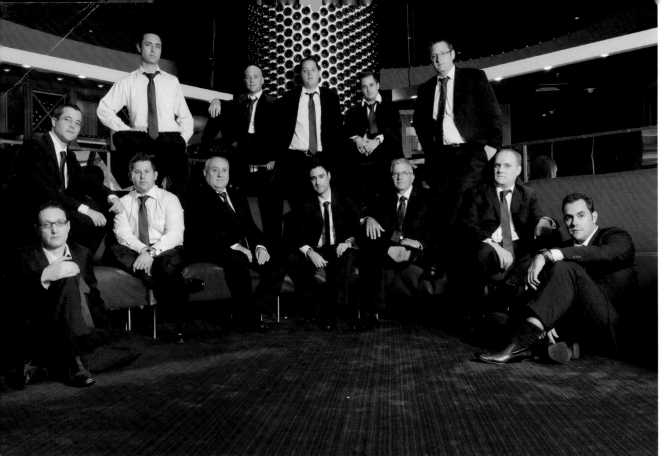

PLATE 491.
Photograph by Brett Florens.

PLATE 492. Photograph by Damon Tucci.

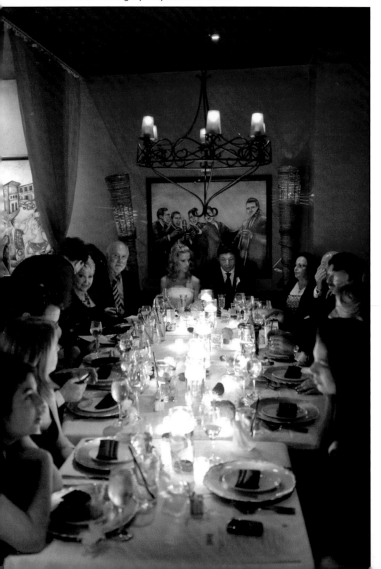

PLATE 493. Photograph by Ellie Vayo.

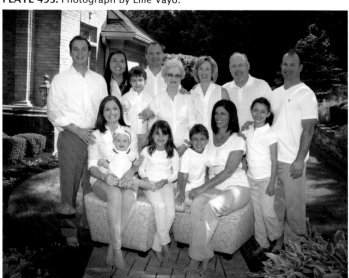

PLATE 494. Photograph by James Williams.

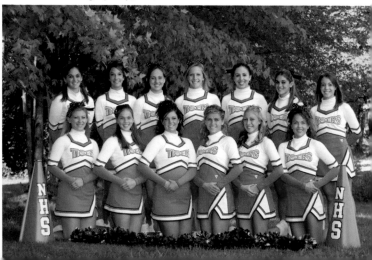

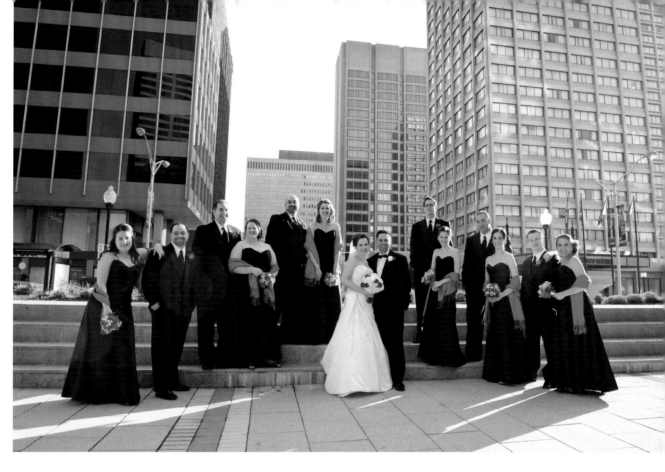

PLATE 495. Photograph by Neil van Niekerk.

PLATE 496. Photograph by Brett Florens.

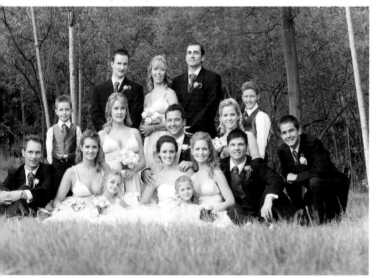

PLATE 497. Photograph by Tracy Dorr.

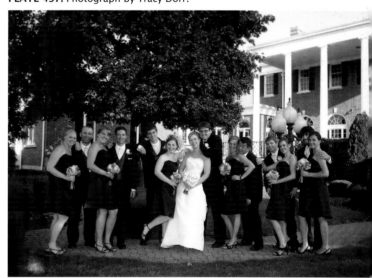

PLATE 498. Photograph by Damon Tucci.

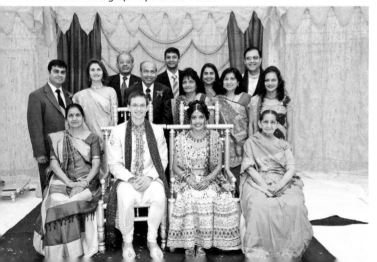

PLATE 499. Photograph by James WIlliams.

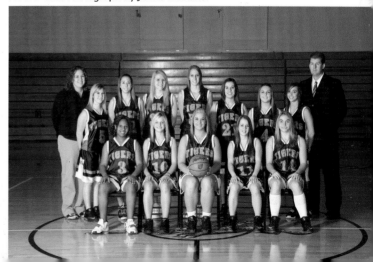

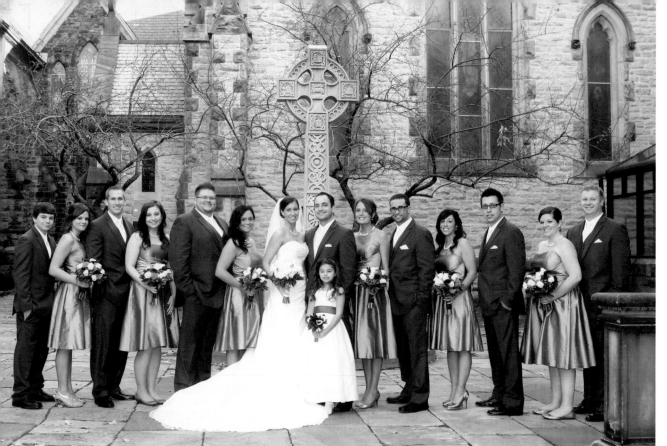

PLATE 500.
Photograph
by Tracy
Dorr.

PLATE 501. Photograph by Tracy Dorr.

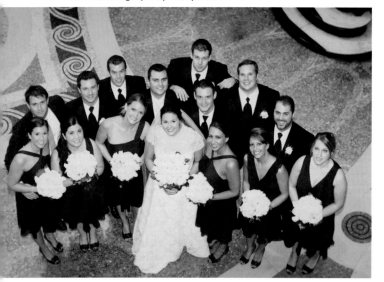

PLATE 502. Photograph by James Williams.

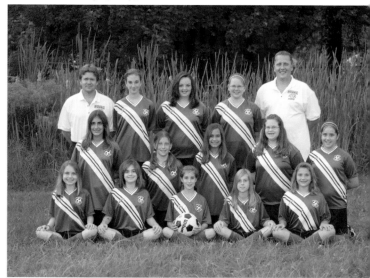

PLATE 503. Photograph by James Williams.

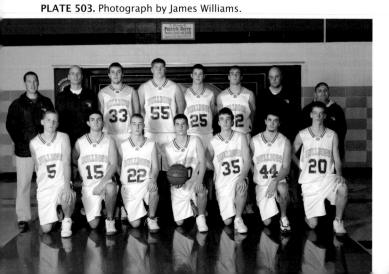

PLATE 504. Photograph by James Williams.

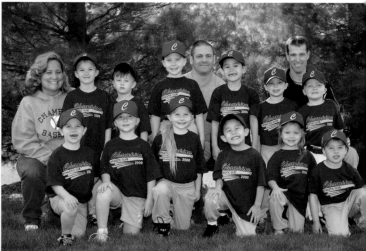

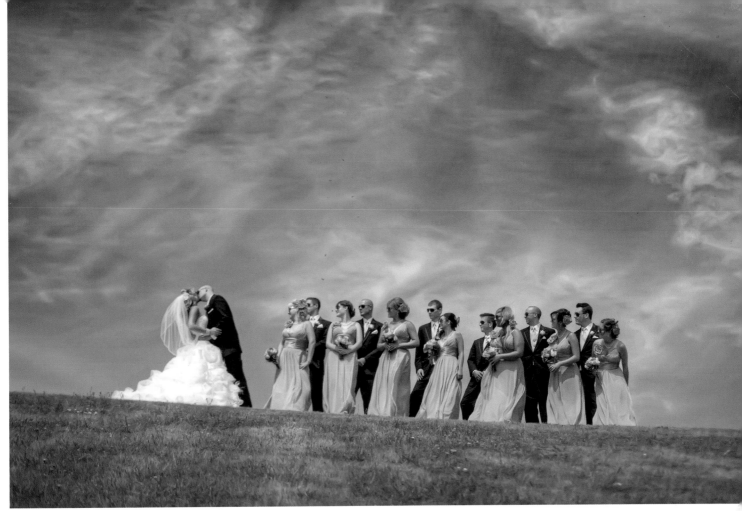

PLATE 505. Photograph by Neal Urban.

PLATE 506. Photograph by Brett Florens.

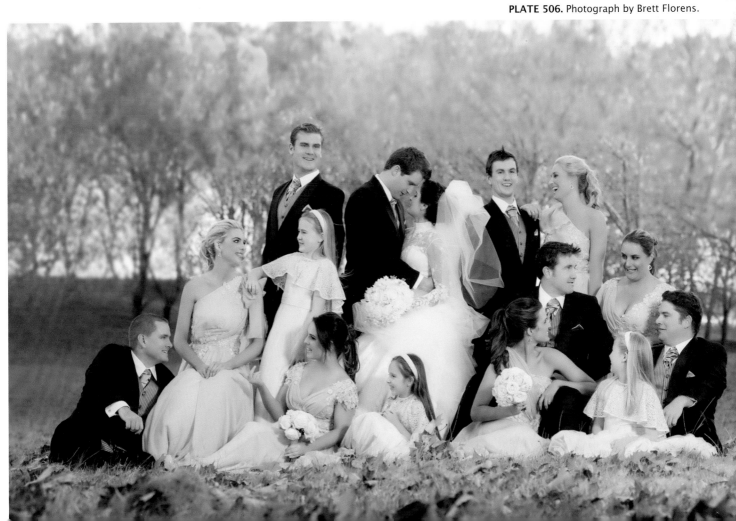

PLATE 507.
Photograph
by Alyn
Stafford.

PLATE 508. Photograph by Jennifer George.

PLATE 509. Photograph by Jennifer George.

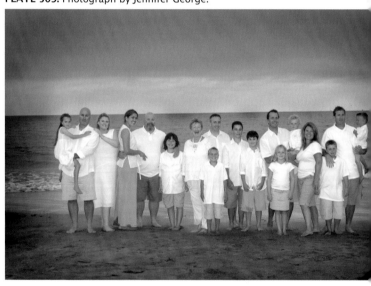

PLATE 510. Photograph by James Williams.

PLATE 511. Photograph by James Williams.

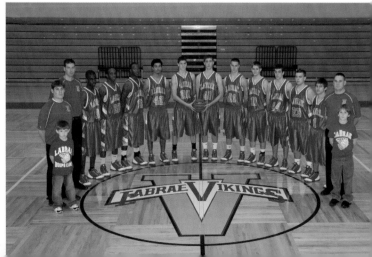

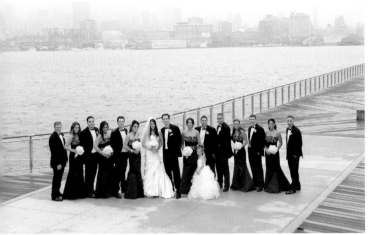

PLATE 512. Photograph by Neil van Niekerk.

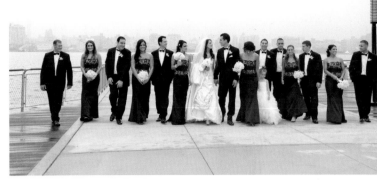

PLATE 513. Photograph by Neil van Niekerk.

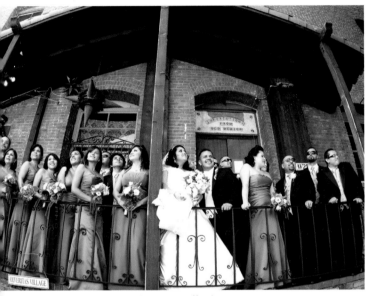

PLATE 514. Photograph by Alyn Stafford.

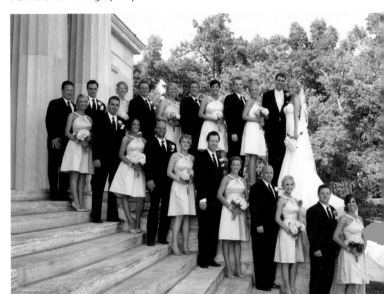

PLATE 515. Photograph by Tracy Dorr.

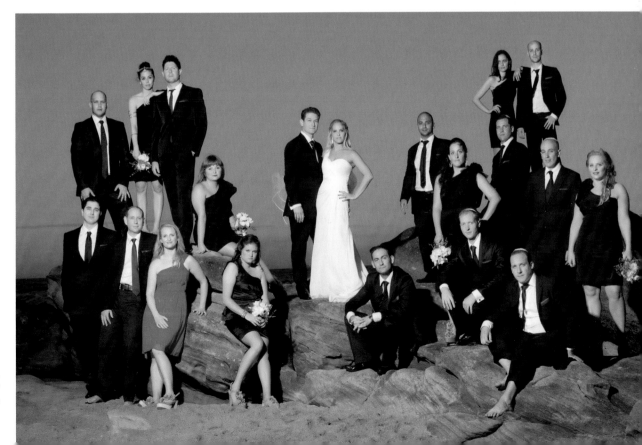

PLATE 516.
Photograph by
Brett Florens.

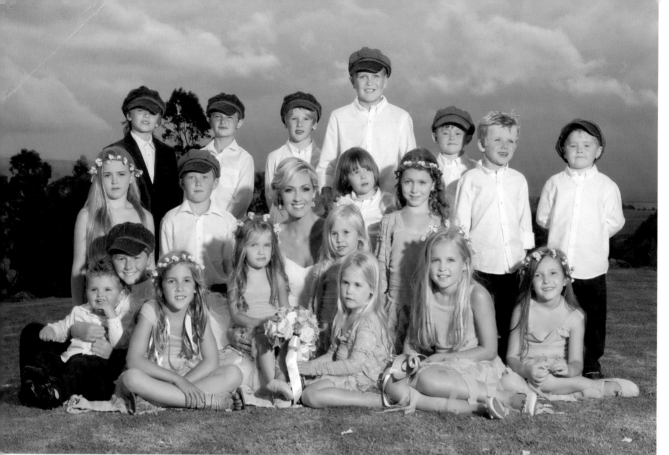

PLATE 517. Photograph by Brett Florens.

PLATE 518. Photograph by James Williams.

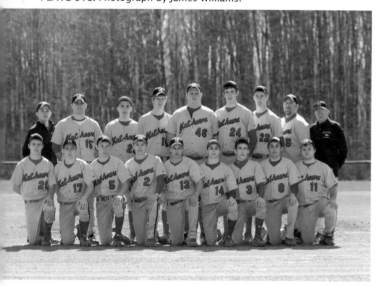

PLATE 519. Photograph by Doug Box.

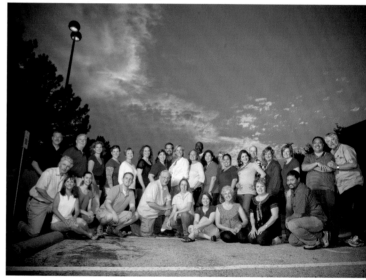

PLATE 520. Photograph by Doug Box.

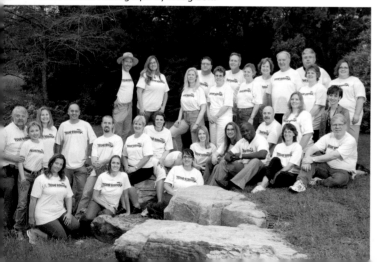

PLATE 521. Photograph by Damon Tucci.

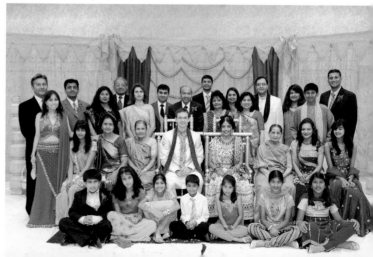

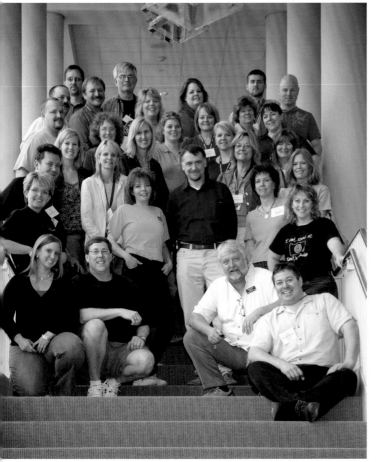

PLATE 522. Photograph by Doug Box.

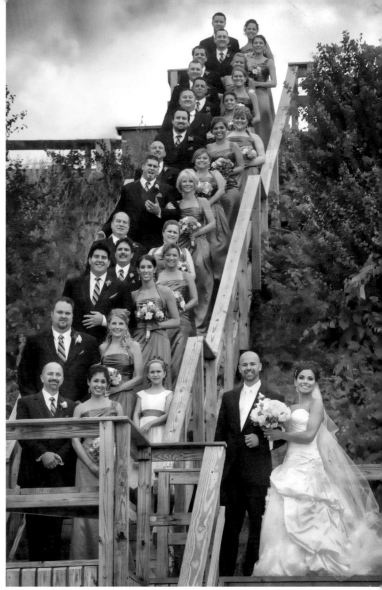

PLATE 523. Photograph by Neal Urban.

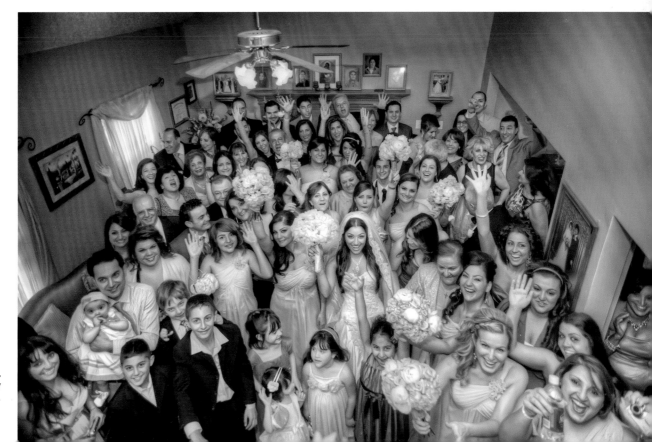

PLATE 524.
Photograph by
Neal Urban.

Posing Fundamentals

This section covers the fundamental rules of traditional posing—techniques that are illustrated in many of the images that appear in this book. While these rules are often intentionally broken by contemporary photographers, most are cornerstones for presenting the human form in a flattering way.

FACIAL VIEWS

In group portraits, the facial views of the subjects may be identical or mixed. In portraits with a larger number of subjects, controlling the fine nuances of the facial views becomes less critical simply because the individual faces become smaller in the frame. For small groups, particularly in shorter portrait lengths, the facial view should be more carefully selected and controlled.

Full-Face View. In a full-face view, the subject's nose is pointed directly at the camera for a very symmetrical look.

Seven-Eighths View. For this type of portrait, the subject's face is turned slightly away from the camera, but both ears are still visible.

Three-Quarters or Two-Thirds View. In these portraits, the subject's face is angled enough that the far ear is hidden from the camera's view. In this pose, the far eye may appear slightly smaller because it is farther away from the camera than the other eye. The head should not be turned so far that the tip of the nose extends past the line of the cheek or that the bridge of the nose obscures the far eye.

Profile View. To create a profile, the subject's head is turned 90 degrees to the camera so that only one eye is visible.

THE SHOULDERS

Traditionally, the subject's shoulders are best posed at an angle to the camera. This is because having the shoulders face the camera directly makes the person look wider than he or she really is and can yield a static composition.

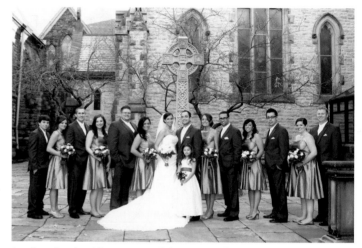

Angling the shoulders in toward the center of the frame helps contain the composition. Photograph by Tracy Dorr.

In larger group portraits, angling the shoulders to the camera helps subjects be positioned in closer proximity. Turning all of the subjects toward the center of the frame also helps contain the composition, drawing the viewer's eye into the group.

THE HEAD

Tilting the Head. Tilting the head slightly produces diagonal lines that help poses feel more dynamic. This is another nuance of posing that will be more important (and more feasible to achieve) in small group portraits than in larger groupings.

Eyes. In almost all portraits, the eyes are the most important part of the face. If the eyes will be very visible (as in a small group portrait shot in a head-and-shoulders length), strive to have the eyelids border the iris. Turning the face slightly away from the camera and directing the subject's eyes back toward the camera reveals more of the white of the eye, making the eyes look larger.

In larger group portraits, the objective will be to ensure the subjects' eyes are all open, directed at the camera (in most cases), and in focus.

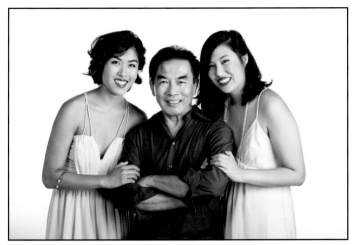

Notice how the pose of the subjects' arms unites them and creates a line that draws your eye into the frame. Photograph by Marc Weisberg.

ARMS

The subjects' arms should not be allowed to hang at their sides. Simply bending the elbows creates appealing diagonal lines in your composition—and placing these lines carefully can help direct the viewer to each subject's face. Having subjects put their hands in their pockets or rest them on their hips immediately produces this effect.

HANDS

Especially in large groups, the number of hands can seem overwhelming when viewed in the final composition. If the hands can't be posed in a way that looks natural and unobtrusive, consider hiding them. Hands can be tucked into pockets, obscured behind other subjects, or even hidden behind bouquets (as in bridal-party portraits).

LEGS

Whether the subjects are standing or seated, the legs look best when they are posed independently rather than identically. This is especially the case in full-length portraits of small groups. In larger groups, it is less of a concern.

BUILDING GROUPS

The easiest way to approach building a group-portrait pose is to identify one or two key people to serve as the anchors. In a family portrait, this might be the parents or, for newborn sessions, the baby. In wedding images, the core could be the bride, the groom, or the couple together. In business portraits, the head of the company or department would likely be the core subject. The other people in the portrait can then be arranged around this core.

When positioning subjects, it is best to avoid placing the subjects' faces in a straight line across the frame. Instead, differ the head heights by combining standing subjects with seated and/or kneeling subjects. It can also be helpful to look for posing aids in your environment. Staircases, ledges, benches, and even sloped terrains can be extremely helpful when designing group poses.

In most cases, you should strive to keep the faces in the group roughly equidistant. Large gaps or uneven placement tend to destroy the look of unity in the group—and if one subject is physically distant from the others, he or she may look like the black sheep of the group. One exception to this would be when intentionally defining the nuclear families within an extended family portrait; in this case, subtle spaces between the subgroups can help define the makeup of the family. Another good reason for uneven spacing would be to emphasize one member of the group. For example, a bride might be posed at a distance from a group of bridesmaids to emphasize her prominence in the event.

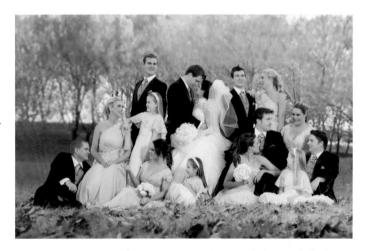

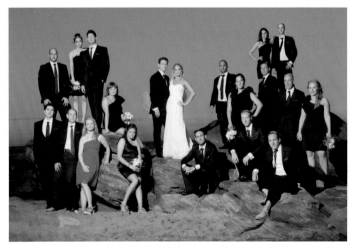

Even spacing creates a unified look (top). Leaving some space around the bride and groom puts the emphasis on them (bottom). Photographs by Brett Florens.

The Photographers

Doug Box—*www.dougbox.com*

Doug is a member of the Camera Craftsmen of America and the author of several books, including *Doug Box's Available Light Photography* and *Doug Box's Flash Photography* (Amherst Media®). He is the owner of Texas Photographic Workshops, an internationally recognized educational facility where he hosts photographers from around the country, teaching all levels of photography. For more information on Doug, go to www.texasphotographicworkshops.com. From there, you can sign up for his free e-newsletter and browse through lots of free information.

Mimika Cooney

www.mimikacooney.com

Mimika Cooney is an award-winning photographer with a maternity, baby, and glamour portrait studio in Charlotte, NC. Born in South Africa, Mimika received her photographic training in England and is an accredited licentiate by the British Institute of Professional Photographers and the Society of Wedding and Portrait Photographers. Mimika is the author of *Boutique Baby Photography: The Digital Photographer's Guide to Success in Maternity and Baby Portraiture* (Amherst Media®).

Tracy Dorr

www.tracydorrphotography.com

Tracy Dorr is the author of *Advanced Wedding Photojournalism: Professional Techniques for Digital Photographers*, *Engagement Portraiture: Master Techniques for Digital Photographers*, and a forthcoming book on props for portrait photography (all from Amherst Media®). She holds a BA in English/Photography from the State University of New York at Buffalo and won three Awards of Excellence from WPPI. She was a Master Class teacher at the WPPI convention in Las Vegas and has contributed to several other books in the *500 Poses* series by Michelle Perkins (Amherst Media®).

Allison Earnest

www.allisonearnestphotography.com

Allison is a Pro Contributor for Lexar Media and writes articles for *PPA Magazine*. She holds a BS in Business Management from the University of Maryland and currently teaches her Sculpting with Light® lighting techniques at universities and lighting workshops throughout the United States. She is the author of *Sculpting with Light®: Techniques for Portrait Photographers*, *The Digital Photographer's Guide to Light Modifiers: Techniques for Sculpting with Light®* and *Lighting for Product Photography* (Amherst Media®).

Brett Florens—*www.brettflorens.com*

Brett's devotion to photography has taken him from photojournalism in his native South Africa to a highly successful career in wedding, commercial, and fashion photography. He has received numerous accolades along the way, the most recent of which was Nikon recognizing him as one of the world's most influential photographers. Brett frequently travels from South Africa to Europe, Australia, and the United States to photograph the weddings of his discerning, high-end clients. He is the author of *Brett Florens' Guide to Photographing Weddings* and *75 Bridal Portraits by Brett Florens* (Amherst Media®).

Jennifer George

www.jennifergeorgephotography.com

Jennifer George has gained a national reputation for her intimate, stylish portraits, winning numerous national awards. She teaches photography as a guest lecturer at colleges and workshops in the United States and abroad and has been featured in *Professional Photographer*, *Rangefinder*, and *Shutterbug*. Her commercial work has appeared in *Forbes*, *Ranch & Coast*, and *American Photo*. She is the author of *The Digital Photographer's Guide to Natural-Light Family Portraits* and *Photographing the Child* (Amherst Media®).

Ryan Klos—*www.ryanklos.com*

Ryan Klos is a photographer and writer whose career has taken him down a winding creative path working as a graphic designer, photographer, and writer. He has written for *Rangefinder* magazine, WBEZ Chicago Public Radio (NPR), the Lightroom-centric blog X= (www.x-equals.com/blog), and many other publications. He currently runs his own studio, Ryan Klos Photography, which specializes in senior portraits. Ryan lives in Woodstock, IL, with his wife, Monica, and two boys. He is the author of *Backdrops and Backgrounds: A Portrait Photographer's Guide* (Amherst Media®).

Christie Mumm

www.jlmcreative.com

Christie Mumm is the owner of JLM Creative Photography, a small boutique studio in downtown Reno, NV, where she works closely with families to capture lasting memories through lifestyle photography. She has been married to her best friend for over ten years and is the mother of one precocious and creative young daughter. Christie is also the author of *Family Photography: The Digital Photographer's Guide to Building a Business on Relationships* (Amherst Media®).

Srinu and Amy Regeti—*www.regetisphotography.com*

The Regetis are internationally recognized for their skill in telling stories through photography. As a talented husband and wife team, they are also well known in the photography industry as motivational speakers. Their work has been featured in such magazines as *Grace Ormonde, Rangefinder, Engaged!,* and *Virginia Bride,* as well as on ABC's *Nightline.* The Regetis operate a full-service studio located in the quaint historic town of Warrenton, VA, in the rolling hills outside of Washington, DC. They are the co-authors of a forthcoming book on portrait photography from Amherst Media®.

Hernan Rodriguez

www.hernanphotography.com

The recipient of numerous international photography awards, Hernan Rodriguez operates a successful studio in the heart of Los Angeles' San Fernando Valley. There, he juggles a steady roster of commercial, product, and celebrity photography, along with portraiture for families, children, and high-school seniors. He has art directed and photographed campaigns for Guess Clothing, Tanline CA, Comfort Zone, and Corona. He has also been featured in *Rangefinder, Studio Photography,* and *Photoshop User* magazines. Hernan is the author of *75 Portraits by Hernan Rodriguez,* also from Amherst Media®.

Krista Smith—*www.saltykissesphotography.com*

Krista Smith specializes in beautiful beach portraits for maternity, engagements, children, and families big or small. Krista has three small children and knows exactly how to approach kids of all temperaments, from shy darlings to rambunctious balls of energy. She takes the time to get to know each family and what they want so that their portraits are never stiff, boring photos of people who look uncomfortable. Her passion for fun, unscripted portraits comes from the frustration of seeing her own family portraits lack the energy and fun she felt they needed, so she is truly dedicated to getting the perfect portrait for all her clients. She is the author of a forthcoming book on natural-light portrait photography from Amherst Media®.

Alyn Stafford

www.alynstaffordphotography.com

Alyn Stafford is a portrait and commercial photographer in Riverside, CA. He holds a degree in Communication Arts from the University of Southern California and worked as Art and Creative Director for national advertising agencies handling clients like Sony, United Airlines, and Airliance—as well as serving as photo editor for *Aviation Lifestyles Magazine.* Alyn teaches in the Visual Communications department of ITT-Tech and runs two blogs (www.digitalsparkle.com and www.alynstafford.com) where he shares his photographic knowledge. He's the author of *Flash Techniques for Location Portraiture* (Amherst Media®).

Damon Tucci

www.damontucci.com

Damon Tucci began his career as an underwater cinematographer and later worked as a photographer for Disney Photographic Services. It was at Disney that he crafted his unique approach to wedding photography, which features a mix of documentary-

style photography and stylized fashion shots. Damon firmly believes that if you don't enjoy what you do, you should do something else. He is the author of *Step-by-Step Wedding Photography* and the co-author of *Tucci and Usmani's The Business of Photography* (Amherst Media®).

Neal Urban—*www.nealurban.com*
Neal Urban is a wedding photographer based in Buffalo, NY, who shoots events across the country. He is especially well-known for his use of HDR techniques to create breathtaking images of brides and grooms in unique locations, both indoors and out. Neal recently won four Accolades of Excellence Awards from WPPI and was the 2011 winner of PDN's Top Knot's People's Choice Award. His work has been featured in *Rangefinder* magazine and *Cosmopolitan Bride* (Chinese edition). Additionally, he is at work on a book about his wedding photography techniques (forthcoming from Amherst Media®).

Neil van Niekerk—*www.neilvn.com*
Neil van Niekerk, originally from Johannesburg, South Africa, is a wedding and portrait photographer based in northern New Jersey. His "Tangents" blog (www.neilvn.com/tangents) has become a popular destination for photographers seeking information on the latest equipment and techniques. He is also the author of *On-Camera Flash Techniques for Digital Wedding and Portrait Photography, Off-Camera Flash Techniques for Digital Photographers*, and *Direction & Quality of Light* (all from Amherst Media®).

Ellie Vayo—*www.ellievayo.com*
Ellie Vayo Photography, Inc. was founded over thirty years ago in Mentor, OH, and has grown into one of the most successful portrait studios in the country. Ellie holds Master and Craftsman degrees as well as PPA and API certifications and has won numerous awards for both photography and marketing from such prestigious organizations as PPA and Senior Photographers International. Her senior portraiture has also been featured in *Rangefinder, Studio Design, Lens,* and *Professional Photographer*. She is the author of *The Art and Business of High School Senior Portrait Photography*, now in its second edition, and *Ellie Vayo's Guide to Boudoir Photography* (both from Amherst Media®).

Marc Weisberg—*www.marcweisberg.com*
Marc Weisberg operates a boutique studio in California, specializing in magazine-style portraits of newborns, children, and families. Marc teaches photography and marketing both privately and as a guest lecturer at local colleges. He taught a Master Class in marketing at the WPPI convention in Las Vegas and has spoken on wedding photography and marketing at the Professional Photographers of California convention in Pasadena. Additionally, he was a featured speaker at the Pictage Partner-Con meetings in Los Angeles and New Orleans. Marc has won over a dozen national and international awards from WPPI and PPA. His photography has been featured in *Rangefinder* magazine as well as in more than a dozen books by Amherst Media®—including *The Best of Wedding Photography* and *The Best of Photographic Lighting* by Bill Hurter, and *500 Poses for Photographing Women* and *500 Poses for Photographing Brides* by Michelle Perkins.

James Williams
www.jameswilliams photography.com
James Williams is certified through the PPA and, in 2004, earned the Accolade of Photographic Mastery from WPPI. In 2005, he earned a Craftsman degree from PPA and the Accolade of Outstanding Photographic Achievement from WPPI. He regularly teaches at photography organizations' events and hosts seminars at his studio. He is the author of *How to Create a High-Profit Photography Business in Any Market, 2nd edition,* and *Master Guide for Team Sports Photography* (both from Amherst Media®).

OTHER BOOKS FROM

Amherst Media®

DON GIANNATTI'S Guide to Professional Photography

Perfect your portfolio and get work in the fashion, food, beauty, or editorial markets. Contains insight and images from top pros. *$39.95 list, 7.5x10, 160p, 220 color images, order no. 1971.*

Master Posing Guide for Portrait Photographers, 2nd Ed.

JD Wacker's must-have posing book has been fully updated. You'll learn fail-safe techniques for posing men, women, kids, and groups. *$39.95 list, 7.5x10, 160p, 220 color images, order no. 1972.*

Painting with Light

Eric Curry shows you how to identify optimal scenes and subjects and choose the best light-painting sources for the shape and texture of the surface you're lighting. $39.95 list, 7.5x10, 160p, 275 color images, index, order no. 1968.

Christopher Grey's Posing, Composition, and Cropping

Make optimal image design choices to produce photographs that flatter your subjects and meet clients' needs. *$39.95 list, 7.5x10, 160p, 330 color images, index, order no. 1969.*

LED Lighting: PROFESSIONAL TECHNIQUES FOR DIGITAL PHOTOGRAPHERS

Kirk Tuck's comprehensive look at LED lighting reveals the ins-and-outs of the technology and shows how to put it to great use. *$34.95 list, 7.5x10, 160p, 380 color images, order no. 1958.*

Nikon® Speedlight® Handbook

Stephanie Zettl gets down and dirty with this dynamic lighting system, showing you how to maximize your results in the studio or on location. *$34.95 list, 7.5x10, 160p, 300 color images, order no. 1959.*

Step-by-Step Posing for Portrait Photography

Jeff Smith provides easy-to-digest, heavily illustrated posing lessons designed to speed learning and maximize success. *$34.95 list, 7.5x10, 160p, 300 color images, order no. 1960.*

Other Books in This Series . . .

500 Poses for Photographing Women

Michelle Perkins compiles an array of striking poses, from head-and-shoulders to full-length, for classic and modern images. *$34.95 list, 8.5x11, 128p, 500 color images, order no. 1879.*

500 Poses for Photographing Brides

Michelle Perkins showcases an array of head-and-shoulders, three-quarter, full-length, and seated and standing poses to showcase the bride and her attire. *$34.95 list, 8.5x11, 128p, 500 color images, index, order no. 1909.*

500 Poses for Photographing Men

Michelle Perkins showcases an array of head-and-shoulders, three-quarter, full-length, and seated and standing poses that make guys look great. *$34.95 list, 8.5x11, 128p, 500 color images, order no. 1934.*

500 Poses for Photographing Couples

Michelle Perkins showcases an array of poses that will give you the creative boost you need to create an evocative, meaningful portrait. *$34.95 list, 8.5x11, 128p, 500 color images, order no. 1943.*

500 Poses for Photographing High School Seniors

Michelle Perkins presents head-and-shoulders, three-quarter, and full-length poses tailored to seniors' eclectic tastes. *$34.95 list, 8.5x11, 128p, 500 color images, order no. 1957.*

Lighting Essentials

LIGHTING FOR TEXTURE, CONTRAST, AND DIMENSION

Don Giannatti explores lighting to define shape, conceal or emphasize texture, and enhance the feeling of a third dimension. *$34.95 list, 7.5x10, 160p, 220 color images, order no. 1961.*

50 Lighting Setups for Portrait Photographers, VOLUME 2

Steven Begleiter provides recipes for portrait success. Concise text, diagrams, and screen shots track the complete creative process. *$34.95 list, 7.5x10, 160p, 250 color images, order no. 1962.*

Legal Handbook for Photographers, THIRD EDITION

Acclaimed intellectual-property attorney Bert Krages shows you how to protect your rights when creating and selling your work. *$39.95 list, 7.5x10, 160p, 110 color images, order no. 1965.*

Behind the Shutter

Salvatore Cincotta shares the business and marketing information you need to build a thriving wedding photography business. *$34.95 list, 7.5x10, 160p, 230 color images, index, order no. 1953.*

Studio Lighting Unplugged

Rod and Robin Deutschmann show you how to use versatile, portable small flash to set up a studio and create high-quality studio lighting effects in *any* location. *$34.95 list, 7.5x10, 160p, 300 color images, index, order no. 1954.*

Master's Guide to Off-Camera Flash

Barry Staver presents basic principles of good lighting and shows you how to apply them with flash, both on and off the camera. *$34.95 list, 7.5x10, 160p, 190 color images, index, order no. 1950.*

Lighting for Architectural Photography

John Siskin teaches you how to work with both strobe and ambient light to capture rich, textural images that your clients will love. *$34.95 list, 7.5x10, 160p, 180 color images, index, order no. 1955.*

Hollywood Lighting

Lou Szoke teaches you how to use hot lights to create timeless Hollywood-style portraits that rival the masterworks of the 1930s and '40s. *$34.95 list, 7.5x10, 160p, 148 color images, 130 diagrams, index, order no. 1956.*

THE BEST OF Senior Portrait Photography, SECOND EDITION

Rangefinder editor Bill Hurter takes you behind the scenes with top pros, revealing the techniques that make their images shine. *$39.95 list, 7.5x10, 160p, 200 color images, order no. 1966.*

Posing for Portrait Photography
A HEAD-TO-TOE GUIDE FOR DIGITAL PHOTOGRAPHERS, 2ND ED.

Jeff Smith shows you how to correct common figure flaws and create natural-looking poses. *$34.95 list, 8.5x11, 128p, 200 color images, index, order no. 1944.*

CHRISTOPHER GREY'S
Vintage Lighting

Re-create portrait styles popular from 1910 to 1970 or tweak the setups to create modern images with an edge. *$34.95 list, 8.5x11, 128p, 185 color images, 15 diagrams, index, order no. 1945.*

WES KRONINGER'S
Lighting Design Techniques
FOR DIGITAL PHOTOGRAPHERS

Create setups that blur the lines between fashion, editorial, and classic portraits. *$34.95 list, 8.5x11, 128p, 80 color images, 60 diagrams, index, order no. 1930.*

UNLEASHING THE RAW POWER OF
Adobe® Camera Raw®

Mark Chen teaches you how to perfect your files for unprecedented results. *$34.95 list, 8.5x11, 128p, 100 color images, 100 screen shots, index, order no. 1925.*

MORE PHOTO BOOKS ARE AVAILABLE

Amherst Media®
PO BOX 586
BUFFALO, NY 14226 USA

Individuals: If possible, purchase books from an Amherst Media retailer. To order directly, visit our web site, or call the toll-free number listed below to place your order. All major credit cards are accepted. *Dealers, distributors & colleges:* Write, call, or fax to place orders. For price information, contact Amherst Media or an Amherst Media sales representative. Net 30 days.

(800) 622-3278 or (716) 874-4450
Fax: (716) 874-4508

All prices, publication dates, and specifications are subject to change without notice. Prices are in U.S. dollars. Payment in U.S. funds only.

WWW.AMHERSTMEDIA.COM
FOR A COMPLETE LIST OF BOOKS AND ADDITIONAL INFORMATION